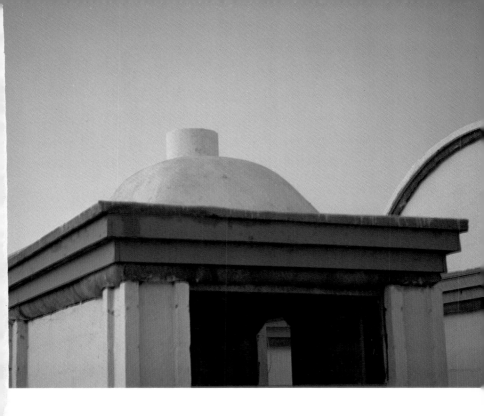

THE PRODUCTION OF HOUSES

The Production of Houses is the fourth in a series of books which describe an entirely new attitude to architecture and planning. The books are intended to provide a complete working alternative to our present ideas about architecture, building, and planning—an alternative which will, we hope, gradually replace current ideas and practices.

THE
PRODUCTION
OF HOUSES

Christopher Alexander

with

Howard Davis
Julio Martinez
Donald Corner

Written with affection and respect for
our apprentices in Mexico

Ramiro Ortuño *Donato Rechy*
Julio Chavez *Jorge Torres*
Emma Rivera *Enrique Ramirez*
Gloria Hernandez *Javier Toscano*

NEW YORK • OXFORD
OXFORD UNIVERSITY PRESS
1985

Library of Congress Cataloging in Publication Data

Alexander, Christopher.
The production of houses.

1. House construction. I. Title.
TH4811.A46 1984 690'.837 82-14097
ISBN 0-19-503223-3

Printing: 9 8 7 6 5 4 3

Printed in the United States of America

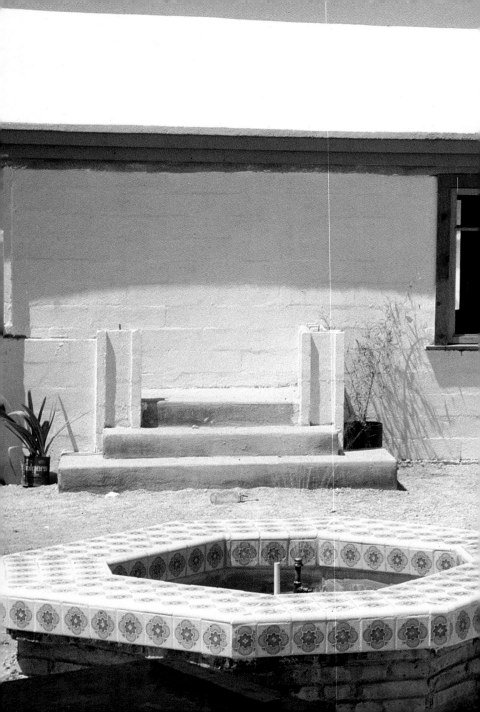

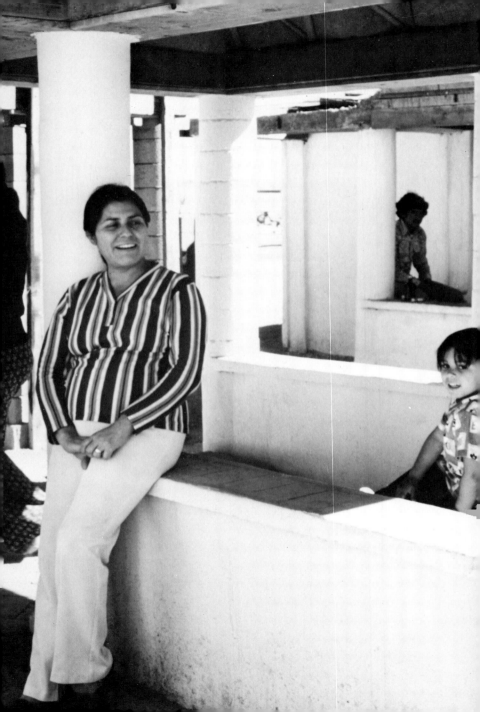

CONTENTS

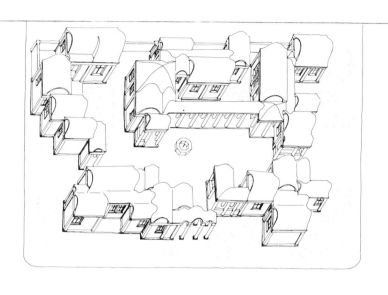

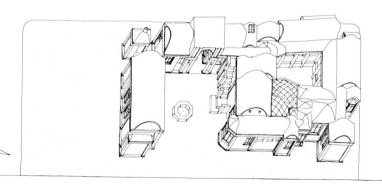

INTRODUCTION

In the next 35 years, 3500 million people
will need places to live: 3500 cities of
1,000,000 residents each. Now there are
less than 300 cities of this size.

In the next 35 years the need is for an-
other 600,000,000 houses, more than ex-
ist in the world now.

Habitat, U.N. Conference 1976

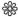

In the modern world, the idea that houses can be loved and beautiful has been eliminated almost altogether. For most of the world's housing, the task of building houses has been reduced to a grim business of facts and figures, an uphill struggle against the relentless surge of technology and bureaucracy, in which human feeling has almost been forgotten. Even in those few houses which openly concern themselves with their appearance, beauty also has been forgotten. What happens there is something remote from feeling, an almost disgusting concern with opulence, with the taste of the marketplace, with fashion. Here, too, the simple values of the human heart do not exist.

The real meaning of beauty, the idea of houses as places which express one's life, directly and simply, the connection between the vitality of the people and the shape of their houses, the connection between the force of social movements and the beauty and vigor of the places where people live—this is all forgotten, vaguely remembered as the elements of some imaginary golden age.

Yet, strangely, little of the literature on so-called "housing," and few of the efforts being made today, are trying to bring these things into the world again. There is a great deal of concern about the price of houses, there is a vast concern with the millions of homeless

people on the earth, there is a widespread concern with industry and technology and the ways in which these things can help to solve the so-called housing problem; there is concern with the importance of "self-help"; there is concern with political control of people over their neighborhoods. But all this is strangely abstract, without feeling. It deals with the issues, but it glides over them. It does not concern itself with feeling; it creates a mental framework in which solutions are as mechanical and as unfeeling as the problems they set out to solve.

We recognize the value of many of the efforts people are making to solve "the housing problem"; but we are concerned, here, in this book, with the feeling at the root of it. We have tried to construct a housing process in which human feeling and human dignity come first; in which the housing process is reestablished as the fundamental human process in which people integrate their values and themselves, in which they form social bonds, in which they become anchored in the earth, in which the houses which are made have, above all, human worth, in the simple, old-fashioned sense that people feel proud and happy to be living in them and would not give them up for anything, because they are *their* houses, because they are the product of *their* lives, because the house is everything to them, the concrete expression of *their* place in the world, the concrete expression of themselves.

To be clear, we have chosen to illustrate this process with examples from one particular project we have built recently in northern Mexico. In this particular Mexican example, the houses have an area of 60–70 square me-

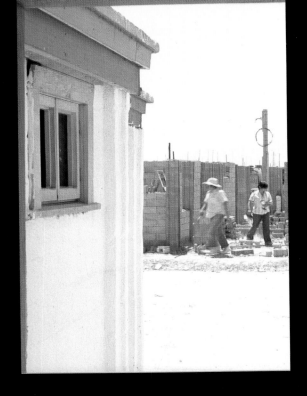

ters, they are arranged around common land, owned jointly by the families, each house is designed by the family who lives in it, and is therefore different from the others. The houses are built from interlocking soil cement blocks, produced by us in our own yard, and have ultralightweight concrete vaults, built over a lightweight woven wood basket. They cost about 40,000 pesos each, which was equivalent to some $3500 American dollars at the time of construction.

However, the specific details of our Mexican project are quite unimportant. What matters is the system of seven general principles, which are presented, one by one, in the chapters which follow. These principles concern the overall organization of a production process, the relation between people and the design of the houses, the fact that the houses are planned by the families themselves, the fact that there is a new kind of architect guiding and managing the process, the fact that the construction is undertaken, and money controlled, in an entirely new way.

We believe that these principles apply to all kinds of housing, in all parts of the world. They are independent of the particular construction details that are used. They apply equally to houses that are expensive and to houses, like ours, that are very cheap. They apply equally to houses which the people help to build for themselves, as they have done in our Mexican project, and to houses which people design for themselves and then have built for them by professional builders. They apply equally to houses built at low densities of two to four houses per acre, to houses built at medium densities of fifteen per acre (like those in our Mexican project), and to houses built at much higher densities, of sixty per acre, in complexes four storeys high.

In short, what is at stake in this book are seven fundamental principles of the housing production process, which must be followed—we believe—under *all* circumstances, and regardless of all other details, to make it possible for people to live in human and decent houses, at a reasonable price.

PART ONE

THE SYSTEM OF PRODUCTION

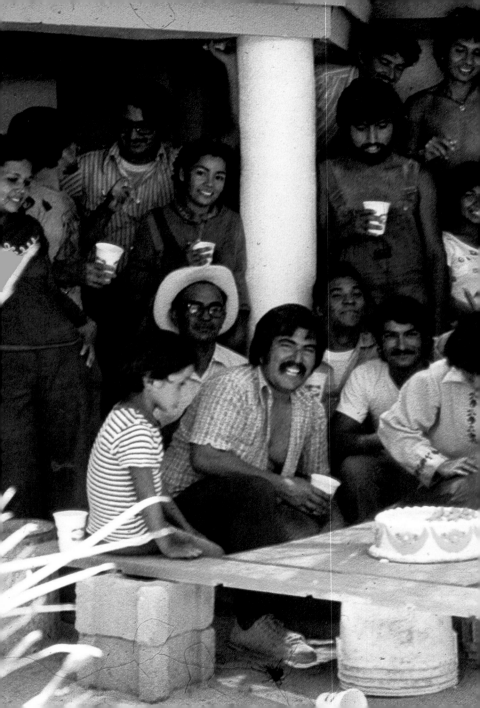

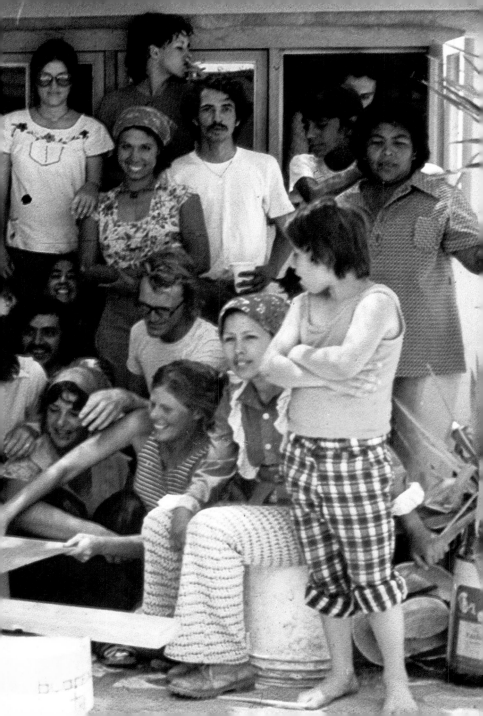

The single largest element of our environment is that created by our houses, or by "housing." Today, most of this "housing" is produced by mass means; that is, it consists of hundreds of houses produced by one form or another of semi-automatic process—either the repetitive construction of tract houses, or the repetitive construction of apartments in apartment buildings.

There is no doubt that the alienation and despair which many people feel, is created, at least in large part, by the depressing burden of this "mass housing" in which people are forced to spend their lives.

It is commonly assumed that this kind of mass housing is an essential of our time since it is not possible to produce houses in sufficient numbers without resort to "mass housing"; since it is not possible to produce houses cheaply enough, except by the means of "mass housing"; and, finally, that it is indeed necessary for us to go further and further in the direction of this mass housing in order to solve the problems of the housing shortage felt by most countries in the world.

We intend to show in this book that these assumptions are wrong. We shall show that there is an entirely different process of housing production, which can produce houses in equally large numbers, but houses that are very much better, that are deeply rooted in the psychological and social nature of the environment, that

are rooted in the personal character of the different people and different families who live in them. And we shall show, too, that houses produced by this new process need not be more expensive than the houses of "mass housing," but may in fact be cheaper—very much cheaper.

Let us be more specific. If we consider the systems of housing production which exist in the world today, we find that almost all of them lack two fundamental necessities of any human society.

First, recognition of the fact that every family and every person, is unique, and must be able to express this uniqueness, in order to express and retain human dignity.

Second, recognition of the fact that every family and every person, is part of society, requires bonds of association with other people—in short, requires a place in society, in which there are relationships with others.

These two complementary necessities are almost entirely missing from today's houses. On the one hand, the houses are identical, machinelike, stamped out of a mold, and almost entirely unable to express the individuality of different families. They suppress individuality, they suppress whatever is wonderful and special about any one family. On the other hand, the houses also fail entirely to give people a basis for small local congregation. Placed and built anonymously, the houses express isolation, lack of relationship, and fail altogether to help create human bonds in which people feel themselves part of the fabric which connects them to their fellow men.

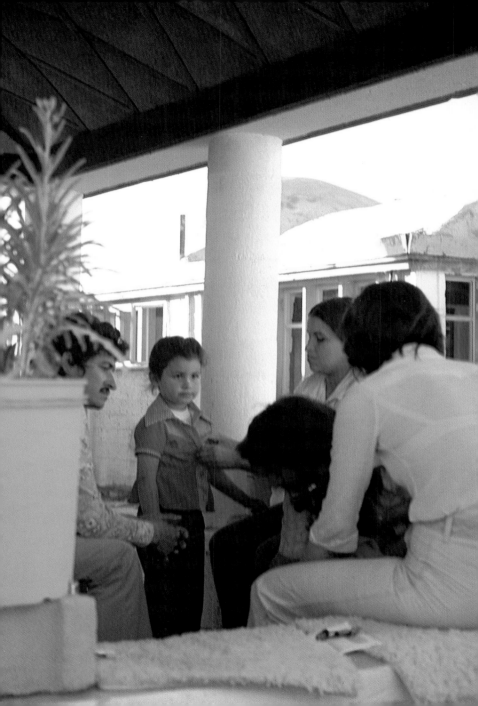

THE SYSTEM OF PRODUCTION

As we shall argue in this book, these problems cannot be solved *at all* without changing the system of production which creates them.

We must recognize, to start with, that the houses in society are always given their character by the system of production which produces them. If the character of the houses is inadequate, as, for instance, it certainly is today, then it can only be improved by modifying this system of production.

At any given moment, the system of housing production is a coherent system. It is not designed by any one person or group of people. But it is, nevertheless, a system: a system of rules, habits, laws, and accepted procedures, taken for granted throughout society and responsible for the production of most of the houses in society.

Although there is no one institution responsible for the invention of this system, still the process which the system embodies is in no way informal. It is highly organized; indeed, so highly organized that any departure from the system is likely to lead to almost interminable difficulties, delays, objections. In fact, only a trickle of nonconforming houses can be built outside the system, in any given year.

Like all systems, the system of housing production is always recognizable by its products; that is to say, by the *form* of housing which it produces. For example, the housing production system currently most widespread in the United States is the one which is called

THE SYSTEM OF PRODUCTION

"tract development": it can be recognized, exactly, by the tracts which it produces. Within this system, developers buy land, develop roads, and then build houses, more or less identical, in quantities of hundreds at a time. These houses are owned by the families; they have private lots; and the process is based on the existence of federally insured bank programs which lend money for these kinds of houses, on the tax incentives which encourage families to make these kinds of purchases, on zoning laws which prescribe density and land use, and so on. The houses are designed, ahead of time, as "model homes," on the drawing board. The model houses are then built, many times over, by contractors, working with crews of specialized labor, themselves most often working as subcontractors . . . The construction techniques emphasize speed; many of the construction workers are novices, working essentially for money, not for the love of what they build . . . All this, ramified throughout society in a million details—in what can be bought in a hardware store, in what a subcontractor can legally do, in the forms of management approved by the state licensing board for contractors and architects— all this together forms the system of production which produces some 400,000 houses per year in the United States alone.

Another common system of housing production, more widespread throughout the world, is the system which produces publicly financed apartment houses in France, Sweden, the USSR, and many other countries. In this system, apartment houses are built for the government by developers (either private or government-controlled); the individual dwellings are identical "cells" arranged

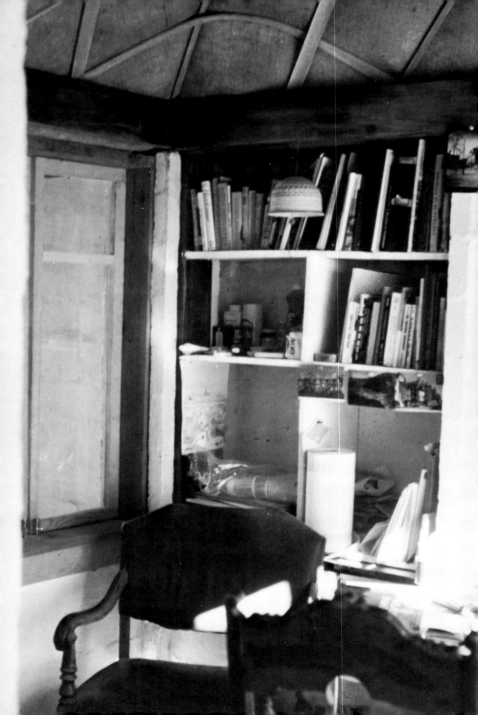

in several storeys of apartments, the cells typically smaller than houses; it is taken for granted that the apartments will later be rented by families who have nothing to do with the process of their production; again, there is a well-developed system of loans for this type of housing; again, the contracting procedures, the title transfers, the loan execution, the process of advertising, and the legal form of rental are all institutionalized, in more or less similar form, throughout the world. This process of production is even more widespread than the process we call "tract development." Families do not have the right to change their dwellings; they cannot undertake any form of improvement; they do not have security of tenure; they have to get permission from management for any change; and apartments are identical, because they come from a standard set of drawings.

We assert, categorically, that neither tract houses nor these types of apartment houses can be made more human merely by "improving their design," so long as the underlying systems of production which create them remain unchanged.

Of course, it is true that in either one of these systems the designs of the buildings can be made *slightly* more intelligent, *slightly* more respectful of human needs, *slightly* more personal in feeling. *However, the alienated character of the buildings which are produced is, in the end, a direct consequence of the deep structure of their production systems; and this character cannot be substantially improved until the systems themselves are altered at the roots.*

The arguments which have led us to this conclusion

have been presented, during the last few years, in the series of books of which this book is Volume 4.

Volume 1, *The Timeless Way of Building*, provides a fundamental analysis of the adaptation between people and buildings, and shows that the human environment can only come to order under circumstances similar to those which existed in most traditional societies, where people are directly responsible for shaping their environment, and where they also have the necessary common "pattern languages" which make it possible for them to cooperate in producing a coherent structure.

Volume 2, *A Pattern Language*, gives one example of a detailed language of the type called for in *The Timeless Way of Building*. It specifies patterns at a wide range of scales, including the largest patterns of a city, the detailed patterns which govern the layout of land and buildings, the patterns which govern the shapes of rooms, and patterns which govern the construction details. The families who laid out the houses and common land described later in this book did so using this pattern language. The patterns they used are mentioned repeatedly in Chapters 3, 4, and 5, of Part Two.

Volume 3, *The Oregon Experiment*, describes the way that a community of 15,000 people (the University of Oregon) is now using a pattern language to govern the planning of its communal land and buildings, and the administrative procedures which make this possible. This experiment has been going on for five or six years now, and is improving all the time, as the process matures.

Volume 5, *The Linz Café* describes a public building recently built in Austria, which embodies many of the ideals of *The Timeless Way of Building*, and shows, in a

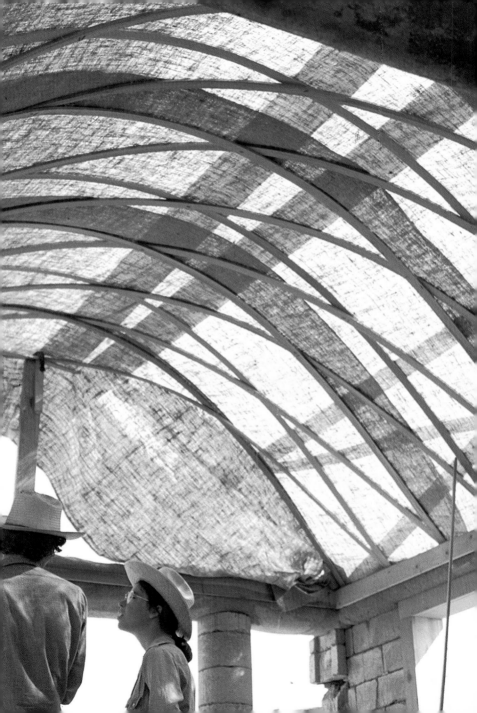

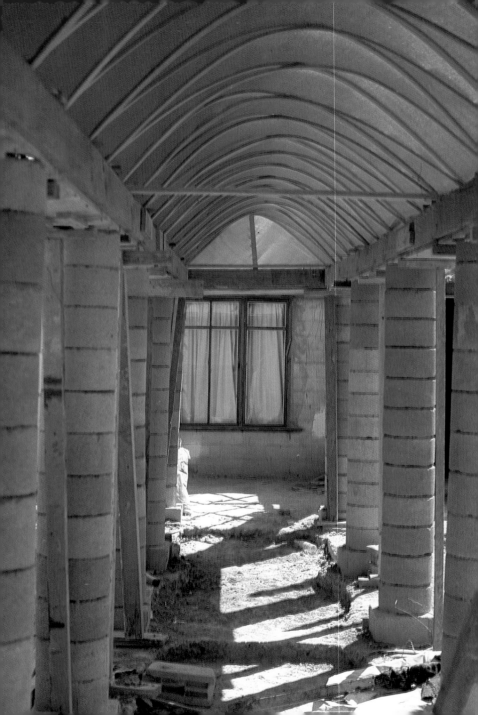

simple case, what such a building really can be like, in our time, and at a reasonable cost.

All four of the books published so far implicitly (though not explicitly) point out that the production process which produces an environment is given its character by its internal distribution of control. That is, each production process is a human system which distributes control over decisions in a certain manner.

Some kinds of distribution of control work well to produce very beautifully organized, orderly, and lovely environments, in which people feel satisfied. Other kinds of distribution of control work badly; they produce environments in which there are abundant mistakes, failures of adaptation, impersonal expenditures in which money is spent by the wrong people, in the wrong place, at the wrong time.

But in every case, the key to the success or failure of the system lies in the *way* that control is distributed. Above all, it is this which determines the quality of the environment.

The argument which leads to this conclusion is, in essence, biological. To understand it, let us draw a comparison between housing projects, which today make up a major part of our man-made world, and any typical part of the biological world—a forest, a plant, an organism, an ocean. In the biological world, there is always an immense complexity; and this complexity comes about as a result of a process of minute adaptation, which painstakingly, slowly, ensures that every part is properly adapted to its conditions.

In this sense, even though, of course, biological systems are all imperfect, there is nevertheless an extraor-

dinary extent to which each part, each form, is "correct," in which each decision, each peculiarity of form required by local adaptation, is "just right." The system contains huge numbers of variables, huge numbers of components. And the process which produces it, the living process of adaptation which is typical in all biological systems, guarantees that each part is as nearly as possible "just right," appropriate to its local conditions, and appropriate in the large, so that it also functions well as part of some larger system than itself.

On the other hand, if we compare a modern "housing project" with a typical part of the biological world, the contrast is stark. Where the biological system shows minute and lovely adaptation at every point and at every level, the typical housing project shows a high level of disastrous failures of adaptation. The houses are "just wrong" in almost every way that matters, even though they are often thought out in broad general terms which should make sense.

A biological system is able to achieve its sensitive and complex adaptations because control over the shape of components is widely distributed at a great many levels throughout the organism. For instance, in an animal, the major arrangement of limbs is under one level of genetic control; the location of organs is controlled at a lower level by a lower-level center; the detailed form of organs—for instance, the exact shape of the lung wall—is controlled by the hormones at the level of the tissue itself; clusters of cells are controlled at another level; and the fine tuning and arrangement of individual cells is controlled, at least in part, by a homeostatic process at the level of the cells themselves. *In*

short, there is fine-grain control over the details of the organism at every level, just where it is needed to produce the right result. It is this fact, above all, which is responsible for the beautiful and subtle adaptation of the parts which form the whole.

By contrast, the production systems which produce housing in the modern world are too centralized: there is insufficient control at the levels which control detail. And if we ask ourselves why the modern housing in the world is so often "just wrong," instead of just right, we shall quickly see that the failures of adaptation are caused, most often, by the fact that the decisions which control the form of the houses are almost all made at a level too remote from the immediate people and sites, to allow reasonable and careful adaptation to specific details of everyday life. Most of the processes which govern the shape of the houses and their parts are controlled at levels of government, or levels of industry, or levels of business, which are remote from the minute particulars of the house and family itself—so that, inevitably, they create alien and abstract forms, bearing only the most general relationship to the real needs, real demands, real daily minute-to-minute details which the members of the household experience.

Of course, all this abstract, arm's-length control of the housing process is typically justified by the argument that low-cost and high-volume production require it. It is argued that even if the machine of industry and the machine of development are incapable of paying attention to the local particulars which proper adaptation and proper biological wholeness would require, nevertheless these machines are still essential, still useful and

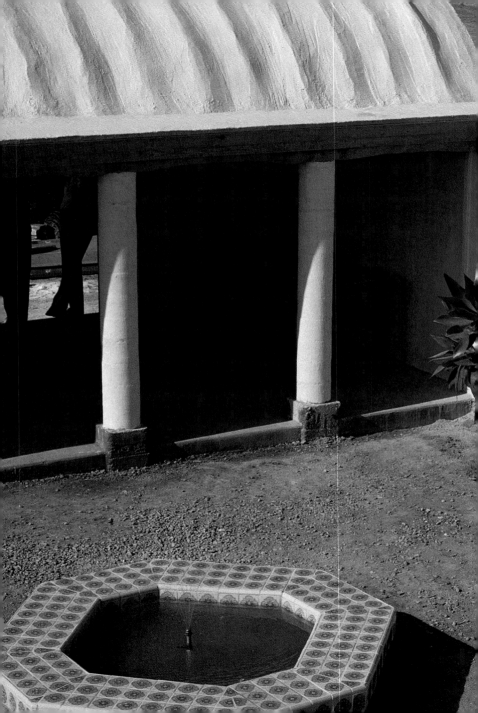

efficient, because they can produce houses in such enormous quantities.

Yet, this is a shallow argument indeed. To argue that inhuman, alienated houses must be produced by the million, in the name of efficiency, and cost, and volume, after all simply means that we—the people of the twentieth century, the people of the great industrial age—have not yet had the wit or the intelligence to devise a system which is both human in its products and efficient at the same time. We can say, at best, that we are in an interim phase, where we knowingly produce intolerable houses for the millions of homeless people on the earth . . . knowing all the while that there must be better processes which will produce satisfying, more human houses, in which people feel adequate, whole in themselves, at one with their lives, and which are also able to produce large numbers of houses at very low costs.

Let us repeat this more simply. Present systems of production are organized in such a way that most decisions are made very much "at arm's length." Decisions are made by people remote from the consequences of the decisions. Architects make decisions about people whose faces they have never seen. Developers make decisions about land where they have never smelled the grass. Engineers make decisions about columns which they will never touch, or paint, or lean against. Government authorities make decisions about roads and sewers without having any human connection at all to the place for which they are making these decisions. The construction workers who nail the boards and lay the bricks have no power of decision at all over the

details which they build. The children who are going to play between the houses have no power of decision at all over even the sandpits where they are going to play. Families move into houses which have been laid out "for" them, and have no control whatever over the most fundamental and intimate aspects of the plan in which they are going to live their lives.

In short, the production systems which we have at present define a pattern of control which makes it almost impossible for things to be done carefully or appropriately, because, *almost without exception*, decisions are in the wrong hands, decisions are being made at levels far removed from the immediate concrete places where they have impact . . . and, all in all, there is a colossal mismatch between the organization of the decision and control, and the needs for appropriateness and good adaptation which the biological reality of the housing system actually requires.

If we are to put this situation right, to bring our production systems into order, we must therefore concentrate, essentially, on this human problem of the distribution of control. What we must find is a system of production which is capable of giving detailed, careful attention to all the particulars which are needed to make each house "just right" at its own level, at its own scale, and which is yet at the same time efficient enough, replicable enough, and simple enough so that it can be carried out on an enormous scale, and at a very low cost.

Specifically, we believe that there are seven kinds of control which play a crucial role in the production process. To identify these seven types of control, we may ask the following seven questions:

1. What kind of person is in charge of the building operation itself?
2. How local to the community is the construction firm responsible for building?
3. Who lays out and controls the common land between the houses, and the array of lots and houses?
4. Who lays out the plans of individual houses?
5. Is the construction system based on the assembly of standard *components,* or is it based on acts of creation which use standard *processes?*
6. How is cost controlled?
7. What is the day-to-day life like, on-site, during the construction operation?

We believe, very simply, that there is an objectively sensible answer to each one of these questions.

1. *What kind of person is in charge of the building operation itself?*

In today's production system, there is no one person in charge. There are various officials, architects, engineers, and contractors, each one carrying out his duties, but without any one of them having any overall view of the whole. What results, inevitably, is a bureaucratic and inhuman situation in which feeling cannot prevail, because each person's feelings are submerged by the bureaucratic process.

However, for adaptation and control to be correct, it is possible to imagine a new kind of master builder who controls all aspects of planning, design, and construction in a very immediate way—but who has direct

charge of no more than a few dozen houses at a time, with direct responsibility to the families who are going to live in those houses, and with the power to respond directly to their wishes.

2. How local to the community is the construction firm responsible for building?

In today's production system, the actual contracting is most often carried out by large corporate combines, with offices and directors far from the neighborhood. Of course, these men and these organizations cannot be responsive to the wishes of the neighborhood, nor to the individual families.

However, for proper adaptation to occur, it is possible to imagine a system of decentralized builder's yards, one or more for each small neighborhood, every few blocks, each one responsible for the physical development of the local neighborhood. This is a human solution which places control within reach of the people who are affected.

3. Who lays out and controls the common land between the houses, and the array of lots and houses?

In today's production system, this is a process carried out in an entirely abstract manner. The city controls the common land between the houses. The administration responsible for the building project lays out this common land by assigning it to a draftsman. The subdivision of the land into lots or apartments is done by an official in an office entirely remote from the real

situation. Inevitably, what is created by this process is inhuman and abstract.

However, for proper social connection between people and their community, it is possible to imagine a building process in which groups of families, of a size small enough so people can talk to each other and reach agreements, can themselves work in clusters, have control over their own common land, and lay out their own lots according to their own designs and their own wishes. This is a human solution which places control over the essential issues in the hands of the people who are most affected by these issues, and who understand them best.

4. *Who lays out the plans of individual houses?*

In today's production system, the individual houses are most often designed by architects, remote from the people, often not even able to know the families, because very often the families have not yet been chosen; and the houses are designed to be standard—as well designed as possible, of course, but essentially standard cells. This is bound to be inhuman. Families who are vastly different in their needs live in boxes designed for average families, all with the same walls, the same windows, the same shaped bedroom, the same shaped kitchen.

However, it is possible to imagine a much more flexible process in which families design their own houses, or apartments, within a fixed cost limit, and with certain necessary ground rules, but in such a way that each house is a celebration of the spirit, a mark, on the earth,

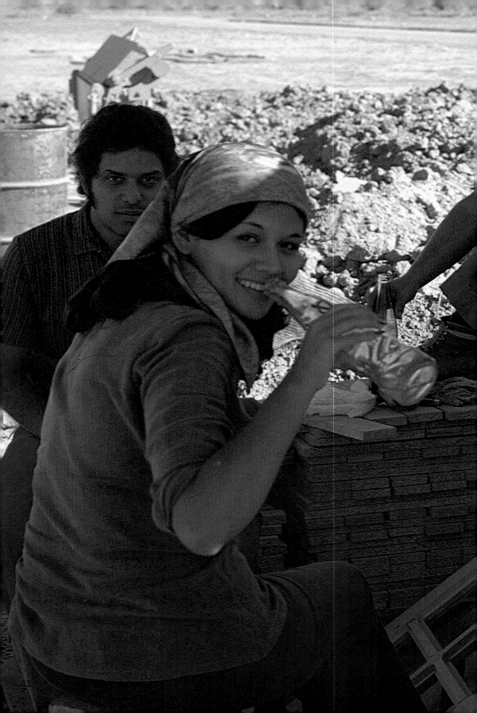

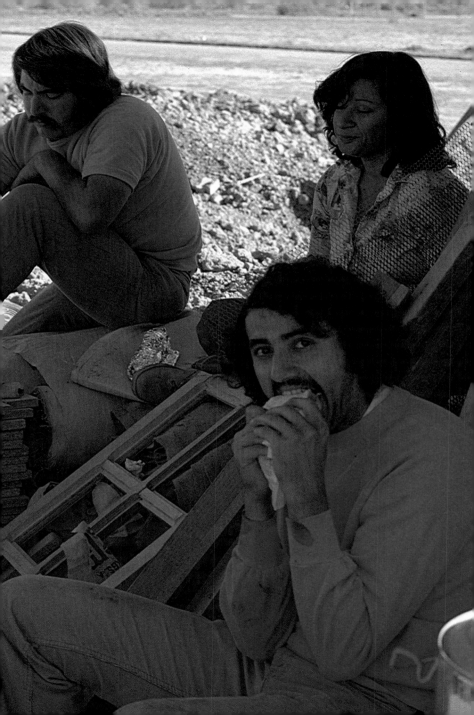

of that family and its special story. These houses would not only be treasured by the families who designed them, so long as they live there, but because the houses have a human touch, because they emerge from some specific human situation and have the touch of life to them, they would also be more human, more full of life, for any other family who comes to live there in the future.

5. *How are the construction details themselves actually produced?*

In today's production system, it has become common to expect houses to be assembled from mass-produced components. Some of these components are small; others are very large. But the variety which can be produced by mixing components is always still variety "within the system," which tyrannizes the design, so that we have twenty different boxes, instead of one kind of box, but they are still all boxes, still all essentially the same.

However, to avoid the tyranny of parts over the whole, it is possible to imagine a system of construction, technically far more advanced, in which what is standard are the *operations* (tile setting, bricklaying, painting, spraying, cutting, etc.), but where the actual size and shape of what is done can vary according to the feeling and requirements of the individual building. This is more human because it allows the builders to make a work of art which captures feeling and spirit—in contrast to the building assembled from fixed components, which must always be, and always seem to be, some kind of mechanical box.

6. *How is cost controlled?*

In today's production system, the importance of cost control is used to centralize as many operations as possible—design, construction, purchase of materials—and to drastically limit local initiative or local spirit from entering the buildings.

However, to prevent cost control from inhibiting reasonable and careful design of individual buildings, it is possible to imagine a more flexible cost-control system which benefits from local initiative, which allows each house to be made, step by step, within a fixed budget, but without controlling the exact way in which this budget is spent, thus allowing each house to be different in the ways it needs to be in order to satisfy the family.

7. *What is the day-to-day life like on the site?*

In today's production system, the site, during actual building operations, is merely a place where "the job is being done." There is no special cause for happiness because houses are being built; none of the workers have any immediate connection with these houses or any special pleasure in them: for them it is "just a job."

However, to overcome the vast alienation of these "housing projects," it is possible to imagine a much more human situation on the site, in which the spiritual importance of these houses becomes a real and effective daily part of life, in which the families themselves contribute as much or as little as they want to, but in which the construction process is a "house rais-

ing," a time of special importance for these families, lived through by the families and the builders together in a way that celebrates its importance and its happiness.

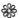

We believe that these seven principles of control together form a kernel which must govern the form of any reasonable housing production system. This does not mean that there are not other, still larger questions, capable of having even greater impact on the production process. For example, it is clear that the distribution of money in society, the flow of money for housing in the economy, the manufacture of building materials, and the political structure of local regions, all have massive effects on the production of housing.

In this sense, we certainly do not claim to have identified the totality of "the housing production system."

However, we do believe that the seven features we have identified do, together, form a necessary core of any production system, which must be present, whether these other larger variables are changed or not. Even if other major social changes were to occur, in which the flow of money, the distribution of political power, and the nature of manufacturing were all to change—even then, we believe that those changes in themselves would still not bring about an adequate approach to the production of houses *unless accompanied by the seven kinds of changes within the system of production that we shall define.*

In short, we believe that these seven principles, which we shall now make precise, are essential to the produc-

tion of houses under all circumstances, and must be followed, whether other necessary social changes are made or not. *In this sense, we do claim that we have identified a nucleus which can tentatively be called "the" production of houses, and not merely "certain aspects" of the production of houses, because we believe that this stuff which we have identified is an invariant kernel which must be present in any reasonable process of housing production if it is to reach human ends—quite regardless of its other attributes.*

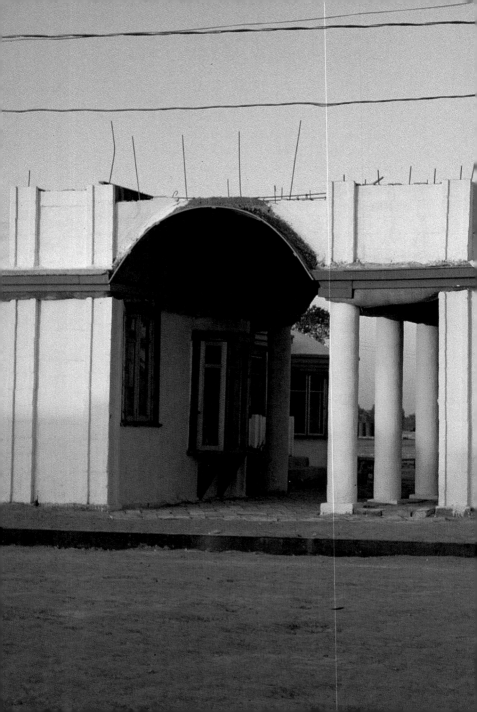

PART TWO

THE MEXICALI
PROJECT

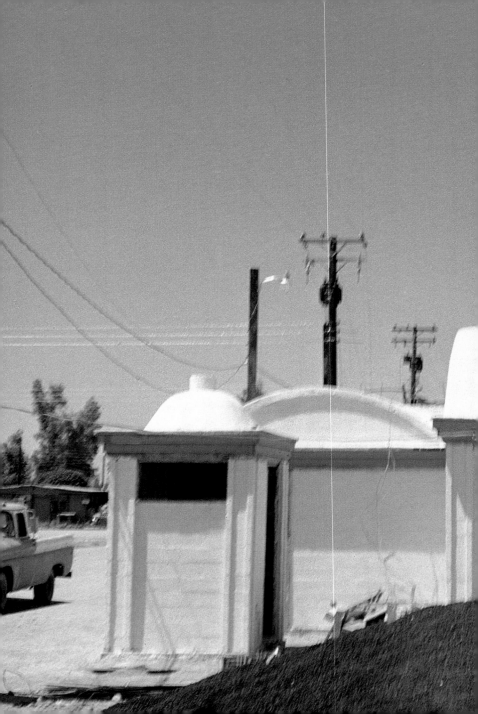

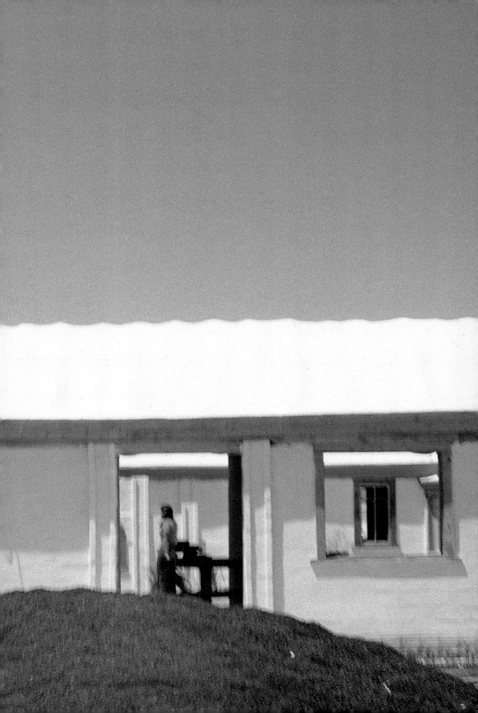

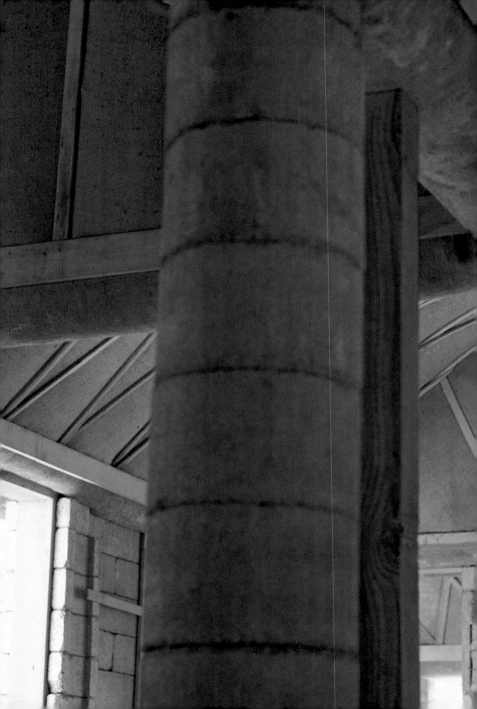

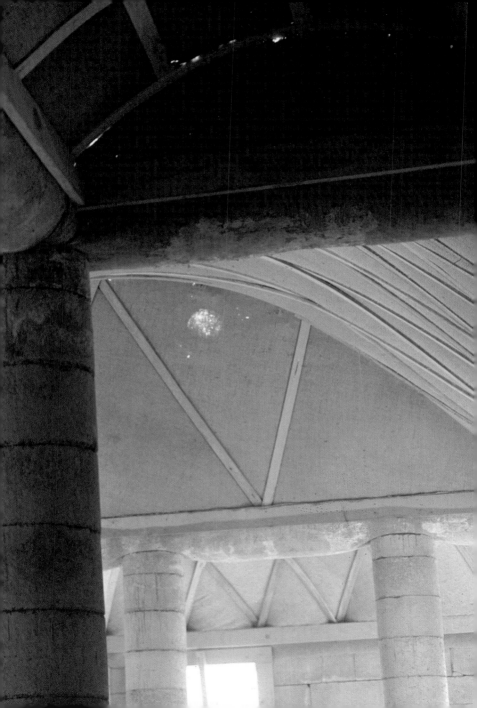

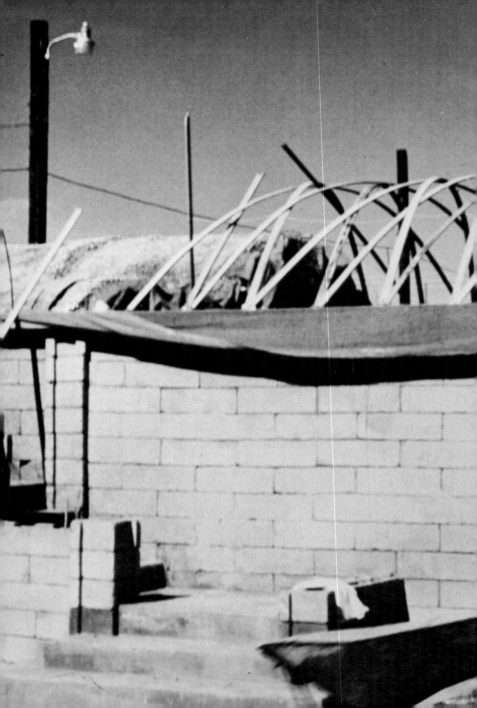

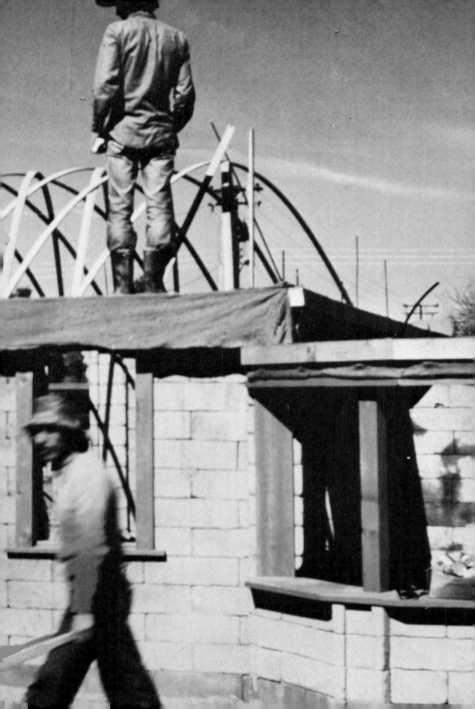

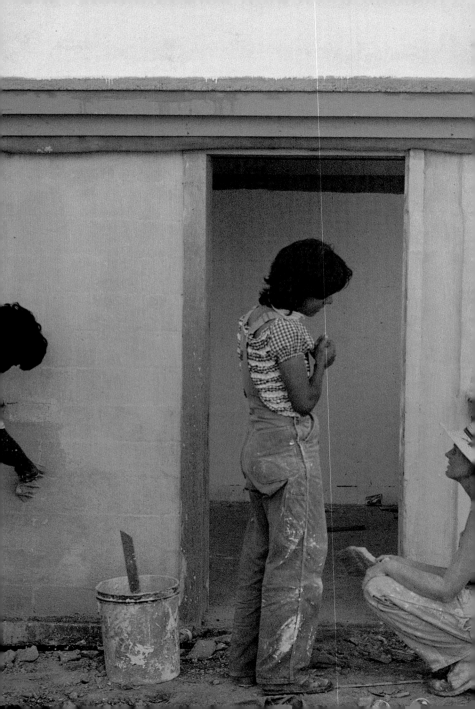

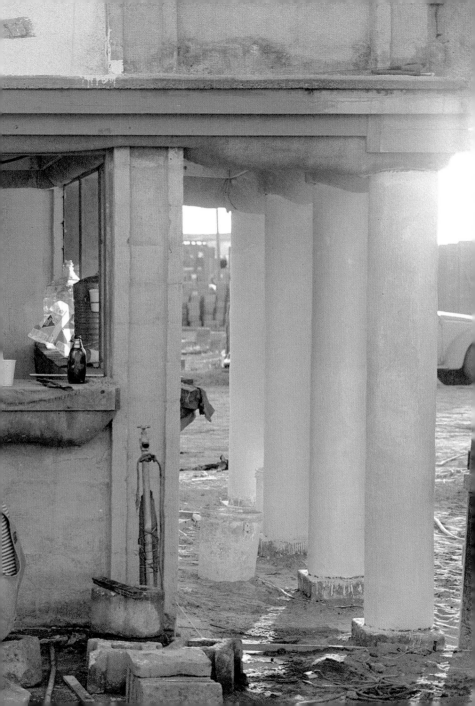

The following seven chapters describe the seven principles of control, and illustrate, with pictures and examples, the way we implemented these seven principles in Mexicali.

CHAPTER I

THE ARCHITECT-BUILDER

THE PRINCIPLE OF THE ARCHITECT-BUILDER

The backbone of the process of production we envisage is a new kind of professional who takes responsibility for the functions which we now attribute to the architect, and also, for the functions which we now attribute to the contractor.

He is responsible for the detailed designs of the houses, and for making sure that the actual design is in the hands of the family. The system of construction, which is the key to the possibility of his work, is under his control and is being continuously changed and improved by him. And he is responsible for the process of construction itself.

He is, in a nutshell, a modern equivalent of the traditional master builder.

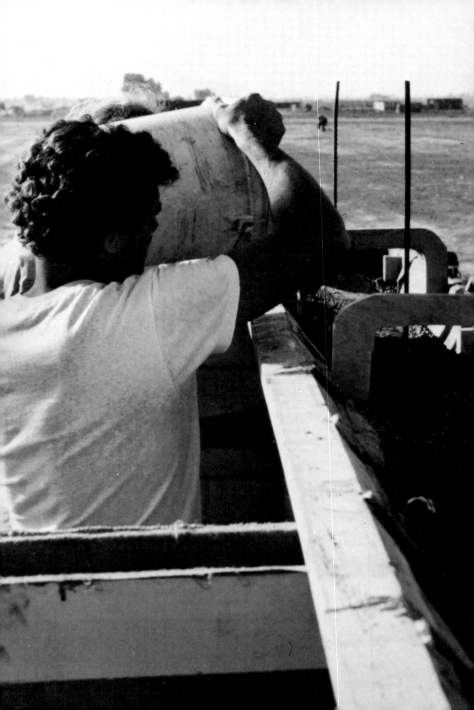

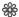

In today's society, a building is made by two entirely different kinds of people, who remain separated throughout the building process. There are the people who design the building, and there are the people who build it. There are *architects,* and there are *contractors.*

We believe that this distinction, this separation of functions, is entirely unworkable, and that a healthy environment cannot be created under circumstances which contain this split, because the split has consequences which do organic damage to the fabric of the buildings and society.

In this chapter we shall first lay out the arguments which lead us to believe that the separation of architect and builder does fundamental damage to society, and which explain why this damage can only be healed by a reintegration of these two functions in a single person.

We shall then show that the integrated architect-builder is not only necessary in general, to solve the problems of building healthy environments, but that the specific program called for by the other books in this series, *The Timeless Way of Building, Pattern Language, The Oregon Experiment,* and *The Linz Café;* require the integration of these functions in a single person.

Finally, we shall show that in the particular case of housing, in the production of houses, there are even

more pressing needs for the integration of these two functions, and we shall then explain the function and responsibility of the architect-builder, as a defined role, within the housing production process—with examples drawn from our work in Mexicali.

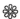

The most fundamental reason for the architect-builder lies in the great complexity of buildings that must be produced in any human building process.

In today's building process, the buildings are sufficiently standardized to make it possible to draw them. It therefore becomes possible to separate the function of designing from the function of construction, and slowly the two functions develop as *architect* and *contractor*, respectively. However, it is precisely this standardized nature of contemporary houses which lies most deeply at the core of their inhuman character.

In the process we shall describe in this book, the most fundamental assumption of all is that the houses will be personal, intimate things of character: that each one will be different in its basic plan, of course, according to its family, but also different in the execution of certain details, different in the amount of love that is put into the door in one, into a window in another, into a garden in a third.

In short, the house is no longer an "object" which is manufactured, but a thing of love, which is nurtured, made, grown, and personal. Under these circumstances, the paraphernalia of the architect's office—the T-squares, working drawings, standard components—all these

things are entirely out of place. We need, instead, a process in which the building is shaped in a human way, where its shaping is a human act, related directly to the family, and related directly also to the men who actually build it.

To understand the extreme way in which the present separation of roles undermines the proper functioning of the construction process, let us first consider a simple functional problem: the task of making a house which is well sited and comfortable. . . . And let us see to what extent the tasks of construction and design are continuously interwoven in a process which correctly solves this problem.

Consider, for instance, some examples of what will make a "better" house. (1) Rooms are warm in winter, cool in summer. (2) The kitchen exactly suits the housewife. (3) Rooms have exactly the right view. (4) The house is solidly built; no leaks, no weak joints, no loose trim. (5) The garden is a really nice place to sit. (6) Plenty of sun and light in the rooms. (7) Rooms are generous where they need to be, and compact when they only need to be small. (8) Materials are well chosen, pleasant to touch, and solid. (9) Each member of the family can find his own place, a place of his or her own, where he can be comfortable.

These good qualities can only be created by continuous interaction of "design" and "construction" during the erection of the building.

Consider the first one: *Rooms are warm in winter, cool in summer.* To get this right, we must be sure that rooms face the winter sun exactly, that they are properly shaded in summer, that windows are oriented to the breeze,

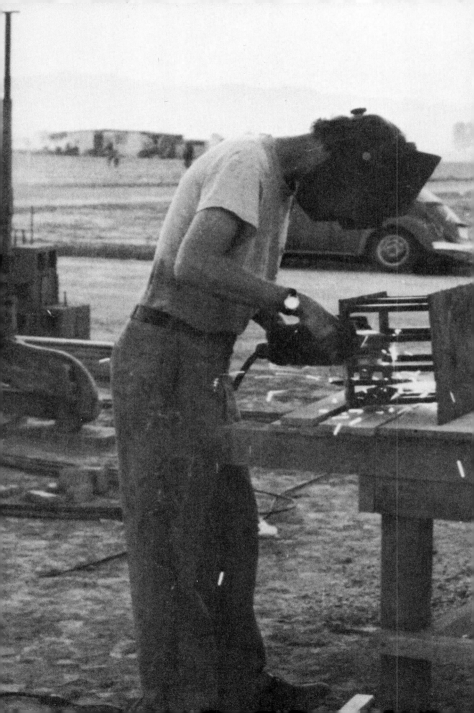

that the house has massive thick walls where the west sun hits them most fiercely, that the house is protected from the most violent winter wind.

In order to build a house which has these features, it will be necessary to stand on the ground and lay the building out with enormous care. If there are fifty houses to be built, then each one will need a slightly different plan, according to its position in the landscape and its relation to other nearby houses. It will be necessary to make decisions about wall thickness, window size, individually for each house—not en masse for all the houses at the same time—and in certain cases, it will be necessary to modify the size of a window, or the thickness of walls, even during the construction itself, according as experience of the climate shows itself in the partly finished house, because, for example, the breeze which circulates in the house will depend on the real configuration of the house itself and cannot be calculated ahead of time.

This requires, then, that decisions about design can be made, individually, house by house, and that they can even be made while construction is under way. It rules out, entirely, any attempt to make these decisions abstractly, for fifty houses at a time, on a drawing. It requires intimate and separate knowledge of every house, the kind of knowledge which only the builder has. It requires control over the house's structure and materials—the kind of control which the builder has—and yet it requires, on a daily basis, the kind of knowledge which an architect has, and the architect's "right" to make decisions about design.

THE ARCHITECT-BUILDER

A contractor, working in the way that contractors work today, does not have the power to make these decisions, since he is working from drawings prepared by someone else. An architect does not have the day-to-day knowledge, nor the time, to make these decisions, since he spends too little time on the site. It requires a system of communication in which the building is not frozen, ahead of time, by drawings, but in which rough plans of the building are translated directly into building, step by step; and for this, *the institutional powers of architect and builder—the power of design and the power of construction—must be wedded in a single process.*

Or consider, now, the second item on our list: *that the kitchen be laid out exactly according to the wishes of the housewife.*

This requires two levels of action which are not available in today's process of mass production. First, it requires that a particular woman enters the process early enough to be able to decide the layout of the kitchen. And this is not merely a question of placing counters and stove in a room whose shape is already fixed. Each person has her own ideas about the way that she wants to face the light, wants to serve meals, wants to be able to look after children while she is cooking, so that the whole room—its size, its orientation, its relation to the rest of the house—comes into question.

This cannot be achieved by a process in which a "standard" house is modified, or in which a kitchen is chosen from several "alternatives." It can only happen as part of a process in which a person is free to conceive the whole house, entire, and in which this can be done simply and easily, without administrative problems. All

this requires, once again, that houses be treated as unique, separate things, each one built according to its own special nature; and this in turn requires that the architect have an amount of time available which is inconceivable in today's mass housing projects. It can be done if the builder is the architect, because he then has the time to spend, the continuous, daily involvement with the houses. But it cannot possibly be done under circumstances where the architect puts down his complete design, in the form of drawings, because it is just too expensive and impractical to do this for each house.

Further, it requires a form of communication between architect and builder which is simple, cheap, and direct, so that the immense expense of fifty different sets of drawings is not required to design fifty different houses. This direct communication becomes relatively impossible when architect and builder are separate, because the communication must be legally binding—exact—and is therefore immensely expensive to prepare. If architect and builder are one and the same person, the communication can be quick, schematic, because it is only a record for "in-house" use. And it therefore becomes cheap enough to do.

Third, in order for the woman to lay out her kitchen successfully, she must be able to enter the process at various times while the house is being built. It is, generally speaking, not possible to make subtle, exact choices about counter sizes, widths, position of stove, shelves, cabinets, in the abstract—that is, long before the building exists. However, once the shell of the building is there, and the kitchen exists, it is then pos-

sible to decide exactly where the details should be by simply standing in the real place and imagining them.

This requires that even at this late date during the process of construction itself, decisions about size, position of shelves, counters, etc., can still be made.

And this requires that the building is still actively open to design decisions, even after its shell is up, and that the builder, who is in the building on a day-to-day basis, has the right to make these decisions with the woman. If the architect is a separate person, again communicating through drawings, the process of choosing each of these kitchens on a direct, person-by-person basis would become impossibly complex and expensive. But if the architect and builder are one and the same, and together have control also over the spending of money, it is extremely simple. The same is true for all the other qualities a good house needs.

In summary, we are committed to a process in which the buildings become felt, human, individual, personal. It is quite impossible to get this if the architect takes responsibility merely for the original design, making some layout on pieces of paper, and then distantly commands some other person to build it. The products of this kind of process will inevitably be cardboard in appearance, alien, dead, mechanical—because it is the abstract nature of the process which makes them so.

The warmth and the humanity, the subtle differences from family to family, the individual character that we seek, can only be created in a process where the architect, who is in charge of laying out the buildings, is also actively and humanly involved in making them, building them, physically shaping them.

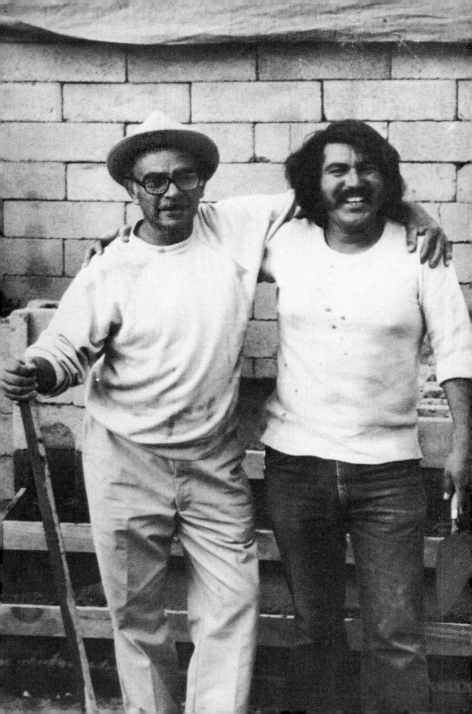

The subtlety of the designs which come from different families, the enormous differences, the ornament, the idiosyncrasies of connection, doorway, garden, loggia, entrance—all these cannot be transmitted through paper, from the architect to the contractor—they can only be made if there is a direct process whereby these elements are decided, on the site itself, by the families and by the architect together, and if the very complex marks made on the site are then transformed directly into building—without the intermediate stage of paper, which inevitably erases all the subtlety. The great complexity needed by a human settlement cannot be transmitted via paper; and the separation of functions between architect and builder is therefore out of the question. The complexity can only be preserved if the architect and contractor are one. *All this makes it clear that the architect must be the builder.*

And the opposite is true also. In modern times, the contractor and his crew are deeply and sadly alienated from the buildings they produce. Since the buildings are seen as "products," no more than that, and since they are specified to the last nail, by the architect, the process of building itself becomes alienated, desiccated, a machine assembly process, with no love in it, no feeling, no warmth, and no humanity.

Once again, since we are deeply committed to changing this situation, it is axiomatic for us that the people who build the houses must be active, mentally and spiritually, while they are building, so that of course they must have the power to make design decisions while they are building, and must have an active relation to the conception of the building, not a passive one. *This*

makes it doubly clear that the builders must be architects.

Finally, and above all, we shall see that this need exists *when we pay attention to the problem of production.* That is, when we ask ourselves, not merely how some charming little house might be built by, or for, one special family . . . but what kind of process might be capable of producing hundreds of thousands of houses per year, all over the world, to solve the global housing problem.

We know that this problem cannot be solved in any reasonable way by making boxes. It must be based on the production of variety. But the production of variety must be large in scale, and it must therefore include at least some kind of uniformity of process. We have come to the conclusion that if a process is indeed going to include the variety of different families, their individuality . . . and somehow *combine* this beautiful variety with the uniformity of construction, uniformity of method, which large-scale production must inevitably require . . . then it seems extremely unlikely that this can be done without some new kind of person who combines the power to get things done on a large scale with the power to get things done in a way that is individual, personal, and human, within each individual house.

This requires a new kind of person, a new kind of administrative structure, a new kind of professional to run the construction process. *It is precisely this which we embody in our concept of the architect-builder.* The architect-builder is not merely some kind of small-scale craftsman, committed to making things beautiful in the small . . . although he is that too. He is, above all,

the kingpin in a process which allows this to happen on a large scale. He is a new kind of person, who can modify the means of production in such a way that very large numbers of houses can be built, and yet preserve the subtlety and detail which makes them human in the small.

The essence of this architect-builder's power lies in the fact that his function is decentralized. Since he must pay attention locally to a larger number of issues than a conventional architect or builder does, he must also contract his horizon and concern himself with a smaller number of buildings than he normally would, so that he can give them the full attention which they need.

For the sake of example, let us imagine building five hundred houses. In today's normal method of building large-scale housing projects, one architect and one contractor often control a rather large volume of houses or apartments. In a typical tract, or in a typical government housing project, an architect might easily be responsible for five hundred houses or five hundred apartments. And the contractor, too, who takes responsibility for their construction, will be building five hundred houses, all at the same time, all by means of the same kind of long-distance control.

The architect-builder that we are talking about has greater powers, but in a more limited domain. Any one architect-builder may control no more than twenty houses at a time, but he will take full responsibility for their design and construction, and he will work far more intensely with the individual families, and with the individual details of the houses. Thus, in this model of

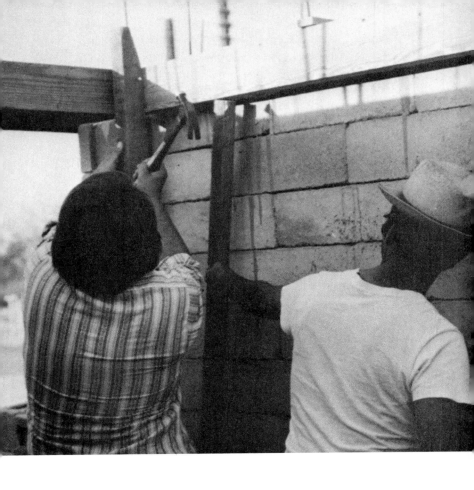

construction, both design and construction are decentralized. In the old system, one architect and one contractor may design and build five hundred houses or apartments in a year. In the new system, twenty-five architect-builders would be needed, each one responsible for no more than twenty houses.

Of course, this means that the architect-builders play a different role in society. There are more of them—taking the place of the alienated construction workers and architectural draftsmen who now provide the manpower to make the centralized system work. And the economics of their professions must change too. All this is discussed in more detail in Part Three, below.

But the main point is this. We envisage a new kind of professional who is able to see the buildings which he builds as works of love, works of craft, individual; and who creates a process in which the families are allowed, and even encouraged, to play their natural role in helping to lay out their houses and helping to create their own community.

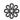

In our Mexicali project, we had the opportunity to test the concept of the architect-builder rather completely. In July 1975, I (Chris Alexander) was approached by Julio Martinez, then working in the Department of Public Works of the State of Baja California, in Mexicali, Mexico. He asked me, on behalf of various groups in Baja California, whether I would be willing to go there to give a course of lectures or seminars on the Center's work. I told him that I had been lecturing enough lately, but that if they were interested in having us do a project in Mexico, I would be very willing to go. I hardly expected that this would lead to anything; however, two weeks later, he con-

tacted me again and said that there was real interest in the possibility of such a building project, and that the State and the Universidad Autonoma de Baja California jointly would invite me down to discuss possible details.

I said that I would like to build a group of houses to test the ideas which had been developing in the Center during recent years, especially the idea that families would design their own houses. A few weeks later, I went down to Mexicali to discuss details. We agreed that the Center would build thirty houses, which families would design for themselves, for a price of $3,500 per house—each house to have an area of approximately 650 square feet.

At the time, the going price for a house of 650 square feet in that part of Mexico was about three times that: some $10,000. The price was therefore remarkable to them. The combination of the low price and the desire of the Mexican authorities to have some contact with the Center for Environmental Structure settled the matter, and we agreed to begin the project in October of that year.

The Center for Environmental Structure assumed responsibility for this housing project, both at the level of architectural design and at the level of construction. We were legally responsible for the design of the houses, and legally responsible for their construction.

In our core team, we had four members: the authors of this book. As far as architectural experience is concerned, Alexander is a licensed architect, and Davis, Martinez, and Corner are all trained architects who were then recently out of school. As far as construction goes,

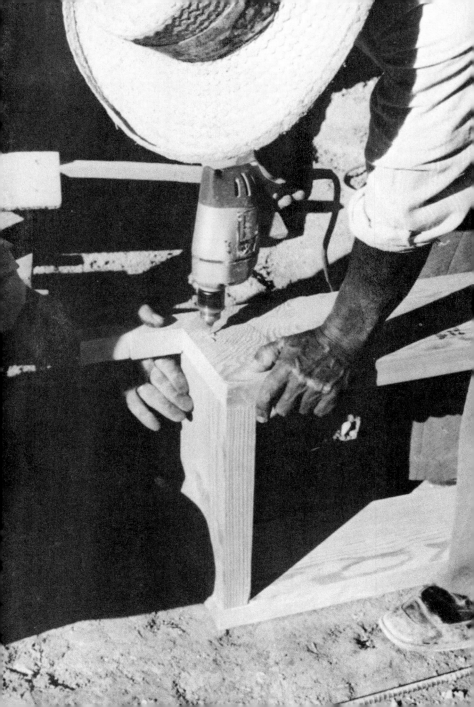

Alexander and Martinez had construction experience. Both are now licensed contractors.

From the very beginning, the State Government of Baja California made it possible for the Center to take all responsibility for design and construction, with a minimum of interference from outside agencies.

Thus, for example, we were not required to show detailed plans of any house to the local building department or to the bank which provided financing. We were free to build as we saw fit, with the assumption that we were responsible and that we could be trusted, since we were in direct daily communication with the families themselves. We were free to place houses where we wished, without constraint from local zoning laws; we were free to divide lots as we saw fit, without constraint from local planning law or subdivision practice; we were free to build the houses with whatever accommodations and facilities we considered suitable—again without constraint from local building authorities. We were free, also, to introduce structural change as we saw fit, within the basic construction system which had been approved—on the grounds that we were responsible engineers and would take whatever steps were necessary to protect the interests of the families and their buildings.

In short, we were free to do almost everything in the way that we believed it had to be done. We were responsible for building, for the building system, for inventing and testing the system, for developing the system, for building experiments, for working with the families, for laying out the land, for defining the subdivision, for interpreting the zoning ordinance, for handling funds.

To define these powers and responsibilities in more detail:

1. *Planning*

We were responsible for the overall layout of the community, and hence for "planning"—and the methods we chose to use, involving the decisions of the families, were entirely up to us.

2. *Zoning*

We were permitted to waive all local zoning laws. That is, our hosts were confident that we would not do anything in the plan which would damage the surrounding community, and we were therefore free to interpret zoning laws as we wished.

3. *Lot Subdivision*

We were responsible for lot subdivision, which is normally undertaken by surveyors. With the help of the families, we laid out lots, according to the process described in Chapter 4, and these lots were then surveyed by a new technique developed to match the complexity of the lots, and then recorded under our supervision.

4. *Design*

We were responsible, as architects, for the design of the houses.

5. *Structural Engineering*

We were also responsible for the engineering design. We designed the building system from scratch, in our

experimental year in Berkeley, and then perfected it in the experimental yard in Mexico; and during the process of development, we were responsible for all phases of structural testing and design.

6. *Materials, Testing, and Development*

We developed a completely new set of materials and components, making use, of course, of the materials locally available.

7. *Manufacturing*

We were also responsible for *manufacturing*. Several of the components and processes which were required by our building system needed manufacture of new components. In a few cases we contracted this manufacturing out. However, in the majority of these cases—and the heaviest—we manufactured our own components.

8. *Building Permits*

We were not required to submit any drawings to the local building officials. The building *process* (as described in Chapter 5) was approved by the Department of Public Works, but we were not required to submit any detailed building plans, since it was assumed that we were responsible and, with the cooperation of the families, would not build anything detrimental to health or safety.

9. *Construction*

We were also directly responsible for construction itself. That is, we were not only architects but also con-

tractors, responsible for the construction of the buildings from beginning to end.

10. Accounting

We were also responsible for the quantity surveys and accounts.

11. Loan Approval

Finally, we also took over some part of the bank's normal functions regarding the negotiation and approval of loans and the disbursement of funds.

It is clear from this brief description that, in the Mexicali project, the powers normally carried by a great variety of different officials were concentrated close to the site, close to the families, within a single firm.

This is essentially what we mean by the "decentralization" which must accompany the role which we call "architect-builder." It will become clear, as we describe the process of design and construction in more detail, that the quality of this project, the unique attention given to each family, the care with which common land could be treated, all arose from the fact that these many powers were vested in us, so that we could always take the action most appropriate to a given case, instead of having to wait for clearance by authorities remote from the case, and, as so often nowadays, ending in frustrating and inappropriate decisions which have no solid foundation in the land or in the people.

We must repeat, for the sake of emphasis, that the need for these considerable powers in the hands of a local architect-builder *is perfectly feasible* in modern so-

ciety, *provided that the individual architect-builder also becomes more modest in the scale of his aims and ambitions.*

Today's system of supervision and control has arisen because architects, builders, engineers, undertake such huge tasks and are all so remote from their immediate building tasks that they must be controlled by very strict regulations, and the responsibilities for these different functions must be rigidly separated. This is quite understandable. When an architect or a contractor makes decisions for thousands of houses, it is clear that his innate "good sense," his love for the immediate buildings, disappears, and is replaced instead by various much less reliable and more abstract motives—among them profit, expediency, and speed.

We are proposing to reestablish the architect-builder's traditional legal powers by *reducing* his sphere of influence. We believe that he can do a good job only so long as he is responsible for a relatively small number of buildings at any given moment, but that as a corollary, when he is responsible for a very small number of buildings only, then his good sense, his instincts, his love of building come into play, and he can be entrusted with far greater powers, greater responsibilities, than he has today.

This does not require an anarchistic state of affairs. It is perfectly possible, for instance, that a single large organization (government department or construction firm) might be responsible for building five hundred houses, but that it would carry out its responsibility by appointing twenty-five autonomous architect-builders, each one responsible for twenty houses, to do the work. In this case, it would again limit the sphere of influ-

ence of each one; but within the sphere of influence, it would greatly increase their powers and responsibilities. What we describe is therefore essentially a change in *organization* and a change in role. *It requires that each architect-builder have more power than architects do today, but over a much more modest domain.*

In the chapters which follow, we shall learn to see the union of architect and builder as a necessary part of the new process of production, as a functionally necessary part in which, for purely practical reasons, the two trades, or two skills, must be united simply to allow the more human and more decentralized process of production to work successfully.

We shall see in Chapter 2, on the builder's yard, how the architect-builder must undertake construction experiments, to develop the construction system, and be willing, even, to undertake manufacturing of parts for the building process.

We shall see in Chapter 3 how the architect-builder leads each group of families in the use of patterns to define their common land; and how, with his help, they can lay out the common land, divide the land to make their lots; and how, at every step, they also make sure that their individual houses will help to reinforce and strengthen the physical space of the common land, so that it works for them.

We shall see in Chapter 4 how the architect-builder helps each family to lay out their own house, by asking them questions about the patterns, one after the other, so that, without pushing them at all, he is able to pull out from them a complete and coherent design which meets their needs perfectly, is structurally sound, and

is yet unique to them—and how he is able to do all this in a day or two, so that it is perfectly within the bounds of what the process can afford.

We shall see in Chapter 5 how the architect-builder physically enters into the construction process; how he uses the construction operations, one by one, one at a time, to complete the house; how the design evolves, under his hands, without ever being fixed in a set of drawings; and how, in this way, the windows, the room heights, the walls which form the garden seats, the columns which make the most beautiful space inside the house, all find their way, at just the right moment, into the house during its construction.

We shall see in Chapter 6 how the cost of the house is kept perfectly within very tight limits by the way that the architect-builder distributes materials to the families, by the way that labor is accounted for, by the way the families themselves enter into the building process, and how the architect-builder's intimate connection with every house is needed to make this cost accounting possible.

And, finally, we shall see in Chapter 7 how the architect-builder himself leads the work of construction, so that the houses are built by what is seen and felt to be a human process—so that when the houses are finished, they are experienced as something that had its roots, not in mechanical abstract production process, but instead in a process which leaves memories, a process which binds families together, unites them, and keeps feeling in the houses.

CHAPTER 2

THE BUILDER'S YARD

THE PRINCIPLE OF THE LOCAL BUILDER'S YARD

The actual production of houses is based on a system of widespread, decentralized local builder's yards. Each of these builder's yards contains the tools, equipment, supplies, materials, and offices needed for the production of houses in the area around it.

The essence of the builder's yard is that it lies physically close to the houses themselves. It becomes a part of the community which the houses create, even a nucleus in that community, which provides the center for later additions, new construction, maintenance, and care of public land, so that the builder's yard is not merely the origin of the production of the houses in the first place, but maintains a continuing relationship to the houses in later years.

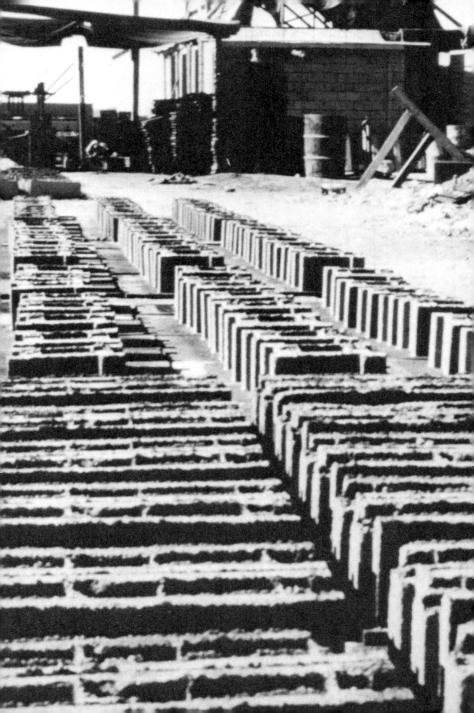

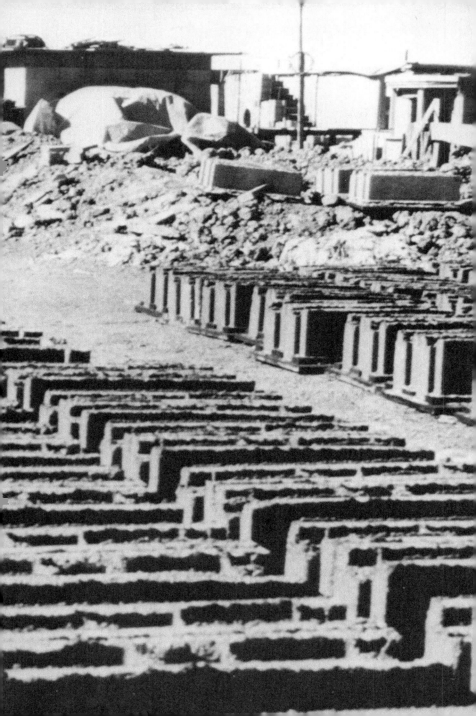

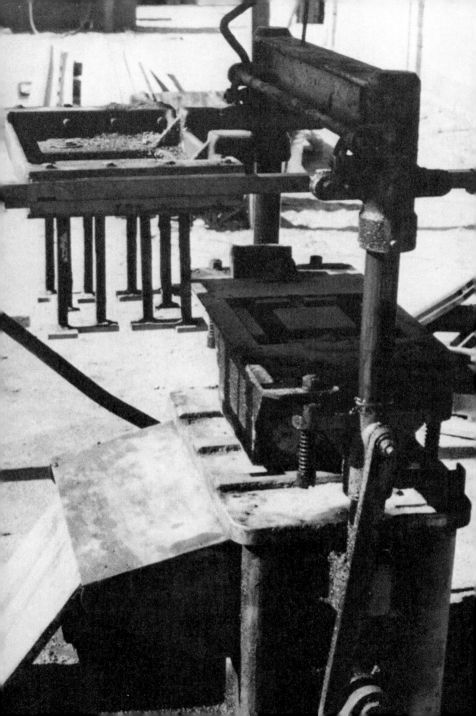

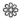

In the first chapter, we have said that present-day control over housing production is misoriented, dramatically, by the separation of design from construction, and by the centralization of authority which typically goes with this separation.

To set things right, we have therefore established the principle of the architect-builder, and the principle that there are large numbers of architect-builders, each of whom takes direct control over a rather small number of houses at any one time . . . so that each architect-builder has direct personal contact with all the houses while they are being built. This means that he can help the families design the houses—and help to build them, when the families want to do that too—all in a personal way, which allows the details of each house to be correctly made.

In essence, then, we have established a process in which control is decentralized, socially, to a large number of builders who have more direct control over design than most builders do today.

Now we come to the spatial, or geographic, correlate of this social decentralization of master builders. For in order to make this social decentralization of control work, the control must also be decentralized geographically, spatially, within the community or town or region where houses are being made.

THE BUILDER'S YARD

In today's society, the process of construction is almost completely centralized. Almost all "modern" systems of production rely on large centralized construction firms. In these cases, control of the construction activity is remote from the immediate neighborhood where construction is taking place. The people who work on the construction site have no personal knowledge of the neighborhood, no knowledge of its peculiar character and needs; and anyway, have no control over what they are doing, since they are merely paid employees, so that even if they did have understanding of the neighborhood, they would be powerless to modify their activities accordingly.

The people who do actually control the construction corporations are not only remote from the nighborhood in spirit, but they also have very little immediate connection with their own building site, which is, for them, merely another source of income. They have no direct sense of responsibility for the neighborhood, and control the construction process on the basis of external issues, externally produced building materials, externally defined labor problems.

To replace the huge centralized system of construction corporations which now control the production of houses, we propose a system of highly decentralized local "builder's yards," each one with an organic relation to the neighborhood which it serves, each one capable of ordering and promoting local manufacture of building materials which are locally appropriate, each one with an ongoing responsibility to function as a nucleus of construction activity within the neighborhood in a coherent way.

THE BUILDER'S YARD

Each of these local builder's yards, which we shall describe in this chapter, is the nucleus of an entirely different, and more personal, relationship between the builder and his community. The existence of the yard implies that the builder has a direct and personal relationship to one particular community, that many or most of his buildings, and works of building, will be in this one community, that he is, in short, attached to this community in an organic way, and, finally, that the builder's yard is the actual physical nucleus, the seedbed of construction, the central kernel spot in the community where he is based, and forms the basis of this more permanent attachment.

The builder's yard is the physical counterpart of the architect-builder. We saw the need, in Chapter 1, for a single person capable of being an anchor point in the immensely complex and fluid human activity that will develop when people design their own houses and clusters of houses. For just the same reason, there must also be a physical anchor point: a source of information, tools, equipment, materials, and guidance. Just as there must be one person that the families can turn to as their leader in the process of house production, so there must be one place which they can come to to resolve their problems, one place which forms a well-defined social center and anchor point for their activities, while their houses are being built and being mended.

Specifically, this builder's yard has the following functions:

1. It provides the group of architect-builders with a home base; in some cases, with an office-workshop base; in some other cases with a living accommodation at the

same time. In the case of our Mexican project, it was all three.

2. It provides a base in which the building system resides. That is, its buildings physically embody the building system and serve as an example of what the various details look like and how they function in a variety of different contexts. And it provides a medium for experimentation with the building process.

3. It also provides the home base from which this building process can be generated. That is,. it contains the complete set of tools which are needed for this process, including specialized tools like cutting jigs for windows, jigs for making perimeter beam spacers, etc.

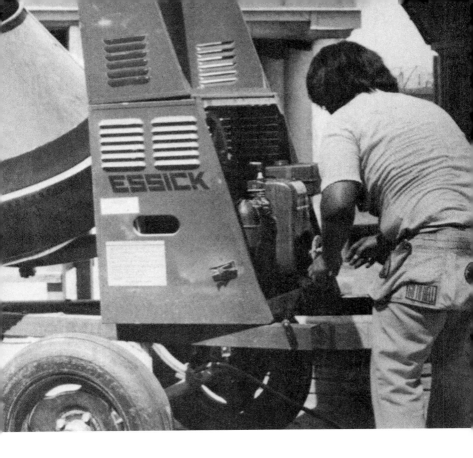

It may be the place where parts themselves are manu-
factured with these tools.

4. It physically contains the pattern language which
the families can use to design their houses. This re-
quires a small room where people can read the lan-
guage, study it and discuss it.

5. It contains all ongoing records of the actual
building process in each cluster: that is, records of bills,
quantities spent, cost control, hours worked by different
families, etc.

6. The builder's yard is also a gathering place for the architect-builders and families, during the construction process. For example, we ourselves had several dances in the loggia, and often spent late afternoon hours drinking around the fountain.

7. The builder's yard also functions as a nucleus in the larger community: there is a taco stand in ours; many people came to use the fountain as a source of water in the early days especially; and it creates the possibility of people throughout the community gradually becoming familiar with the building process, and perhaps taking it on themselves.

8. Finally, the builder's yard, once the building project is over, takes on a function as a community center, school, playground, church, dance hall, café, whatever seems appropriate: at this stage, most of the tools have gone, and it contains only a minimum kit of tools needed for routine repairs.

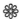

In the Mexicali project, we developed a very complete version of the builder's yard. Indeed, this yard was so extensive that it was almost as large as an entire cluster of houses. It was the seedbed, the kernel, of our project in Mexicali, and it did function almost exactly according to the model we describe in this chapter.

In order to understand this builder's yard as it was, a dynamic thing, a source of action and inspiration, the heart of all our work, we begin our description of the yard in Mexicali by going back to the very beginning—not merely to the layout of the builder's yard, but to an

even earlier point, before we had even defined the construction system we were going to use.

For the place that became our builder's yard was, and was built, as a result of a continuous, ongoing series of experiments in construction; it was both the site of our experiments and their outcome, both the construction yard for the construction of the families' houses and the laboratory where we worked out the methods of construction we would use.

To grasp this clearly, it is necessary to understand the extreme way in which we, the architects and builders of this project, combined and saw as one the design of the buildings and their physical construction.

It is not merely that we were responsible for both. It was something much more, a physical love for the buildings and the building materials, a passion, a constant preoccupation with the physical structure of the buildings as fundamental to their larger layout and plan—a feeling that we were actually *making* these buildings, not merely designing them, and that we were therefore responsible for every detail in a way that had to be understood through hands and fingers—thoroughly understood, the way a painter understands his paint or a good cook understands the soup by tasting it.

And for this reason, we necessarily considered our builder's yard as a kind of experimental manufacturing workshop where we not only made blocks, beams, and other components, but where we invented them, tested them, developed them. *The ongoing course of these experiments, our growing understanding of the way the physical buildings could be built as simply and as beautifully as possible, was absolutely central to our lives in Mexico.*

In short, from the very beginning of our project, we were conscious, above all, that it was a "construction" project—that the making of these buildings was, above all, an act of *making*, not merely an act of design. And in this spirit, we recognized, too, that the building system, the physical fabric of the buildings, was immensely important for three vital and connected reasons:

First, that to build buildings with the simplicity we wanted, with the possibility of individual designs, and built by people who knew nothing about building, would need a new kind of building process: one which unfolds while the house is being built, and which is easy to understand and transparently obvious in the way it fits together.

Second, that to build buildings which are buildings of the people, humane, simple, perhaps joyful, innocent, would require an entirely new kind of building process also, since those which already exist, complicated or simple, have become adapted so often to the joyless and mechanical conditions of our time.

Third, that after all, we had to build houses for some $3,500 each, and that this meant that a new system would have to be devised in which every peso spent would create something of value, even under such conditions of extreme poverty and low cost—and this again meant that we had to invent materials, components, and processes with a very special character.

We began with certain assumptions. First, we decided that we would use the very fine adobe soil in Mexicali to manufacture soil-cement blocks which would be both cheaper than concrete blocks and also

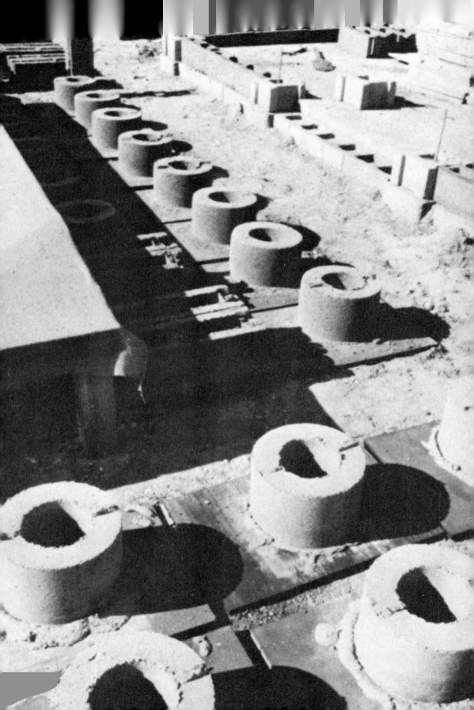

give much better insulation against the intense summer heat (115 degrees). From the very beginning, before we even went to Mexico, we had already begun to test a series of different possible blocks; we made rudimentary moulds from plywood, and pressed soil cement into them; tested a variety of different shapes; tried different mixes. Then, by the time we reached Mexico, we were ready to begin a much more complex series of tests. We bought a Rosacometa, an Italian block-making machine capable of making two concrete blocks at a time. We modified the machine so that we could compress the material, since the soil-cement mixture needed compression—not just vibration, as a concrete block does.

As for the shape of the blocks, that was extremely important. We designed special corner blocks: castellated blocks which receive the walls and which allow a building to be laid out without drawings. . . .

We designed the wall blocks, long, narrow blocks, with flanges for interlock, so that the walls could simply be stacked, without mortar, and the cells then filled with grout to stiffen them. . . .

We designed the round column blocks—not available anywhere—which made it possible for porches and arcades and loggias to have these beautiful thick white round columns. . . .

We designed special foundation blocks, with rebars set right into them, so that the foundation could be laid out dry, on the ground, and the slab then poured inside the perimeter of the foundation blocks, in such a way that the slab would grip the rebars in the blocks and make the whole thing solid.

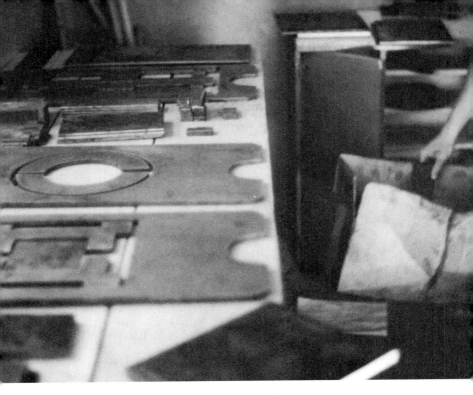

Preparing the block molds

None of this would have been possible if we had not ourselves made the moulds and ourselves made the blocks. We needed our own yard, our own pallets, and our own techniques to make these things; and it was these things, these seeming details, which made the project possible and made it what it was. We undertook an exhaustive series of experiments to determine the best mix, the best pressure, and the form of pallets which would best receive the blocks from our specially designed moulds. We designed the moulds, and fabricated them, first by cutting the steel, and then welding them—all this in our own workshop, on the site. We

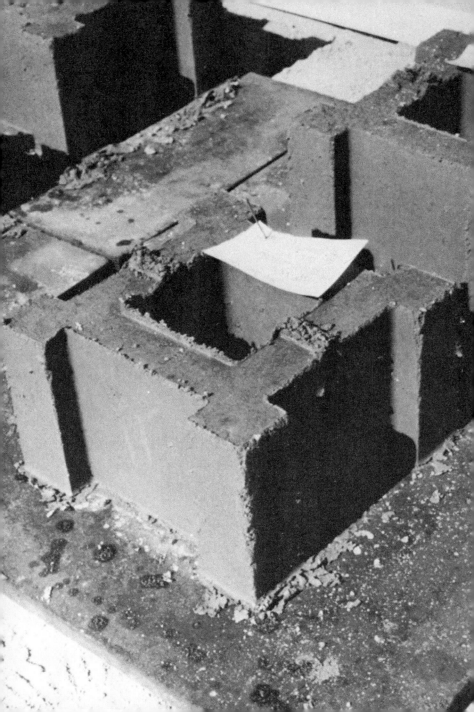

had our own drying yards and our own curing yards; we experimented with different aggregates, with different sands, from different parts of the mountains.

And we began, also, a large-scale series of experiments in the assembly of the buildings themselves. The vaults themselves we made with a mixture of volcanic pumice (a black lightweight rock locally available) and perlite (an ultralightweight and more expensive aggregate brought from California). During the course of our experiments on mix design, we experimented also with sawdust concretes, with thinner mixes, and with sawdust-perlite concretes.

The same in the design of the baskets which hold up the vaults. Our first baskets were woven in a rectangular fashion. Then we discovered that they became stronger when we pinned each intersection in the basket with a small nail; finally it became stronger still when we used a diamond lattice——strong enough so that these thin strips of material, $\frac{3}{8}$ of an inch thick, $1\frac{1}{4}$ inches wide, woven at one-foot centers over a sixteen-foot span, would form a basket that could support a man spread-eagled on it.

So again with the perimeter beams. Our first beams were the most rudimentary of all: a long burlap bag, hung from two thin 1x4's which ran along the upper edges of the beam. These burlap bags, filled with concrete, became beams . . . and in the loggia, our first building, you can see them. But the bags were hard to control . . . we tried a variety of other designs for the beams . . . finally settled on one made of two 2x6's, which stayed in place when the beam was poured and cured.

And the reinforcing in the walls. We needed reinforcing in the cells to stiffen the walls against upturning earthquake forces. We thought we could improve on the price of steel. Wanted to use bamboo . . . but couldn't get any bamboo in that part of Mexico. Then we tried palm branches . . . very cheap, easy to get, very stringy, with lots of tough fibers for tension. They seemed great. But after we had tried them in half a dozen walls, and the walls had been there a few days, we noticed certain hairline cracks in the walls. They corresponded exactly to the places where we had used the palm branches, and we realized that the wet grout, poured in over the reinforcing, made the palm branch expand, swell, and put so much pressure on the setting grout that it made fine cracks in it—so we had to give it up, even though it was so strong and so cheap.

For every one of these experiments, the builder's yard served as our experimental ground. We could not possibly have done the project in the way we did without this daily, personal connection to the materials themselves, until we knew them perfectly, knew exactly what they could do, which ways to make a detail work, and which ones didn't. And the spirit, the feeling for the buildings, the possibility of using these new materials, new configurations, the possibility of creating a system of construction which people who knew nothing about building could follow, could use successfully in their own houses, depended essentially on this daily connection which we had to the design and to the building, both It depended, in its very essence, on the fact that these buildings were, for us, made things, things understood, built, never drawn, never thought out for

someone else to build . . . and that everything we ever knew was something we learned ourselves, in our own yard, from trial and error and experience.

This is the crux, the reason why a group of houses of this kind can only be made by a group of builder-architects—architects and builders both—working *in a builder's yard*.

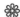

We see, then, that our builder's yard played an essential role in the physical development of construction techniques, which led to the emergence of a workable building system.

But at the same time, it was also intended as a place for people to come to, since it was a model of the very principles of planning and design which the houses themselves would later follow.

For these reasons, in our Mexican experiment the builder's yard was laid out as carefully as—perhaps even more carefully than—the houses themselves.

Since it was, in our intention, the heart of the community in that area, it is also a most beautiful place, which embodies, in its layout and design, all the ideas and feelings about the environment which we tried to put later into the houses themselves. It was, in fact, to be a place of inspiration, where the families would see just what an environment, correctly made, could be.

It has two courtyards, one a great courtyard where people enter through an arched main gateway. This courtyard is surrounded by the toolsheds, and the loggia, and the taco stand, and the stairs leading up to the

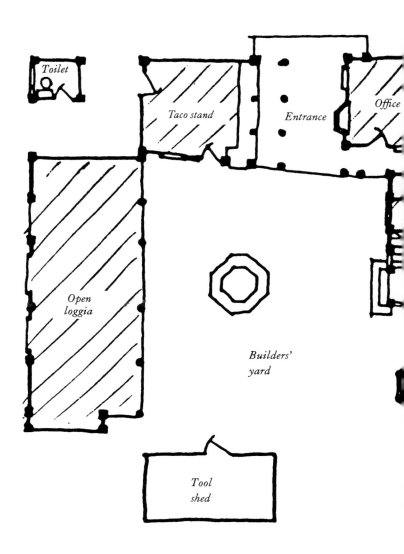

Toilet

Taco stand

Entrance

Office

Open
loggia

Builders'
yard

Tool
shed

Arcade

Interior
Garden

Apartments for builders

Outdoor
room

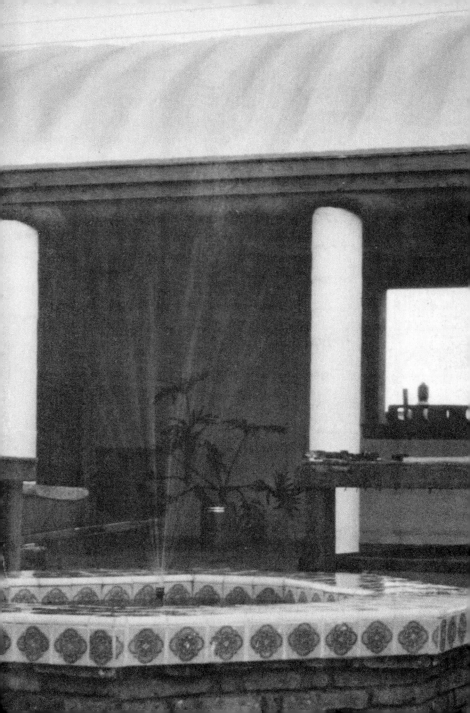

second floor of the main gateway. It has a fountain in the middle.

The second courtyard, a private, interior court, is fully surrounded by a tiny colonnade, an arcade surrounding a central garden, and off this arcade there are various small rooms: living rooms, bedrooms, workshops, places where we, and later our apprentices, worked and lived while we were building the houses.

So the builder's yard was not only a physical nucleus for the construction. It also provided the physical model for what was to be built around it. The details that had been developed in the builder's yard were copied in the houses and the surrounding neighborhood. The patterns which were embodied in the builder's yard were copied in the houses built around it. The yard was the physical and spiritual starting point for the whole process, and it remained so throughout the process of production.

From the very beginning of the project, even from the first or second week, the yard began to function in this way. It was necessary to make block tests, to begin manufacture of blocks themselves, to organize the tools, to have a "home base" for meetings and building decisions. The block machine, the Rosacometa, was delivered and installed on one side of the site, positioned in-between the place where the raw materials for block manufacture would be delivered and the place where the blocks would cure and dry. These materials (sand, gravel, and cement) were delivered, and block production started in the second week. On the bare site, the block factory was already in operation—although that required various makeshift shelters: one for the machine itself, to keep the hot sun off the workers; and

112

one for the blocks, to keep the sun off when drying.

The loggia was the first experimental building to be completed and as soon as it was up, it was being used as a workshop, a place to do the woodwork for the perimeter beams, a place to do small repair jobs on the machine, and a place to have lunch in the shade after doing concrete work in the hot sun.

And throughout the project, the builder's yard was functioning as the social center of the project. The accounts, materials requests, and financial records were handled in the office. The individual architect-builders shared rooms; there they worked out building details, discussed problems with the families, played poker. On the other side of the yard, the block-making operation was proceeding at full steam: every couple of days, a truckload of sand and gravel would come; and truckloads of bags of cement for the blocks, rebars, and other materials were delivered behind the loggia before being allocated to the different families. The loggia itself housed the expensive woodworking tools; on workbenches there, the window and door frames were built, wood for the perimeter beams were sanded and cut, windows and doors were assembled.

The builder's yard was also an object of great interest in the community; it was the place where people came first to find out what was going on; it was the place where local officials were taken to see what was being proposed; it was the place where the initial contracts and loans for the houses were signed in a public ceremony.

From the very beginning of the builder's yard, the people of the neighborhood steadily used the fountain and the faucets near the fountain as a source of water.

The following pages show local families taking water from the fountain in the builders' yard

Sometimes they simply came there to haul water for their own use. Sometimes they came to do their laundry there. But the water was a center of activity.

And then, during construction, the builder's yard was again a continuous center of social activities: parties for the families and builders, dances for the students training there. At night, with a fire in the middle of the larger courtyard and music in the loggia, it became almost a carnival.

In the end, a builder's yard only makes sense if it has a long-term reality in a neighborhood. And this means that it must be inserted into a neighborhood with the understanding that the various functions which the architect-builders perform (teaching the pattern language, helping people design their own houses, helping people build their own houses, helping in the gradual repair of the neighborhood as a whole) all have a long-term life. This is a political and economic question. *But the builder's yard will only have a long-term life if it is clearly understood as a new social institution with an important function in every neighborhood, and with the funding—taken out of city or state or federal taxes—to support its existence.*

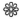

If we ask how the idea of the builder's yard might be implemented in different housing projects, we must recognize that it might take a great variety of forms in different places.

In the simplest case, it might be no more than a temporary house for the architect-builders. After con-

struction this house could be sold and occupied by a family . . . or it might be used as a store or as a wayside inn.

In one case we know of in the Philippines, the builder's yard exists as a low-cost community hardware store run by a Jesuit priest to provide building materials and building know-how to poor families who want to build their houses for themselves.

In another case, the builder's yard might become a local center of art where painting and sculpture flourish alongside the building operation and as part of it, and where these arts become part of the community—first, perhaps, in a slightly frivolous way, and then, gradually, as people establish their connection to it, the yard can become more and more of a place where children, housewives, men after work, become serious artists who have a serious contribution to make to the community.

In the case of a cooperative village in northern Israel, which we are building now, the builder's yard will itself be a cooperative industry, owned communally by all members of the cooperative village, and run by three or four of them for the benefit of the others, so that it is helping the cooperative economically by helping to provide the economic base which the newly formed cooperative requires in order to flourish.

The most modest version of a builder's yard that we know about—and perhaps the most effective—is the one being tried on a national scale in Mexico under the direction of Abel Ibañez. These yards will be spread throughout the country, and will serve some eight hundred families each, spread throughout an area of local communities. Each of these yards will sell compo-

nents and materials, piecemeal, to the families who are building their own houses. Any family can obtain a loan for material, provided they have enough income to pay for it month by month over a two-year period. Under these circumstances, each family will be able to build their house, room by room, as they can afford it. And the yard will not only provide them with credit and cheap materials, but also with architectural and engineering help—in short, essentially, with the services of an architect-builder, to help them use the materials they buy.

In any case, we believe that the local builder's yard, in one form or another, is an essential part of the process of housing production. It is precisely the builder's yard which is capable of decentralizing production, ultimately making it sensible and rooted in ordinary human experience. It is the closeness of the builder's yard to the community, its presence as the heart and nucleus of building activity in each local neighborhood, that is capable of transforming the housing process, making it a thing that has, above all, to do with people, and eliminating, once and for all, the idea of housing production as a mechanical and abstract process.

CHAPTER 3

THE COLLECTIVE DESIGN
OF COMMON LAND

THE PRINCIPLE OF COLLECTIVE DESIGN

*On any particular building site, the process of production
must begin with the layout of common land. We believe
it is essential that this layout be controlled by the families
themselves, not by some abstract, arm's-length arrange-
ment.*

*Of course, as we shall see in Chapter 4, the families
will lay out their own individual houses for themselves.
However, before they come to the stage of laying out their
houses, they must first play a role in laying out the com-
mon land between their houses, so that this public unit of
space, this common land which leads into their houses, is
not some abstract mechanical thing, done for them by the
city or by a developer, but is itself unique and personal
to all the families, a collective expression of their will, a
permanent part of the world which is uniquely "theirs."*

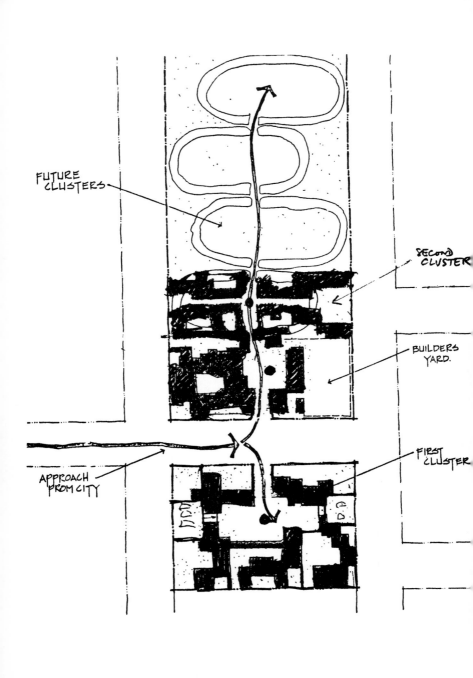

FUTURE
CLUSTERS

SECOND
CLUSTER

BUILDERS
YARD.

FIRST
CLUSTER

APPROACH
FROM CITY

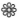

In almost all present-day forms of housing production, the public land or common land is controlled by public agencies remote from the people who will actually live there and use it. For example, the planning and zoning departments of a typical city have merciless control over the layout of public land, in the form of rules and laws which crush any attempts by people to be spontaneous. The process by which design and layout of public land, and subdivision, is achieved is a bureaucratic process which, in its nature, precludes any possible human feeling.

As part of this highly abstract control of common land, most systems of production rely on some kind of abstract arrangement of houses, which we might loosely call "the grid." The houses in a public housing development are arranged on a grid. The normal pattern of streets is a grid. The arrangement of apartments inside a large apartment building is essentially gridlike. Even the houses in a Mexican barrio, though themselves built slowly, are laid out within a rigid grid of streets and water lines defined beforehand by the government.

The grid, then, is a mechanical and abstract array of houses, independent of human social groups, with no congruent social structure. It need not be exactly geometrical. For instance, the curving lines of streets in a modern California tract are grids, in this abstract sense.

The curving lines only create the illusion of nature and humanness. In their essence they are as gridlike and mechanical as all the rest.

Within this gridlike array, houses are produced mechanically, as units or digits, within the grid. The grid is a mechanical point of reference which allows the mechanics of actual house production to take place as efficiently as possible.

However, since the grid must, to serve its purpose, conform to various very strictly controlled rules, the effect of this grid is to take control of common land, and public land, entirely away from the people who live in the houses. The street then belongs to the city, or the "corporation," or the "tract," or the "developer." People have no personal relation to it. And, most im-

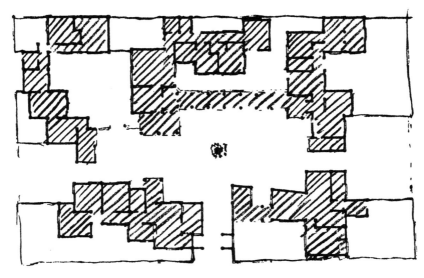

The first cluster of houses

portant, it can play no role in helping people to organize themselves as functioning, personal, human groups.

To replace this abstract "gridlike" array of houses on a street, we propose a new type of array of houses which is more personal in nature, which gives people immediate and effective control over their common land, and which also serves as a natural human unit of production, during the building process and afterwards. This array we shall call the cluster.

A "cluster," in the sense we mean it, is any group of houses which share common land that is under their control, which contains a principle of social organization that guarantees that the people in the cluster have concrete common aims and work together, and which gives the families enough power so that they (not others) define the location of their individual houses with respect to the common land.

A cluster has no definite size, but tends to contain a relatively small number of families. At its smallest, it might contain no more than two houses, provided that these two houses also own common land which they use in common, and provided that the occupants of the houses have the power just described above about the relative location of their individual houses with respect to this common land.

At the large end of the scale, a cluster might be a whole street, provided, once again, that the people in the houses (*not the city*) collectively own the physical land of the street, have power over it, and have the power to determine the relation of their individual houses to it.

Thus, a cluster is a dynamic social structure which

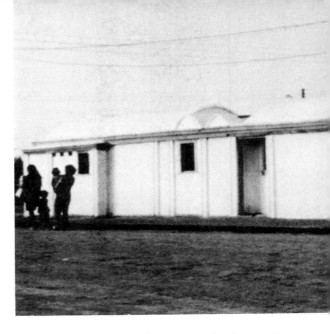

takes physical shape, and which is governed, above all, by the common land at its heart, and by the fluidity of the relations between the individual families and this common land.

The functional basis for communally owned common land is given in two patterns from *A Pattern Language*, COMMON LAND, pp. 336–340, and HOUSE CLUSTER, pp. 197–203. We shall not repeat those discussions here. However, it is essential to recognize one point. A cluster works because it is a human group, a cluster of families. It derives all its meaning, all its value, from the human connections between people, and these cannot be created by the physical geometry alone.

In this sense, the so-called "cluster plans" of modern tract developments and architectural housing schemes, although they seem superficially similar to what we propose here, are in fact quite different, and in our opinion almost without value. They are merely empty shells, in the

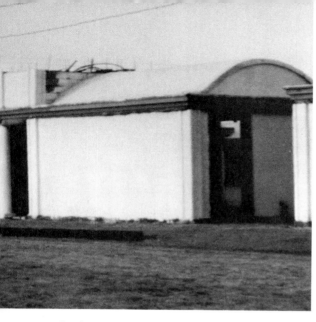

physical form of clusters, without the human content that actually makes the cluster function. As we shall see in the pages which follow, almost all the effort which goes into the formation of a cluster is *human* effort: it lies in the *human* process by which a group of people come to know each other, work together, trust each other, and together make their world. That is what matters about a cluster. That is what makes it essential.

In the Mexicali project, we were able to implement the collective design of common land very thoroughly to form house clusters which are heart felt social entities. In our agreement with the government, we specified that we needed to identify groups of families *before* houses or house clusters were laid out. Our process then

followed a series of steps which allowed the members
of each cluster to lay out their common land together,
for themselves.

In the following pages, we define these steps for
cluster layout in general terms which could be used again
in another project by any reader. We use the specific
experience of our work with the first cluster of families
to illustrate the way that these steps work in practice.

STEP ONE: LOCATION OF THE CLUSTER

Each cluster depends for its organization entirely on
the families who are going to live there, and who col-
lectively will help to lay it out. However, the actual
location of the cluster needs to be fixed before the fam-
ilies themselves come into the picture. We have found
that the definition of the piece of land provides the ral-

lying point, the physical focus, around which the families collect.

The locations which we chose for our clusters followed naturally from the development which preceded them. Since the builder's yard was built at the head of the site, it was natural for the first clusters to be built in positions next to the builder's yard, in positions which extend the development of the builder's yard.

STEP TWO: CONGREGATION OF THE FAMILIES

Once we have decided where a particular cluster will be, we are in a position to gather the families together. In Mexicali, the families were found through the credit union (ISSSTECALI), which sent out advertisements to all its members, inviting them to come forward if they wanted to design their own houses, and help to build them, at a price of 40,000 pesos ($3,500).

Since our first cluster had room for five families, we simply waited until five families signed up, and then began.

The First Five Families (listed by family representative)

> Señor Julio Rodriguez Regla, age 38
>> Married: wife, age 32; four children, ages
>>> 10, 8, 6, and 4
>> Occupation: Water meter inspector
>> Income: 3,825 pesos/month

> Señora Lilia Duran Hernandez de Guzman, age
> 34

ISSSTECALI

Programa Habitacional
de Auto - Construcción

EL ISSSTECALI INICIARA ESTE NUEVO PROGRAMA HABITACIONAL CON LOS SIGUIENTES REQUISITOS:

1.—UNICAMENTE PODRAN PARTICIPAR NUESTROS AFILIADOS.

2.—DEBERAN PERCIBIR UN SUELDO MENSUAL NO MAYOR DE $ 5,000.00.

3.—NO DEBEN TENER CASA PROPIA.

4.—DEBEN SER CASADOS, CON UN MINIMO DE DOS HIJOS.

5.—ESTAR DISPUESTOS A PARTICIPAR Y APORTAR SU TRABAJO PERSONAL EN SU TIEMPO LIBRE.

6.—SERAN DIRIGIDOS Y ENSEÑADOS A PROYECTAR SU PROPIA VIVIENDA Y A CONSTRUIRLA.

7.—DEBERAN CUBRIR EL VALOR DEL TERRENO Y OBRAS DE URBANIZACION A BIENES RAICES DEL ESTADO.

8.—EL ISSSTECALI LES PRESTARA $40,000.00 PARA LA CONSTRUCCION.

9.—ESTE PROGRAMA ES UNA COMBINACION CON EL "CENTER OF ENVIRONMENTAL STRUCTURE" (Centro de Desarrollo Habitacional), LA UNIVERSIDAD AUTONOMA DE BAJA CALIFORNIA Y LA ESCUELA DE ARQUITECTURA.

10.—EN LA PRIMERA ETAPA SE SELECCIONARAN 30 FAMILIAS.

11.—LAS CASAS SE CONSTRUIRAN EN EL CONJUNTO URBANO "ORIZABA DE LA CIUDAD DE MEXICALI.

12.—LAS SOLICITUDES Y DEMAS INFORMES SE PROPORCIONARAN EN EL DEPARTAMENTO DE PRESTACIONES ECONOMICAS Y SOCIALES DEL ISSSTECALI, EN AVENIDA MADERO No. 710.

Mexicali, B. C., Noviembre de 1975.-

ATENTAMENTE.

LA DIRECCION GENERAL.

Married: husband, age 34; one child, age 5 months
Occupation: Nurse
Income: 3,467 pesos/month
Husband's income: 900 pesos/month

Señora Emma Cosio Colbert, age 37
Not married: ten children, ages 17, 15, 13, 10, 9, 8, 5,4, 3, and 8 months
Occupation: Court stenographer
Income: 5,118 pesos/month

Señor José Tapia Betancourt, age 25
Married: wife, age 23; three children, ages 3, 2, and 2
Occupation: Clerk in office of Tourism
Income: 3,752 pesos/month

Señora Makaria Reyes Lopez de Serna, age 27
Married: husband, age 30; two children, ages 2 and 1
Occupation: Nurse
Income: 4,048 pesos/month
Husband's income: 3,800 pesos/month (policeman)

We asked each family to put down a deposit of $200 (6 percent of the price of the house), to guarantee their commitment through the process. The process would have been greatly jeopardized if families had been free to drop out in the middle. However, it is also worth noting that perfect stability is also not essential. In fact,

in our first cluster, one family did drop out after a few days, by the time the lots had been defined. It was still easy to find another family to replace them; and everything then went ahead quite smoothly.

STEP THREE: CHOICE OF A PATTERN LANGUAGE FOR THE CLUSTER

In this next step, we chose those patterns from *A Pattern Language* which seemed relevant to the families, and distributed these patterns for discussion and modification. The pattern language itself was chosen by the process described on pages xxxv–xl of *A Pattern Language.*

Discussion of these patterns with the families was interesting, and the families became enthusiastic about the project as they began to see the richness inherent in the patterns. However, our efforts to get them to modify this language, to contribute other patterns of their own, were disappointing.

Under normal circumstances, the architect-builder of a particular area would also modify and refine these patterns, according to local custom. In this particular project, we were so occupied by the demands of construction that we had little time to undertake work of this sort. (See, for instance, the Peruvian patterns specific to Peru, given in *Houses Generated by Patterns,* Center for Environmental Structure, 1969.)

LAYOUT OF COMMON LAND

THE PATTERNS WE USED

HOUSE CLUSTER
COMMON LAND
MAIN ENTRANCE
PATH NETWORK
SMALL PARKING LOTS
DEGREES OF PUBLICNESS
BUILDING FRONTS
ARCADES
GALLERY SURROUND
PRIVATE TERRACE ON COMMON LAND
NORTHEAST OPEN SPACE
WINGS OF LIGHT
POSITIVE OPEN SPACE
CONNECTED BUILDINGS
LONG THIN HOUSE
MAIN ENTRANCE
HALF-HIDDEN GARDEN
ENTRANCE TRANSITION
PATIOS WHICH LIVE
COMMON AREAS AT THE HEART
INTIMACY GRADIENT
CAR CONNECTION
PUBLIC OUTDOOR ROOM
CHILD'S PLAY
FAMILY OF ENTRANCES
SEATS ON STAIRS
FRONT-DOOR BENCH

STEP FOUR: LAYOUT OF COMMON LAND

The first five families met with us, one afternoon, out on the site where the first cluster was to be built. We began that afternoon with a very general discussion in which we explain that each family would design their own house, but that before we came to that, we had first to design the cluster itself, together, and locate the individual houses within the overall cluster.

We finished the first day with a discussion of the following patterns: HOUSE CLUSTER, COMMON LAND, SMALL PARKING LOTS, DEGREES OF PUBLICNESS, MAIN GATEWAY, and PUBLIC OUTDOOR ROOM; and we agreed to meet the next afternoon to make decisions about these patterns in the land.

In order to locate these common patterns, we needed to know the relative areas that various functions required. We decided to work as follows, per house: COMMON LAND 30 m²/house, PARKING 30 m²/house, HOUSE 60 m²/house, GARDEN 90 m²/house.

In a cluster of five houses, there are therefore 150 m² of common land; 150 m² for parking; a total built area of 300 m² in the form of five houses; and a total area of 450 m² in private open space. These relative areas require that the houses and private lots are shallow, and long around the perimeter of the common land, so that they form a ring around it.

The next afternoon, we met again and stood on the site trying to visualize where the common land might be, where the parking lots would be, where the main

gateways would be, and where the public outdoor room would be. Since the GATEWAY clearly needed to face the builder's yard, we came to the conclusion that the parking lots would be best placed along the sides, out of the way, with minor gateways coming in from the parking lots to the common land. The common land itself, the heart of the whole project, fell rather obviously into the middle, with an elongated shape, like the shape of the cluster itself.

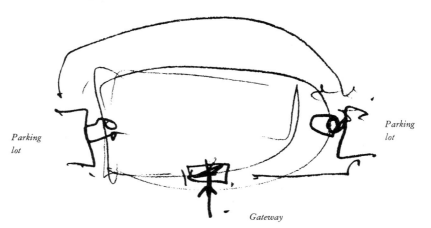

Parking lot

Parking lot

Gateway

We agreed, also, that there needed to be some kind of common place in the middle where families could barbecue meat (carne asada), perhaps with a fountain near it; and we placed a group of stones to show us roughly where this common PUBLIC OUTDOOR ROOM would be.

The most interesting discussion that afternoon concerned the pattern DEGREES OF PUBLICNESS. We explained that some families might want to be more pub-

lic—more in the center of noise—and that others might want to be more private and quiet. This difference, though potentially slight in a cluster of only five families, actually became acute when we considered that one family had ten children, and another had only one child. And, indeed, the families with ten and five children, respectively, declared that they wanted to be in the middle of the activity, while one of the young families,

Most private

Most public

with only one child, said that they wanted as much quiet and separation as was possible within the arrangement of the cluster. It was therefore agreed that the common land of the cluster would not be one simple rectangle, but that it would be shaped like a bottle, with the wider, larger part more public, and with the neck a narrower part where one might reasonably expect less activity and therefore a little more peace and quiet.

At the end of the day, the common land had been created. Although we played a major role in defining it, it was clearly understood and felt, as a communal thing, the result of a communal act. Everyone felt that it was theirs, their decision, that they had created it; and that it was not only theirs, but unique in all the world; it was their home.

STEP FIVE: CHOICE OF INDIVIDUAL LOTS

We now had a rough idea of the overall outline of the cluster. We knew where its common land was, its main gateways, its parking lots, its public outdoor room. So far, though, we did not know where the houses would be, nor even which family would go in which part of the cluster.

It was clear, given the very rough overall shape and the position of the main gateways, that there would have to be one house in each corner, and one in the middle. With this very general knowledge, we began the process of choosing the lots. We met one afternoon, and we asked each family to decide which part of the cluster appealed to them most, and to go and stand there.

The range of choices was remarkable. Two families, the music teacher's and Jesus the barber's, wanted to be in the same place, the northeast corner on the main street, because they hoped to open small shops. Emma Cosio and Julio Rodriguez both wanted to be in the northwest corner. José Tapia wanted to be in the southwest corner, on the bottleneck for quietness, and away from the main road.

Of course, we had to settle the conflicts in those cases where two families wanted the same spot. In order to resolve the conflicts, we followed the general rule that a person could exchange location for size: that is, a person who was willing to take his second choice of location would be entitled to a slightly larger lot, to compensate him.

Emma Cosio, for example, with ten children, needed a large lot. We told her that if she were willing to give up the corner location which she wanted most, and put her house in the middle, we would be willing to give her substantially more area to make up for the loss. Because of her large family, she accepted this proposal gladly.

As far as the conflict of the two families who both wanted the northeast corner was concerned, we held a long discussion with the two of them, again explaining that whoever of the two was willing to give up this location for the southeast corner (also on the street, and also capable of having a small shop there) would once again get slightly more area. Finally, the music teacher accepted, and, as can be seen in the plan, the southeast lot is slightly larger than the northeast lot, to make the compensation.

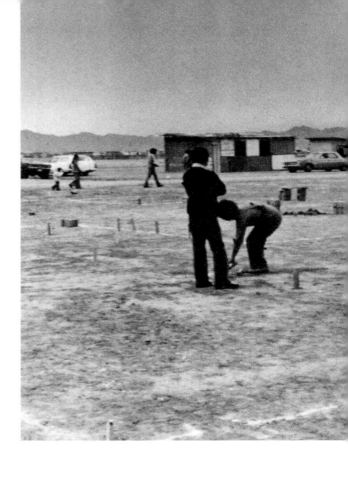

STEP SIX: SUBDIVISION OF LOTS

The fact that each family now had their chosen cor-
ner did not, of itself, completely fix the lot boundaries
which marked each of their lots. Next, we had to draw
actual lot lines, corresponding to the locations of the
individual families and the overall configuration of the
cluster.

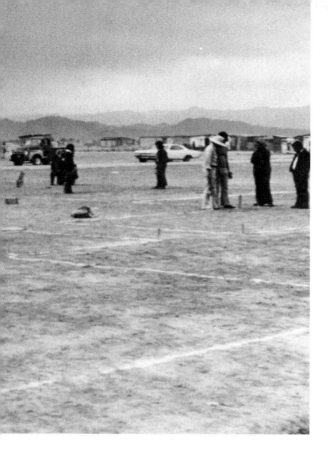

In order to establish these lot boundaries, it was necessary to make a very large number of experiments by moving stakes from one position to another, adjusting areas, until the common land had its appropriate shape and the individual lots had their appropriate areas.

This process took two days. We placed stakes to correspond to the major corners of the common land, placed

stakes to mark the corners of the individual lots, looked
at them, moved the stakes, looked again, and so on,
until we finally had a complete layout that reflected the
previous decisions accurately and also felt right.

It is helpful to remember how fundamentally differ-
ent this process is from the normal process by which
lots are subdivided and laid out. *The individual lots are
not fixed in advance, but are defined by the families them-
selves, as part of a process of group interaction.* In this
respect, the cluster is completely different from a sub-
division, where lots are defined impersonally, by a de-
veloper or by the city.

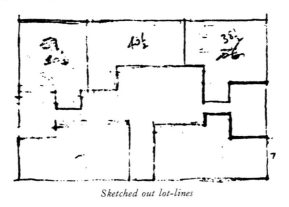

Sketched out lot-lines

In this process, the cluster as a whole first takes on
a unique character, as a direct expression of the group's
wishes and needs; and second, each private lot is then
placed in relation to this unique common land, so that
each lot itself then takes on its own unique shape and
character, according to its position.

The specific geometry which reflects this unique and
complex order is necessarily, then, unique and idiosyn-
cratic. It is hard to lay out, hard to measure, and hard

to survey. Indeed, it is worth describing the process of surveying the lots. After we had staked out the lots, the city surveyors came from the Department of Public Lands to survey and record them. The first time they came back with their survey, it was hopelessly off— with lot shapes on their drawing that were entirely different from the lots actually staked out on the land. This happened because the surveying techniques they used were so much adapted to the normal layout of subdivisions (straight lines, perfect right angles, etc.) that their procedure was simply too inaccurate to record the complexity of the actual stake marks properly. The surveyors had to come back three times, finally with their supervising engineer, before they could make a platt which accurately recorded the lot lines as they really were.

In the usual procedure, reality is governed by paper. In our process, the paper merely records the much more vivid reality that is worked out on the site by the families themselves—and the resulting complexity of the common land and private lots reflects much more accurately the real complexity of needs and hopes and dreams that all the families and individuals have.

STEP SEVEN: PLACING OF HOUSES IN THEIR INDIVIDUAL LOTS

We now come to the most interesting and important part of the whole process. Once the private lots have been determined, the natural next step is to locate the indvidual houses on their lots. If this were a purely private act, it could take place one house at a time, without reference to the cluster, and we should be de-

scribing it in the next chapter, under the design of individual houses. In fact, however, the location of the individual houses plays a crucial role in the creation of the communality of the cluster as a whole. *If the houses are well placed, they help shape the common land, and the cluster becomes coherent. If the houses are badly placed, they fail to shape the common land, and the cluster degenerates into a loose aggregation of individual houses, with no communal spirit.*

The crux of this issue lies in the treatment of the boundary between common land and private land. If the houses are placed in such a way as to help form this boundary, the common land succeeds. If not, it fails.

It is also true that the placing of the houses in their lots has a crucial effect on the shape and usefulness of individual outdoor space—the courtyards and gardens of the individual houses. If it is done well, it has enormous benefits for the houses. But if it is done badly, it cannot be repaired; and it is too late, at the stage of individual house design, to do anything about it.

In short, the placing of the houses on their lots is in many ways the most crucial single act that takes place during the design-construction process. It is the position of the buildings which entirely creates the space, indoor and outdoor. If this is done right, everything falls into place beautifully. If this is not done right, no amount of good design and hard work later can correct it.

IT IS ESPECIALLY IMPORTANT TO DISCUSS THIS, BECAUSE IT IS EXTREMELY HARD TO DO, AND REQUIRES MORE SKILL THAN ALMOST ANY OTHER SINGLE ACT.

In order to discuss it, we shall show a series of examples in which it is done, more and less well.

First, we show an example in which none of the outdoor space is properly handled. This is an early version of a layout, for the cluster, done during the discussions by one of our apprentices. As you can see, it has very bad positive space, both in the common land and in the individual lots.

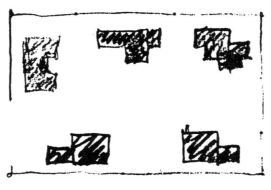

Bad space

Next, we show an example, which also came up during the discussions, in which the positive space of the individual lots is well handled; but the common land is still bad. This example shows the individual houses placed in such a way that they form beautifully positive-shaped gardens. Unfortunately, in this layout, the common land has no positive space at all. Of course, one might try to make the shape of the common land positive by building ways, in the positions indicated on the drawing. But real world experience shows that these kinds of walls rarely get built where they are supposed to be built. Unless the houses themselves actually *form* the common land, the positive quality of the common space just won't materialize.

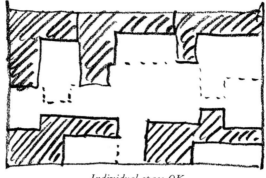

Individual space OK
Common space bad

Next we show the layout of houses, as they were actually built. The illustration shows a diagram, drawn on the blackboard in the builder's yard, while final discussions were going on. In this case, there is a compromise. The buildings are brought forward, on their individual lots, so that they do help to form the common land in a

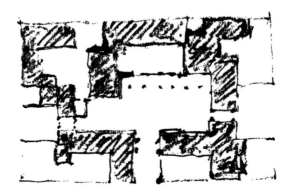

Final layout

146

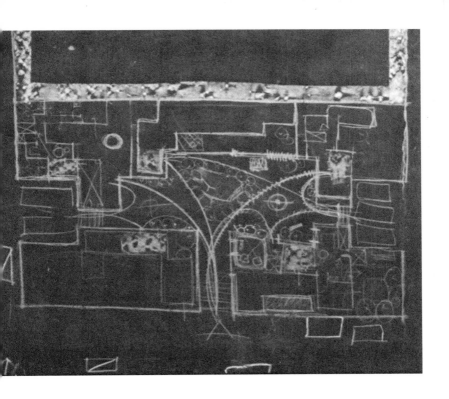

positive way. But, in order to accomplish this, the individual land, on the individual lots, is no longer so simple and beautifully positive, as in the last diagram, so the individual gardens are not really positive. Also, as you can see, the common land doesn't really reach a beautiful shape either. So, unfortunately, the final layout of the cluster we built just isn't as good as it ought to be, because we were not aware, while we did it, of the enormous seriousness of this problem . . . we left it too late, and we allowed a series of decisions to be made, irretrievably, by the families before we realized that the positive quality of the individual space, and of the common land, had been violated.

After this experience, we understood the problem well. In the second cluster, of four families, (which was laid out by families, but unfortunately never built), we took care of this problem early enough in the game, with the result that both homes, and individual gardens, and common land, all have beautifully positive space, which is shaped only by the position of the houses. The following two diagrams, show drawings which were made on the backs of envelopes, at the time those families were laying out their land. The photograph also shows the chalked layout of the second cluster, on the land.

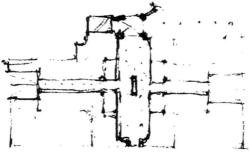

Second cluster common land

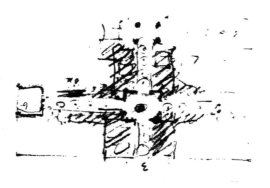

Step Eight: Arcades and Porches

Once the houses are roughly placed on their individual lots, we have then to complete the process by which each house helps to form the common land.

Essentially, the idea of this step is that each house provides a portion of the wall which forms the common land, and that to make this wall work properly, it must be made of something solid, which is also suitable for

Arcades around the common land

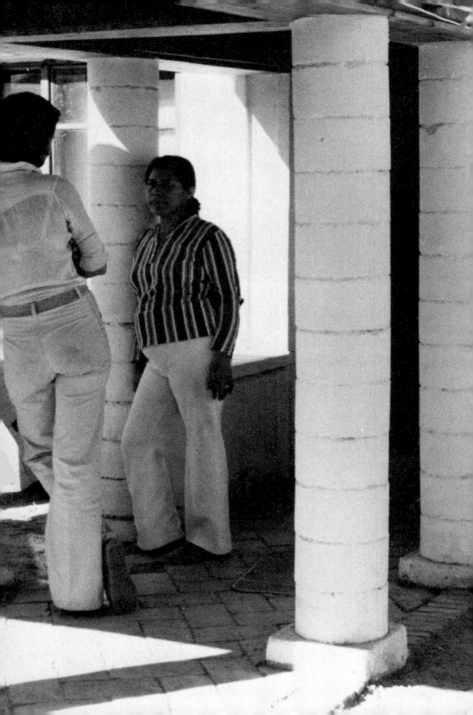

human use, so that it is not a blind wall, but a human, useful wall, which follows the prescription of the patterns BUILDING FRONTS, BUILDING EDGE, GALLERY SURROUND, ARCADES, PORCHES, SITTING WALL, etc.

To begin this work, we explained to the families that each of them has an obligation to the community and is responsible for doing certain valuable things along the boundary line. Examples were given:

1. Where the parking lot needs to be separated from the common land, I explained that the house in that position needs to place something there, to protect the common land. It can be a wall, a walled garden, a room, a porch, but it cannot be nothing, since that makes things worse for everyone.

2. The same principle applies where the gateway comes in; each house there has the responsibility of helping to create the gateway.

3. Similarly with the public outdoor room: whichever family is near it has the obligation to design their own house in such a way as to enhance this connection and make sense of it.

4. And in general, the boundary of every lot must be made up of either buildings, or walls around gardens, or porches, or arcades, because all these things make the common land more pleasant.

The families seemed to understand all this very clearly. They had no questions, surprisingly, and said simply that it made sense and that they wanted to do it. We helped them do it by giving them certain rules of thumb they had to follow. For example, every house had to have at least 11 percent of its area in the form of porches.

In the course of this step, we placed the long arcade in front of Emma Cosio's house. Lilia Duran placed her front porch in such a way as to help form the main entrance. José Tapia moved the front of his house in such a way that his front porch helped to form the bottleneck between the parking lot and the common land.

Even though the placing of houses in the first cluster was far from ideal (as discussed above), it was possible, with the help of all these arcades, porches, and garden walls, to make the common land very beautiful, well defined, connected nicely to each house, and with the proper sense of enclosure.

Step Nine: The Details of the Common Land

Finally, once the boundary of the common land is completely defined by the location of individual houses, arcades, porches, and garden walls, it only remains to place the various elements that make the common land itself complete.

In the case of the first cluster, the discussion centered around four items:

1. The main gateway (GATEWAY AND MAIN entrance)
2. The minor entrances from the small parking lots (CAR-HOUSE CONNECTION)
3. A place to barbecue meat and sit out in the summer (PUBLIC OUTDOOR ROOM)
4. A fountain (POOLS AND STREAMS)

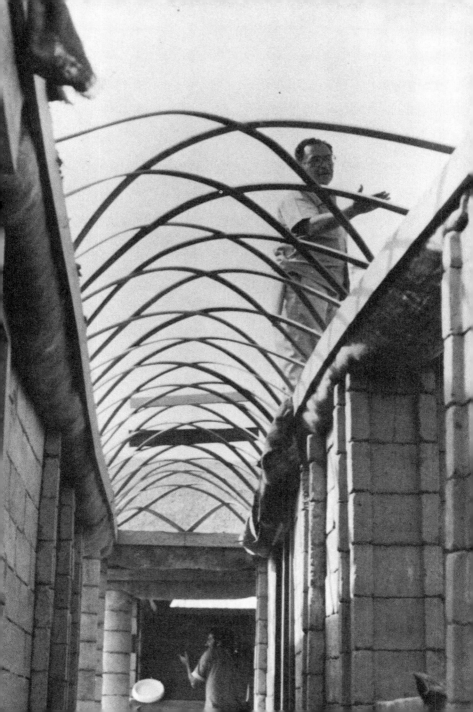

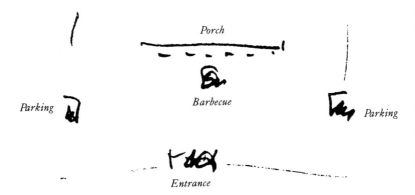

Porch

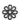

Barbecue

Parking

Parking

Entrance

The families enjoyed this process very much. These elements meant a lot to them and made good sense. Without much effort, it was possible to sketch out, in the dust, the location and nature of these elements, and to talk about the ways in which they might be built. Once these elements were decided and staked out, the common land was more or less complete and the cluster finished.

❁

In other countries, or in other situations, the collective design of common land might take many different forms. Of course, the land does not always need to be physically enclosed, the way it is in Mexicali. Nor does it always need to be done at low density, as it is in Mexicali.

Streets, when they are carefully made, and when they are made for people, not as abstract transportation arteries, are the most beautiful common land of all.

For instance, we have made simulations which show how a similar clustering process would work at the density of two-storey row houses.

And in another project we have shown how the clusters can work when they are at even higher density, four storeys high.

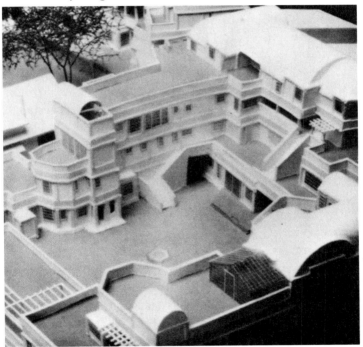

In both cases, the essential activity of the cluster—the definition of common land, the placing of communal functions, the choice of lots, the definition of individual lots, the development of a social group during the process of design, and the process of construction—are all still there.

Finally, we note that the collective control of common land is not something which we have invented. In one form or another, it has existed for thousands and thousands of years.

Until about two hundred years ago, the space between houses was always controlled by the families who lived in the houses, so that there was always identifiable common land, looked after by groups of some ten to twenty people living in close proximity and having the possibility of ordinary daily interaction.

The streets and squares of Bath, though they seem streetlike in outward character, are socially based on the collective design of common land. The grouping of houses in compounds, common in India and Africa, is based on the collective design of common land, though these clusters are much looser and more informal. The arrangement of the houses in a Trobriand village, arranged in an open circle, is clusterlike. Even the loose juxtaposition of farmhouses on the American prairie of the pioneer days was essentially clusterlike, because again the common land between the houses was laid out collectively. And, of course, the high-density packing of houses in a town like Casablanca or Fez is clusterlike again, with hidden courtyards leading to further courtyards from which the houses open.

Although it is certainly possible for houses to be grouped in many different ways, in different climates, at different densities, and in different building traditions, nevertheless we consider that, in some form or other, the collective control of common land, shared by a small group of families, is a fundamental necessity of the human world.

CHAPTER 4

THE LAYOUT OF
INDIVIDUAL HOUSES

THE LAYOUT OF INDIVIDUAL HOUSES

Fundamental to the process of production—perhaps most fundamental of all—is the principle that families lay out their houses for themselves. This does not necessarily mean that the members of the family also contribute labor to the process of construction—but it does mean that we consider it to be a fundamental right for every family to control their own immediate environment. When new houses are being built, the ground plan of these houses, their fundamental arrangement, should come not from the developers or builders or the government—but from the individual families themselves, so that each house is the product of the hopes and dreams of one particular family.

In order to make this possible, there must be some system of rules, some pattern language, or some other similar flexible instrument which makes it possible for families to do this in a competent way. This essential condition is fully discussed in The Timeless Way of Building, *and is explained in practical detail on the following pages.*

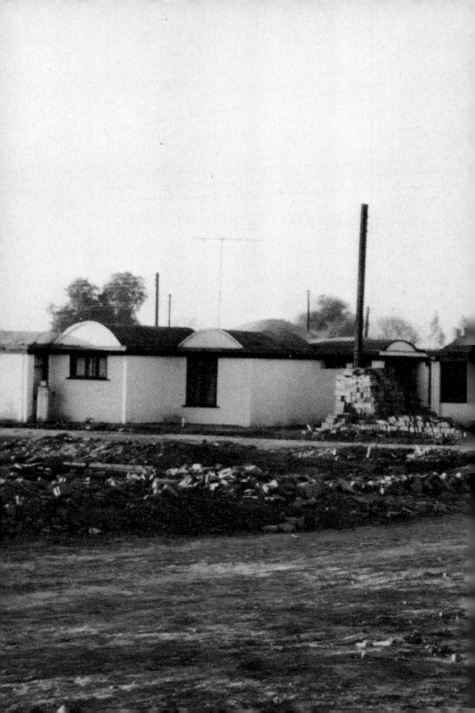

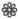

Present-day forms of housing production almost all rely on the idea of highly repetitive "standardized" units of housing. This is true in tract-house construction, it is true in the factory production of trailer houses, it is true in the production of large apartment complexes, and it is true in virtually all forms of public housing and high-rise housing. In every case, there are a very small number of different houses or apartments which are repeated a hundredfold or a thousandfold. It is often even true in the case of squatter housing, where people build their houses for themselves. In most squatter settlements, the well-built houses that gradually replace the packing cases are modelled after very limited government-produced plans, in which the same layout is repeated again and again, not merely in its outline but in detail. The fact that each family builds its own house only slightly relieves the monotony of the identical repetition. And even in those cases of public housing where architects or planners provide a "framework" within which families are free to move walls, the illusion of freedom is still dominated by the much harsher reality of a plan that is still essentially mechanical in nature, with a few moves that can be made "within the system," much like the variations of exercise permissible within a prison yard.

All this standardization is created by the "necessities"

of production, which seem to require massive standard-ization in order to produce high volume and low prices. Yet, in fact, even huge as they are, these processes still produce relatively small volumes, and at very high prices. And whatever the motives for standardization, the fact is that under these conditions the control of the dwelling which is to be used by the family is taken *entirely* out of the family's hands. The control lies in the hands of architects, administrators, city officials, and bank overseers, all remote from the immediate daily life of the family who will actually live in the house. Under the conditions of this distant control, it is inev-itable that the house is alienating and machinelike.

We shall therefore replace this distant control with a process in which control lies in the hands of the fami-lies themselves. We replace the idea of standardized housing units with the idea of houses (or apartments) designed by the families who are to live in them, each one designed entirely according to the family's own unique needs and character, so that as a matter of feel-ing, each house becomes a genuine life base, a place for the heart, a place in which the family, as a unique being in society, may be anchored and nourished.

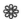

In Mexicali we were able to implement the principle of individual house design completely. Each family laid out their own house according to their own desires, and the house was built directly from the layout which the family made on the ground.

The extraordinary character of this process is visible

in a brief passage from my notebook. It describes an incident that happened very early in the project.

FIRST MEETING WITH FIRST GROUP OF FAMILIES

January 1976

Everything went well. One amazing thing.

These families have been briefed several times by the union (ISSSTECALI); they have read the initial announcement in the papers; and they have spent several hours discussing the project with the student who will lead the design. But still, until the meeting this afternoon, none of them understood that all the houses are going to be different. This came up when someone asked, "How many bedrooms will these houses have?" I explained, of course, that each house will be different, according to the tastes and needs of the individual families. An incredible light came into their faces when they realized that each house would be adapted to their specific needs, and desires, and imagination. . . .

This passage shows how very deep-seated the oppression is which makes people assume that houses are all alike, and which keeps people separate from the natural function and process through which they make their own lives concrete in the world. That process has been pushed and pushed, so far down that people are almost entirely unaware of it any longer, even as a possibility—and when it becomes clear to them that it is possible, and that it is going to happen, they light up as if something magical has been given back to them.

What is this "something"? Each family has a house which fits them perfectly: it has their wishes, their dreams, their ideas of life; it has to do with their chil-

dren, their ways of cooking, their ways of gardening, their ways of sleeping. It is a place which they can love, because through it, and in it, they have constructed their world.

Let us begin the chapter, then, by briefly describing just what each of these worlds is like, so that the uniqueness of each family and the differences between all of them are clear and concrete.

Lilia's house

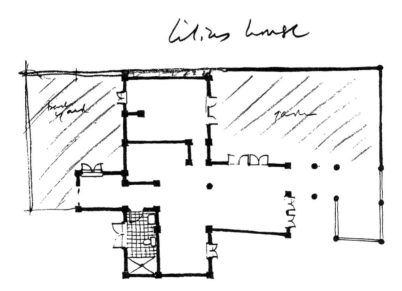

Lilia Duran

Lilia, who is a nurse, and her husband Jesus, who is a barber, had only one child, about two years old, when they started construction. Their daughter is everything to them; they protect her, love her, and in the finished house, she is, metaphorically and literally, at

the center. The house is the smallest of the five, and shaped like a Greek cross, with a family room in the middle of the cross, and their daughter's bed, in an alcove, right off the family room, at the heart of everything, where they "can watch her." The house is small, because the Durans hope to build a barbershop one day for Jesus, and so decided to save their money. Between the front door of the house and the place where they hope to put the barbershop one day, right next to the cluster's entrance, there is an immense porch, similar to the one Lilia had in her house while she was growing up.

José Tapia

José Tapia and his wife have two small children, and José's brother Pancho is also living with them. Both José and Pancho have always worked with their hands, and they were both immensely energetic; their house was almost always ahead of everyone else's.

At the same time, the Tapias are very private. When the cluster was being laid out, they wanted their house to be as far as possible from the main center of activity in the cluster—which led to the configuration and location described in the last chapter. Then, in the house itself, the same feeling of privacy made them place the main bedroom as far away as possible from the main entrance and the common land. This gave the house the most elongated form of the five—it has the greatest sense of privacy. And it is elongated still further, in the middle, by the alcove near the kitchen, which was built specially for Pancho for as long as he lives with them and until he has a wife and family of his own.

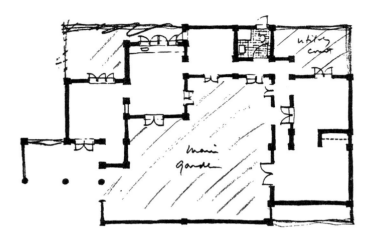

José is very interested in politics. He believes that projects like this one are important for people to realize their full potential and potency—much more important than government programs—and he said several times during the project that he wants sometime to continue this kind of work, to help other families to do the same thing.

Emma Cosio

Emma Cosio is divorced and has ten children: the eldest, fifteen; the youngest, two. Hers is, of course, the largest of the five houses, and it has the largest and most distinctive dome in the cluster: the family room, capable of seating the whole family around a table, has the largest span and the highest vault of any room or building in the complex, so it can be seen from the

distance as the highest dome. Beyond the family rooms, the house is different from the other two already described because it breaks into a maze of rooms and alcoves where all ten children sleep, with the master bedroom beyond—placed so that, outside it, there is space for a workshop where Emma hopes one day to make clothes and to prepare vegetables for sale.

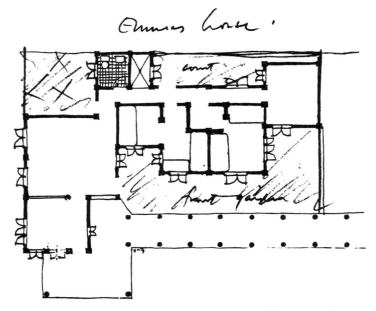

Emma works as a secretary in the office of a high political official, and she is quite involved politically herself. She was enthusiastic about the project in the beginning, but was always the first to complain when something was going wrong. Although, in the beginning of construction, her teenage children were quite helpful and worked with enthusiasm, later on, unfor-

tunately, neither she nor her children were of much help on the site—either in the actual construction or even in the design decisions which had to be made during the construction. Her house is the least well finished of all five.

Julio Rodriguez

Julio Rodriguez, short and stocky, was the most outgoing of all five participants. At the initial meetings, he always arrived on the site with a small bottle of tequila in his pocket to get things going; and later on, during the fiestas, he brought his guitar and guitar-playing friends. Julio works as a meter reader for the

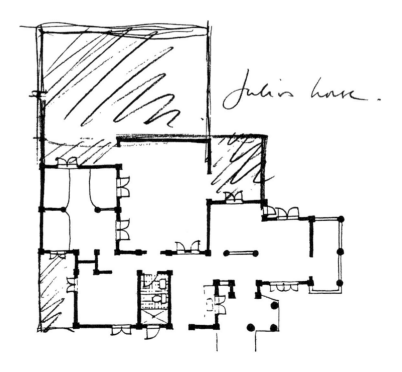

electric company; his wife keeps house and takes care of their four children. Julio has a great sense of humor, kept us all laughing, and was also quite sensible and sophisticated in the decisions he made about his house.

Julio's house has two main features which make it different from the other houses. The main separation of the house into public and private sections puts the kitchen on the private side, with the bedrooms, so that you can't see it when you are in the public part. The dining room and living room, quite extensive, with an entrance and with a porch that both look into the common land very nicely, are the heart of the house.

Also, Julio put all his four children into one room. Each bed has an alcove; but he has placed the emphasis in his house on space for people visiting—not on private space for individual members of the family.

Makaria Reyes

Makaria is a nurse, like Lilia, and is a friend of Lilia's. Her husband is a policeman. Both are quite young, in their mid-twenties; they have two children. They are very conscious of making life nice for themselves, of improving themselves, and of giving their children a better place in the world than they have. Their children have the nicest and most expensive toys in the cluster. The house is beautiful, clean, and very carefully finished, for Makaria likes to keep it incredibly clean and shiny and neat. But she had to build it without her husband's help: being a policeman, he didn't want to get his hands dirty, so she asked an old uncle of hers to help finish the house, and it has a level of professionalism in the finishes that the other houses don't

have. The wall surfaces, the counter tops, the floors, and the paint are all meticulous and perfect.

In the plan there are very large bedrooms and comparatively small living areas. Each child has his own

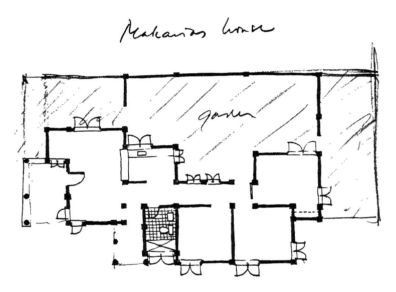

room, and these large bedrooms owe their existence to the fact that everyone in the family is encouraged to be "something" in life and needs space and private room.

At the same time, this house is the center of the cluster now, with neighbors coming and going all the time. Makaria says that she loves this kind of thing, although it never happened in the neighborhood where she lived before. It happens partly because she is so friendly, and partly because of the unusual position of the kitchen in her house, placed with such care right inside the front door, where everyone is welcome.

We see from these brief descriptions how each house is an integral whole that mirrors the nature and aspirations of each family in a unique way. Now we shall describe the mechanics of the process which made this possible. To begin the process, we met the families once, on the site, and explained that they were now going to design their houses. We told them that this process would hinge on a pattern language similar to the one they had been using for the common land. Each family got a copy of this language to read. With help from two student apprentices, they went through the language, discussed the patterns, and added patterns of their own. Then they began their design simply by following the sequence of the language in the way described in the following pages.

1. SIZE AND COST OF THE HOUSE

Before they began to design their houses, the families had to know approximately how large their houses were to be. This was explained to them in the following way. They were told that the houses would cost 585 pesos per square meter (this was based on our own detailed cost estimates presented in Chapter 6), and they were told also that each of their loans had been approved for a house of 60–70 square meters (a total construction cost of about 40,000 pesos). However, it was made clear to them that they could build slightly more or slightly less at the same rate per square meter, so that each house might end up with a slightly different

size and a price proportionately related to its area. Each family was then in a position to decide how much they could afford, and, working backwards, how large their individual house would be.

The prices and areas which the first five families chose for their houses turned out as follows:

Lilia Durán	39,099 pesos*	$65.5m^2$
Julio Rodriguez	43,932 pesos	$75.2m^2$
Makaria Reyes	44,356 pesos	$76.0m^2$
José Tapia	43,110 pesos	$73.7m^2$
Emma Cosio	49,001 pesos	$84.6m^2$

*These prices reflect materials only. Families were free to use as much or as little paid labor as they wanted, and paid for it themselves. This is described in more detail in Chapter 6. All prices are in 1976 pesos.

2. THE PATTERN LANGUAGE

In order to get a reasonable house which works well and which nevertheless expresses the uniqueness of each family, the families all used an instrument we call the pattern language. This language has been thoroughly described in two earlier volumes in this series, *The Timeless Way of Building* and *A Pattern Language*. The particular pattern language which families used to lay out their own houses contained twenty-one patterns in it, which are listed below:

NORTHEAST OUTDOOR SPACE
POSITIVE OUTDOOR SPACE
LONG THIN HOUSE

LAYOUT OF INDIVIDUAL HOUSES

MAIN ENTRANCE
HALF-HIDDEN GARDEN
FRONT PORCH
INTIMACY GRADIENT
COMMON AREAS AT THE HEART
FARMHOUSE KITCHEN
COUPLE'S REALM
CHILDREN'S REALM
BACK PORCH
SEQUENCE OF SITTING SPACES
BED ALCOVES
BATHING ROOM
THE SHAPE OF INDOOR SPACE
LIGHT ON TWO SIDES OF EVERY ROOM
CLOSETS BETWEEN ROOMS
STRUCTURE FOLLOWS SOCIAL SPACES
COLUMNS AT THE CORNERS
NATURAL DOORS AND WINDOWS

As we shall see in the discussion which follows, this language has the amazing capacity to unify the generic needs which are felt by every family, and which make a house functional and sensible, with the unique idiosyncrasies that make every family different, and thus to produce a house which is unique and personal, but also one which satisfies the basic needs of a good house.

It is therefore this pattern language which allowed us to produce a variety of houses, each one essentially a variant of a fundamental house "type" (defined by the twenty-one patterns together), and yet each one personal and unique according to the special character of the family who used it. In the next sections, we shall pre-

sent the way in which these patterns were used, one by one, and show what impact they had on the different houses. The patterns were used in the order we present them. Thus, the fact that they appear in a specific order is not an artefact of our book format, but is an operational feature of the process by which the families used the language. Since the patterns are arranged in an order which makes sense, it is possible to pay attention to them one at a time, and to be sure that a coherent and workable house unfolds gradually from the impact of the patterns, one at a time, in the order given by the language.

3. DEFINITION OF THE GARDEN AREAS

a. *Northeast Outdoor Space*

The first patterns help the family decide exactly where to place their houses on the given lot. They do this not so much by trying to place the *building,* but by asking themselves which part of the lot will be most useful and pleasant as open space or *garden.* This first pattern begins the process.

Since there is intense heat in Mexicali, and we have observed that outdoor spaces to the north are used year-round, while those on the south side can only be used in winter, we start by placing gardens to the north of every site, preferably to the northeast and protected from the west, since there are very strong dusty winds from the west.

José and Emma followed this pattern exactly. Mak-

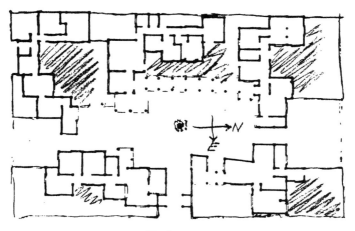

Northeast space

aria could not follow it strictly, because she had the responsibility of making her house help to form the cluster entrance, so the house had to be at the extreme north end of her site. She did place a porch to the north, though, to get the pattern in small form. Lilia placed the outdoor space to the east of her house—and so protected it from the western winds, but not from the sun. Julio, like Makaria, could not place the outdoors to the northeast, because at the east end of his site he had to place his house to help form the entrance to the parking lot. But he did put his garden on the north, getting protection from the wind with a garden wall, and later he made a covered porch at the east end of the house.

b. *Positive Outdoor Space*

For this outdoor space to be useful and pleasant, we make sure that it has coherent shape and enough enclosure to make it private and an obvious *place*.

Very few of the families did this well. Out of the five, only José did it fully. Lilia did a halfhearted version of it. Emma's house was repaired later, with the common land arcade, to give it this character after the fact. Makaria and Julio did not do this at all.

This pattern is one of the most difficult in the language to do correctly. We did not supervise the families carefully enough while this pattern was being done, to help them get it right. And by the time we realized what was happening, it was too late.

However, having realized our mistake, and taking more care in the second cluster, all four families in the second cluster did it perfectly. The fact that the first five houses did not have this pattern is therefore one of the most serious shortcomings of the project. But it is a perfectly solvable problem, as we see in the second cluster.

4. LOCATION OF THE HOUSE'S BASIC VOLUME

Long Thin House

To create this positive outdoor space, we wrap the house around it in such a way as to create the common land we have already identified. The longer and narrower we can make the house, the more spacious it seems, in spite of its small size. And the longer it is, the more effectively it can wrap around the outdoor space to make that feel enclosed.

All the families except Lilia's have some version of this pattern. Lilia, for the reasons described already, has

Long and thin houses

a cross-shaped house which is very small. To some degree, the others all have the long narrow character which makes them seem spacious. However, except in José's, where the pattern is full-fledged, the pattern is not given the full play which makes it most valuable. Instead of having a "chain" of rooms, with the house only one room thick, both Makaria and Emma have a clump of rooms at the bedroom end, like a tract house, and the corridors spoil the spacious character created by a fully developed chain of rooms.

Even in the half-formed version which these families have, this pattern helped them greatly to place the houses on the land, and is certainly responsible for the large roomy feeling these tiny houses have.

5. DEFINITION OF APPROACH

a. *Main Entrance*

Next, the families placed the entrance to the house. This has a controlling influence on everything that follows. The entrance has to be visible, easy to approach, and in a place which commands a nice view of the common land.

All the families did this very nicely. Each main entrance is well placed and very visible, and each one has a porch, so the five entrances form a beautiful family of entrances. (See FAMILY OF ENTRANCES in *A Pattern Language*.) It took some work to make José realize that it made sense to place his entrance where he finally put it. At first it was further to the west, so his house did not extend all the way to the east as it does now, and

the entrance was not visible. That was, in naive terms, a more ordinary way of doing the house plan, because the house was not so stretched out. But after discussing it and recognizing that the most beautiful place for the entrance is, indeed, where it is now, we showed José that the slightly unusual character it gave his house was not a disadvantage, but would, on the contrary, give it charm—and it ended up alright.

b. *Half-Hidden Garden*

To make the outdoor space just right, we adjust the location of the house, and of the walls and porches around the outdoor space, so that the garden is half private and half visible—protected, yet with a definite indirect relation to the common land, so one can see into the common land from the garden, and also see the comings and goings at the front door.

Both José and Lilia used this pattern. They placed their porches near the main entrance in such a way as to give the garden behind a very nice feeling.

c. *Front Porch*

We enhance the entrance with a porch. Every house has to have at least 11 percent of its area in the form of porches; and each porch is placed so that it not only embellishes the entrance of the house, but also helps to form the common land.

It was explained to each family that the price of the house *includes* a porch or arcade, with a roof and columns but no walls, totalling at least 11 percent of the area of the house. This meant that the porch area would not be included in their costs, *and gave the fami-*

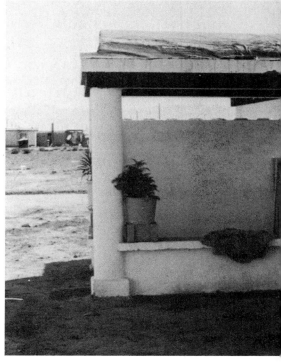

lies an incentive to provide themselves with a larger porch.

It was very essential for us to proceed in this way because we discovered quickly that families are not willing to pay for the cost of porches when it is presented to them as a direct cost, since they do not at first understand the vast and enormous benefit they get from it. In fact, because it connects indoors and outdoors, a porch makes a much larger area livable, makes the outdoors around the building habitable, and therefore effectively increases the living area of the house by perhaps 30 percent. Thus a porch of seven square meters,

say, does far more to increase the effective living area of a house than an extra room of three and a half square meters (which costs about the same because it also creates connection to the still larger outdoor area beyond, and makes that useful too.

However, we found that families are almost completely unable to see this point. Thus, if the choice between porch and bedroom is left to the family, they will almost all choose a bedroom—even if the porch is reckoned at half the cost per square meter.

For this reason, to make sure that houses had porches,

in spite of the family's misunderstanding of this point, we included the cost of a porch as an "overhead," so that the family got it anyway, whether they wanted it or not. Each family was allowed to have a porch with an area 11 percent of the whole house area, without paying for it.

This worked excellently. Now that the houses are complete, the families love their porches and recognize the disproportionate value which they have. As you can see in the pictures of the finished houses, the actual built porches play an enormous role in the well-being and daily life of the families.

6. DEFINITION OF BASIC INTERNAL LAYOUT

a. *Intimacy Gradient*

Within the house, we then create the gradient of intimacy. This means that immediately next to the entrance we have those rooms which are most public; further from the entrance the less public rooms; and the most private rooms are furthest from the entrance.

Two families used this pattern in its extreme form: José's and Emma's. In both these houses, after the entrance you come to an area devoted to public rooms, and then, behind them, there is an area devoted to private rooms. Makaria and Julio used a weaker form of the pattern, which we might call a "branching" form: in each case, after the entrance the living areas are to one side, and the sleeping rooms are deeper, to the other side. It is not clear whether they had good reasons for this, or whether they would have been better off to use

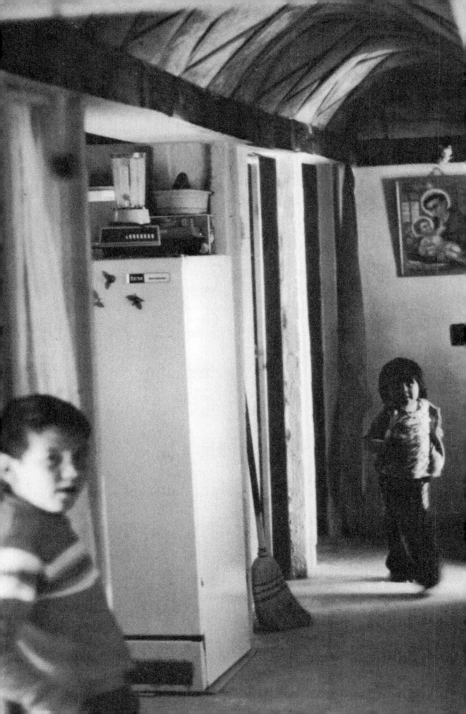

the stronger form. Finally, Lilia's little house is so small that the pattern has little effect—except to put the main bedroom well out of the way and "deepest into the house."

b. *Common Areas at the Heart*

With the intimacy gradient fixed, we now make one place in the common part of the house a clearly useful central common space—placed so that everyone going in and out of the house goes past this place and greets the other members of the family.

All five families did this successfully. It is so fundamental to the Mexican sense of the family that it was

Intimacy gradient, and common areas at the heart

perhaps almost automatic for them. As far as the geometry is concerned, each house had already begun to take on an entirely different configuration—so, of course, by this time in the design process, the pattern took an entirely different form in each of the five cases.

c. *Farmhouse Kitchen*

Within the common area, we define the kitchen as a place where cooking, talking, TV, card games, can all happen together.

This is a very controversial pattern in the United States—and apparently also in Mexico. The extreme form of the pattern says that the kitchen is part of a comfortable living area, but different families vary widely in the extent to which they wish to use this pattern.

Emma chose the extreme form: her kitchen is inside the large family room at the center of her house. Lilia chose a more modest version: her kitchen is at one end of the room, which also contains a dining table, but it is less central in the house. Makaria chose an intermediate version: her kitchen is a small room off the living room, but entirely open to it across a counter, so Makaria can talk to people in the living room even when she is cooking. Her kitchen is a very elegant and beautiful place for this version of the pattern. José's and Julio's families both chose to have the kitchen as a separate room: in José's case, separate, but next to the dining room, in Julio's case, entirely separate—not even next to it, but quite hidden.

This pattern is very important, because it draws attention to something which we have not described so

far. Even when people do not agree with the version of
a pattern that is stated in a pattern language, the pattern
still gives them the opportunity to consider the relation-
ship between the elements mentioned; and whether they
choose the "book" version or their own version, it helps
them to define this relationship, and so helps the build-
ing to emerge.

*But regardless of the relationship one chooses, the plac-
ing of the kitchen with respect to other living areas must
come at this moment in the unfolding of the house plan.*

The pattern is vital because it presents the family
with the need to place the kitchen in the house, and it
draws their attention to the vital question of how inti-
mately the kitchen is to be connected to the living areas
of the house.

d. *Couple's Realm*

Within the private part of the house, we place a def-
inite realm, a separate area where man and wife have
their domain.

None of the families took this pattern very seriously.
All of them have a modest version of it: they placed
the master bedroom in a position as remote and private
as possible within the house. But beyond that, nothing
much happened. None of them took the trouble to make
it a "realm" in the beautiful sense which the pattern
describes.

e. *Children's Realm*

Also within the sleeping area, we make a definite
realm for the children, and connect it to the outdoors
so that children can move freely between these rooms

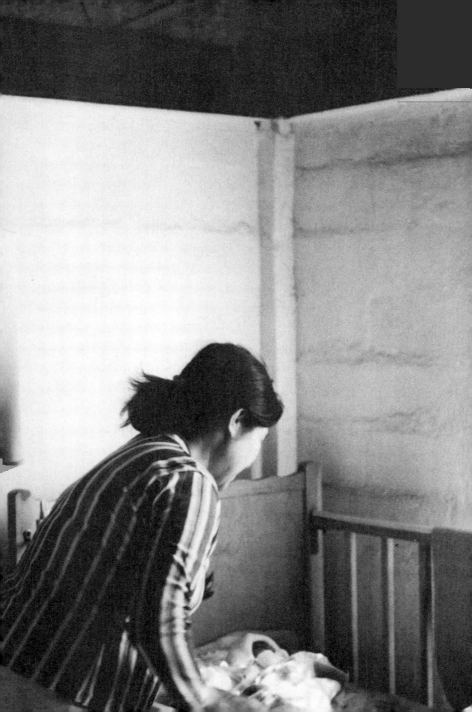

and the outside without causing too much noise and chaos in the private areas where adults are likely to want peace and quiet.

All five families used some version of this pattern, but it was most successfully done in the houses of Julio and José. Julio placed his main entrance so that children would pass the adult sitting places on their way outdoors; and in José's house, the location of the main corridor, with a door leading to the garden, gave the children a beautiful relationship to the outdoors.

7. MINOR AREAS

a. *Back Porch*

Outside the kitchen, and invisible from common land, we place a laundry—sink, drain, and an area for washing clothes. Usually we make it large enough to provide storage for old furniture, spare tires, and other materials too.

This is a new pattern, not at first in the language we gave the families. It developed spontaneously during the design work. Every family wanted one and put it into their designs.

b. *Sequence of Sitting Spaces*

Within the house, along the corridors and in the common areas, we make a series of places which are nice to sit in: out on the porch, in the living room, near the kitchen, and in the passages.

If we look at a house, we may ask: "How many places are there in the house where you can actually

LAYOUT OF INDIVIDUAL HOUSES

be?" It sounds obvious, but it isn't. Some houses give you lots of places to "perch"; others don't. These five houses are unusually nice in this respect; they have many places to "perch" and are very friendly as a result. Examples: the low walls outside Lilia's and José's houses; the bar in Makaria's house; the place where the entrance runs into the kitchn in Makaria's house, where everyone stops to talk; the entrance of Julio's house; the bay window at the end of the corridor in Julio's house; the main alcove in José's house; and many others, too many to write down.

c. *Bed Alcoves*

Where the children sleep, we divide their sleeping spaces into small alcoves, so that each child has his own area, however small, which is part of the larger area that all the children share.

Julio did this beautifully: his own room for four children has three alcoves, marked by columns, one alcove with a double bunk in it. Lilia placed her one central alcove off the farmhouse kitchen.

d. *Bathing Room*

We put the bathroom in a place which is convenient to the bedrooms and living rooms, and try to make it as nice a room as possible, more than just a box with a shower and a toilet, but a fresh place where the light comes in and makes it pleasant to be there in peace.

No one did this in its fullest form. The main thing we got from the pattern was simply that it told people when they had to put the bathroom into their plan.

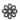

At this stage, each family had a fairly clear idea about their house. They were able to walk about in it in their imagination—and to walk it out, approximately, on the site. However, up until this stage, none of them had actually put any stakes into the ground; there were no exact measurements, no precise delineations of the shape of rooms or the exact position of walls.

We now took the families to their sites and asked them to lay the houses out on the ground with stakes. In the course of doing this, certain more detailed patterns became important.

8. REFINEMENT OF THE HOUSE'S DETAILED PLAN

a. *The Shape of Indoor Space*

We start by making every room a reasonable shape in its own terms, approximately rectangular, with a length and width that feel comfortable from experience.

To do this, we asked the families to consider each room in relation to existing rooms which they already knew. The stakes on the ground are often misleading unless they are placed with reference to dimensions that people have felt and lived with. If there was no room of the corresponding size and shape which the family could remember, we encouraged them to make "experiments" at home—mocking up room sizes, changing length and width—until the rooms felt just right.

b. *Light on Two Sides of Every Room*

At the same time that the rooms get their shape, it is necessary to make sure that every room has the capacity to have a window on at least two sides.

As the families began to place the stakes in the ground, and the rooms got their definite dimensions, we asked each family to be sure that there was going to be enough light—and that the light came in from two sides. In the case of these small houses it was easy, because the houses are most often only one room deep. All the families did it successfully.

c. *Closets Between Rooms*

We place closets between rooms where rooms need to be protected from each other acoustically.

When rooms are being staked out in the ground, this is the last moment that closets can be included. They have substantial thickness and volume, and must be provided at this stage. Several of the families have roomy closets, but only José's is well placed between his main bedroom and the child's bedroom. It also provides a very nice passage between the parents' room and the child's room. Lilia's, Makaria's, and Julio's closets are all afterthoughts which provide space but do not help to separate the rooms.

9. LOCATION OF COLUMNS AND VAULTS

a. *Structure Follows Social Spaces*

Now we assign the position of the main structural elements—ceilings and roofs—to the individual rooms.

Vaults in the layout of houses

In this particular case the roofs are vaults, so every part of the house has to be considered as a vault, and we have to check the plan to make sure that we understand the way the vaults are going to work. In another building system, the same problem would arise for beams, floors, pitched roofs, or whatever other structural form is being used.

This is a difficult and important step. The families cannot do it for themselves. It is essential that the architect-builder help them, because it can be hard to visualize. Sometimes a plan that seems perfectly clear is hard to vault, because there is an "overlapping" corner between two rectangles, for instance, that would require intersecting vaults—very hard to build. In several places in the house plans, we found minor "errors" of this sort, which had to be corrected by moving a wall

slightly by inserting an extra column or an extra beam.

Also, the choice of vaults has a major effect on the feeling of the building. For example, suppose a kitchen and dining room are next to each other. Should there be two separate vaults, or should there be a single vault? In the first case, there will be a low beam separating the two spaces, and they will be very distinct; in the second case, the single vault will create one space with two activities in it—entirely different in feeling. *So the process of choosing the vaults is the last major decision that is left in the design of the house, and it has an immense effect on the way the finished house will feel to live in.*

b. *Columns at the Corners*

We make sure that each vault is properly supported at the corners by the necessary columns. And we add columns where necessary if any vaults are supported on long clear span beams. Roughly, we say that no clear span can be more than six feet long. If there is a larger opening than that, we put in extra columns.

In most cases this pattern was easy to follow, and the fact that the columns are visible inside, at the corners of the rooms, does much to give the little rooms their elegance. Also, the freestanding cylindrical columns, introduced to help separate two spaces or to support clear spanning beams, are very nice—especially the one between Makaria's entrance and living room, the one in Julio's living room, and the one which creates the separation between the living room and the kitchen in Lilia's house.

In a few cases, insufficient care with this pattern caused chaos, most noticeably in the maze of bed al-

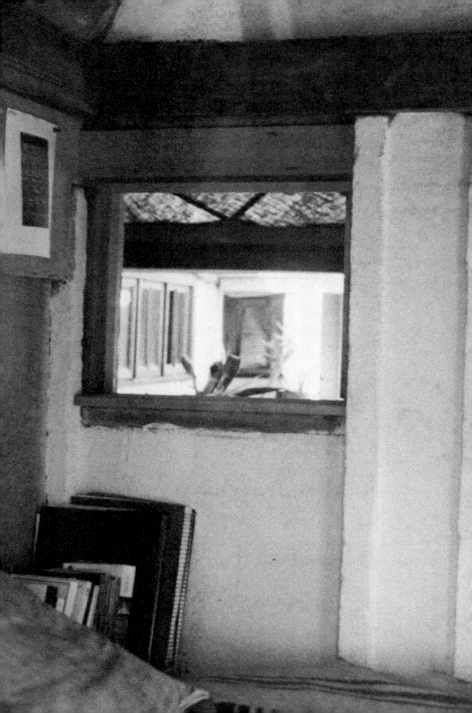

coves in Emma's house, where the columns are very poorly placed and the space suffers.

10. POSITION OF OPENINGS

Natural Doors and Windows

Within the structure of the columns and beams, we identify the positions of doors and windows by standing in each room and trying to imagine how much light we want there and which views will make the room as nice as possible.

At this stage, the families only needed to get a rough idea of where they would put their windows. The detailed position and size of the windows was fixed during construction, while the walls were going up, when it was possible to feel the impact of the windows properly. This is described in the next chapter.

Doors, however, had to be fixed exactly, at this stage, since they have an effect on the pouring of the slab.

With this, the staking out of the houses was complete, and the houses were ready to begin construction. (See Chapter 5.)

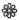

Let us now evaluate the houses which the families laid out for themselves.

We observe, first of all, that the houses are not at all the same as the houses which families typically create in the barrios when they build for themselves. For example, in Mexicali the standard house which people

most often build for themselves is a little square box. The total area is perhaps 450 square feet. Toilets are often outside. Construction is of common brick and mortar, with poured concrete stiffening columns and bond beams, and a flat wooden roof. The houses are plastered right away on the inside and later on the outside, when the family gets enough money to do it. Windows and doors are generally bought secondhand. The floor is a concrete slab.

This kind of box may be designed and built by a family acting on their own initiative: but it is a poor design, and has almost no redeeming features. How can this happen? Are we not claiming that the design will be best when the families do it for themselves? How can we criticize a little square house as a poor design, when the families themselves have laid it out and built it? The answer is that when a culture is broken apart and the people of that culture have no living pattern language, then no amount of self-help or self-design will give them the knowledge they need to build a house wisely for themselves. The people who make this square house have forgotten everything they ever knew (culturally) of how to build a house, and are making something without knowledge.

A person may cook for himself—but he still has to know how to cook. If he doesn't know some simple rules for making food, but just puts eggs and olive oil and bread and milk into a pan, the result will be a mess. If you want to cook an omelet, you have to know the rules for making omelets.

Just so, one needs to know the rules for making houses, to make a good house; and it is only when a

person uses a good pattern language to lay out his house that we can expect the result to be a success.

We assume, then, that the layout of a house, within a pattern language, requires great skill and subtlety. And we assume that the pattern language we have given the families does, to some extent, put that skill and subtlety into their hands. *But to what extent does it work? Is the process a success?*

Of course, we can see that the houses are richer and more interesting than a simple square concrete-and-brick box. Superficially, then, it seems reasonable to say that the families have made better houses for themselves than other people in Mexicali usually make when they design houses for themselves. *But are the houses which our families have designed better than the mass-produced houses presently designed by architects? That is, after all, the fundamental question.*

When it became clear that the families had indeed designed their own houses, and that the houses were so very different from one another, several of the officials connected with the project began to be alarmed. Engineer Rogelio Blanco, for instance, Director of Public Works, and Brindiz Herrera, Director of ISSSTE-CALI, the credit union financing the houses, began to express doubts that the plans were "properly" laid out. As they put it, "after all, it was impossible for families with no expertise to design their houses properly, didn't I agree?"

I said that I did not agree, and asked them to examine the houses for themselves. They came to the site one day, when the houses were half built, and looked around. After a while, they came and told me that they

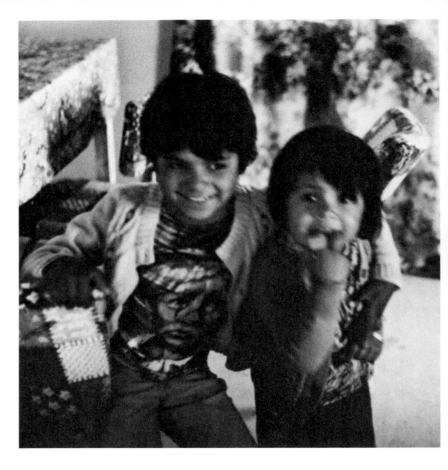

found it very strange, for instance, that the bedrooms
in Makaria's house were so large, and the common areas
so small. Wasn't it true that the bedrooms were dispro-
portionately large? Let's ask Makaria herself, I said.
We invited her to come and talk to us, and I asked her
why the bedrooms in her house were so large, and the
common areas so small. Might this not cause problems
in the house, since there was relatively so little room
for gathering? This is what she said: "Of course, yes,
we did it on purpose. You see, we ourselves, in our

lives, have been poor. But we are determined that our children shall have every opportunity for a better life, to make the best life possible for themselves. We only have two children . . . we are giving each of them the largest room we can afford, so that each one can use his room for anything he wants as he grows up: as a study, a workshop, a place where he can make something of himself. That is why we decided to put as much space as we could afford into our children's rooms, so that they could make the best out of life for themselves. As for the common room, the family room . . . well, when we are there, we are all there together, and we want to be close together. So why do we need so much space? That is why we made the family and dining room quite small."

This story, such a convincing and unarguable reality, shows yet again how much more the individual families know than we do about their own needs.

But when I explained Makaria's story to the officials in the government, they shrugged and said, "Well, anyway, they do not understand how to lay out a house." What can one say in the face of such arrogant certainty?

For the certainty of the officials that Makaria's plan was "mistaken" merely because it was unusual was quite wrong. The plan was unusual because it needed to be, to serve the purposes of the life of this family, as the members of that family saw their own needs. And for that family a "correctly" laid out plan, with smaller bedrooms and larger common areas, would have been entirely wrong. The only real mistake in this situation was the mistaken view that the officials had, that there had been a mistake.

This is of enormous importance. Over and over again, we found that the families did understand, deeply and concretely, what they needed; while the arrogant views of the bank, of the public officials, that they knew what was good for the families, or that only "architects" were competent to decide such questions, were pompous and absurd.

Even we ourselves did not always fully appreciate the extent to which families do know what is best for them. It is, for instance, worth telling the following story of what happened one day during the layout and construction of Julio Rodriguez's house, as I recorded it in my notebook:

An interesting incident. Today, we had some discussion with Julio Rodriguez and his wife. At first, the students had laid out their porch so that it was 5 inches higher than the floor inside; I showed them that this was very uncomfortable, would make people feel as if they were falling off, and that it should be brought down to the level of the floor.

The wall blocks had already been laid. So now the question was, do we remove these wall blocks, make a door, etc.? I assumed that there would be a door from the living room, cut through the wall, and there was some discussion about exactly where.

Then the question was, where would the exterior of the porch be open to the outside—where was there to be no wall? I assumed that the porch would be open on the side facing the common land.

Then, suddenly, it turned out that Julio didn't want any openings, wanted the low wall all around. This seemed very enclosed, but he pointed out that if it were open, even in one place, it would be used as a main entrance to the house, since it is closer to parking—and this would destroy both it

and the beautiful main entrance they have gone to some lengths to create. So they will make the porch entirely enclosed around the outside by a low wall, and only accessible from the inside—a sort of outdoor room. Very fascinating; and very sophisticated on their part. It is significant, perhaps, that this happened just one day after Julio and his wife first began to feel, in a realistic sense, that the process of building the house was in *their* hands, and began to feel comfortable in their possession of it.

It is clear, then, that the designs made by the families are a "success." They are far better than the mass-produced houses now being designed and built by architects. But we must recognize that this is not only because the families designed them for themselves. It is also because they used a "language" which made it possible for them to represent their feelings accurately in the layout of the houses.

One final note. People sometimes wonder if the principle of individual house design makes sense in a world where dwellings are changing hands so often, in a world where people move all the time. If one family designs a house, and another family moves into it, later, three years later . . . is this house, designed by one family, and then occupied by another, still compatible with the principle? Does it make sense for the second family? Would it not make more sense to have standardized houses, since the long-term occupancy is so unpredictable?

The principle of individual house design does make sense even under these conditions. If we examine the real-estate market, we find that the houses which command the highest prices are the ones which are unique, which have charm, which have character, which stand alone. These houses, many of them built years ago, have the charm (and *value*) which they have, precisely because they were designed by some particular group of

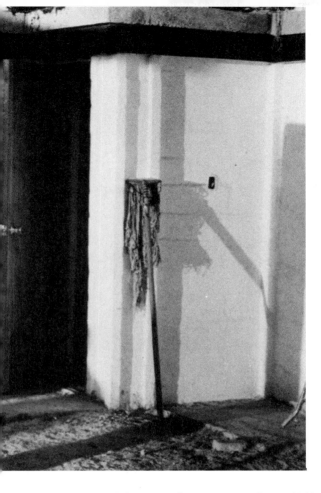

people. The fact that some entirely different family is now moving in does not alter the fact that these houses are more human because they are based on a human reality—and that it is *this* which makes them valuable.

Another way of looking at the same thing is this: if we imagine the variety of houses available to be extremely great, corresponding to the range of variety that exists in actual families, we then see that a family which

buys an existing house has a far greater choice. It can choose from among a huge variety of houses, which differ in psychological qualities and peculiar character—and the situation where all this variety exists on the market gives people the opportunity to find a house which corresponds to their idiosyncrasies and special needs, much more than anything they can choose from now among the small range of limited, standardized houses.

So the principle of individual house design creates more humanness, more opportunity for a close relation between house and family, even when many families are buying or moving into houses which other families have made.

And, of course, it is also true that the process in which families design their own houses, because it does create such a close bond, also *reduces* the extent to which the families desire to move. It slows down the race in which people tramp from house to house. It settles them. It tends to help society to settle down, and to maintain community.

CHAPTER 5

STEP-BY-STEP CONSTRUCTION

THE PRINCIPLE OF STEP-BY-STEP CONSTRUCTION

Imagine, now, that each family has laid out their own house for themselves, so that each one is marked out on the ground with stakes or stones or chalk marks.

How is it possible that all these houses, with their great diversity, can be produced in a simple and orderly manner which does not cost more than usual?

In the process we are defining, the different houses, laid out by different families, are not built from a system of "standard" drawings or from a system of standard "components," but are instead governed by a system of operations to be performed one after the other, step by step.

These individual steps or "operations" are so defined that they can be applied freely to each plan (provided that it follows certain minimal rules), and will, when properly executed, make a complete and structurally sound building from each plan, without the need for working drawings of each building.

The process is therefore capable of allowing mass production of large numbers of houses which are all different, without increasing cost.

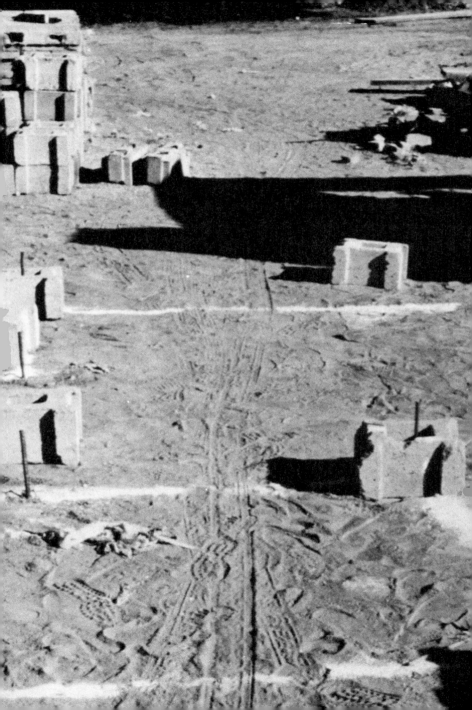

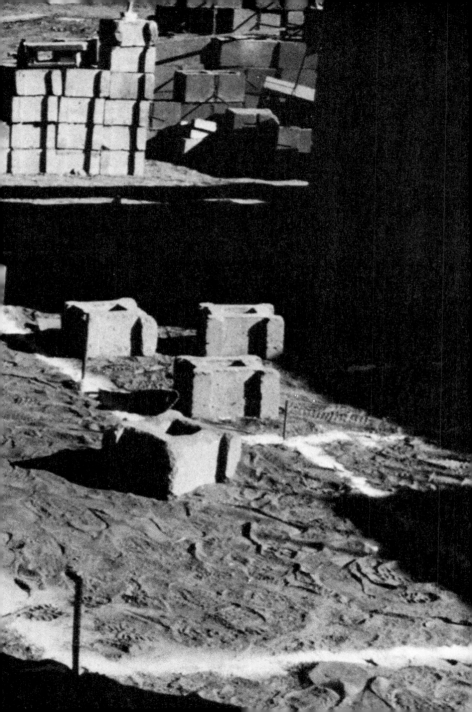

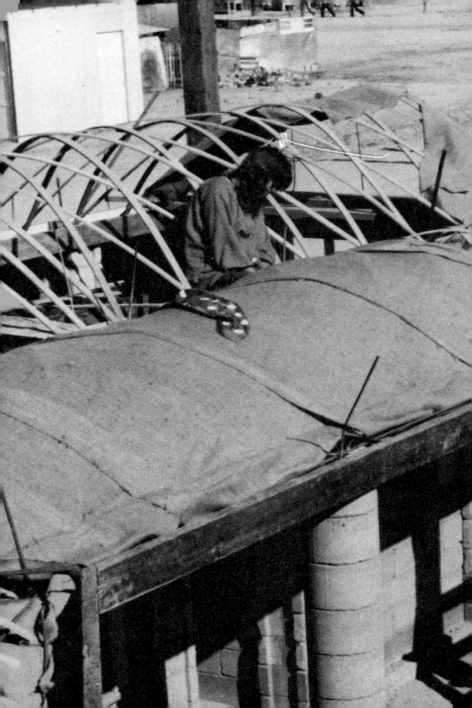

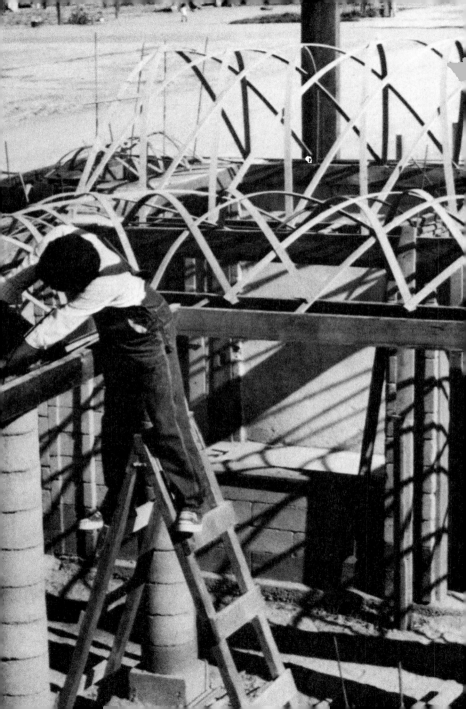

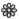

Today's systems of housing production almost all rely, in one form or another, on standardized building components. These components may be very small (electrical boxes, for instance), or intermediate (2x4 studs), or very large (precast concrete rooms); but regardless of their size, buildings are understood to be *assembled* out of these components. In this sense, then, the actual construction phase of the housing production process has become an assembly phase: an occasion where prefabricated units are assembled, on site, to produce the complete houses.

It has been little understood how vast the effect of this has been on housing: how enormous the degree of control achieved, unintentionally, by these components and by the demands of their assembly. Yet, as anyone who has intimate knowledge of building knows, these components are merciless in their demands. They control the arrangement of details. They prohibit variation. They are inflexible with respect to ornament, or whimsy, or humor, or any little human touch a person might like to make.

It is said sometimes that, given our industrial age, these components are unavoidable, that they are the carriers of the wonders of industrialization. Yet, this is not true at all.

A house is an organic system, like a living creature. Its fabric cannot be properly adapted to its needs and functions unless the process of adapting goes all the way down to small details. In one house a certain shelf makes sense; in another it doesn't. In one house two columns make a basis for a seat; in another house these columns should be differently connected. In one house a front door is narrow; in another, wide. In one house the edge of the roof is higher, because that particular house has a place where people sleep on the roof; in another house steps make a place to sit and the base of the house, because the garden is so beautiful.

In short, the detailed adaptation of a house to its inhabitants must go all the way down to the details of construction; it cannot stop short, in the *plan*. Present methods of housing production make such adaptation impossible. Standard components, attached by standard connections, are assembled by workmen and crane operators who know nothing about the houses, have no feeling for what is going to happen in them, and cannot possibly adapt the details of construction to fit the needs of the inhabitants. And it is not only the process of construction that is at fault, but the techniques of construction, too: large panels, prefabricated components, dry assembly—none of them permit this ongoing daily adaptation of the building details to the building, which good design requires.

We therefore intend to replace the idea of a building system as a system of components to be assembled, with a step-by-step system of building *operations*, each one capable of making immediate, low-cost, high-speed, on-

site adjustment to the emerging building as it is being built, so that detailed control over the building's shape and details passes into the hands of the builder and out of the hands of the designer of components or of the draftsman at the plant.

In this case we define the building system in terms of the actions that are needed to produce a building, not in terms of the physical components. This does not imply that there are no physical components. Of course there are. But the components are not standardized. Instead, only the actions, or the operations, are standardized. The components, which get created by the operations, take whatever size and shape they need to, to fit perfectly into the place where they will be.

We see at once that this is a much richer idea than the idea or a building system as a set of components. Even though the building process is considered standard, because its individual operations are all standard— still the buildings which can be made of these standard operations are much richer and show a much vaster range of possible variation than combinations of modular components can ever do. And at the same time, the buildings also have a beautiful simplicity. All igloos, for example, are made by the same process. No two are alike. But they have a much more organic unity, a much subtler adaptation of each one to its circumstances, than the arrangement of modular components could ever have.

Indeed, the twentieth century is the first period in history when building *has* been based on standard *components* rather than on a standardized set of *operations*. Even the construction of the traditional Japanese house,

whose dimensions in plan are based on the standard 3'
× 6' tatami "module," is actually based on operations
in which materials are crafted individually at the house,
and allow great variety of actual plan and section. The
stone houses of southern Europe, the brick houses of
England and northern Europe, the wooden houses and
churches of Scandinavia and Russia, all are built with
a series of standard operations which allow the gradual
development of the design from the initial layout on
the ground. The largest module in a brick house is the
brick—and even bricks are friable so that they can be
cut; the wooden members are all cut to size; the plaster
can cover any dimension of wall and ceiling. The ma-
terials can adapt to variations in the design, to slight
curves in the wall, to the unforeseen need which arises
in an organic construction process to move a door two
inches this way, or a window three inches that way.

The full reasoning behind the idea that operations are
more fundamental than components is given in *The
Timeless Way of Building*—especially in Chapters 8, 19,
and 23—so we shall not repeat the arguments here.
Instead, we shall assume that the reader is familiar with
those arguments, and go on to define certain additional
points which it is necessary to understand in order to
construct such a system of standard operations.

Above all, it is certainly not enough merely to con-
ceive the building system as a set of *any* operations. In
a weak sense, even the most tyrannical modular build-
ing system is *also* a set of operations—but this does very
little good for the buildings it produces. The building
system will produce organic buildings, good buildings,
buildings whose parts are well adapted to the whole,

only when the particular operations it contains meet certain very definite critiera. We have identified four of these criteria:

1. The operations do not impose dimensional constraints on the plan of the building. Instead, they create parts which are adapted in size to the place where they occur.
2. The sequence of operations *generates* the building from a rough layout designed directly on the ground; it does not merely fill in the physical reality of a previously detailed design.
3. The building operations are consistent with the patterns used to lay out the house plan.
4. Each operation is complete in itself, and is felt as a psychological fact of "accomplishment" when it is completed.

In the pages which follow, we shall explain the basis for these four criteria. Then, in the pages beyond that, we shall define the actual step-by-step operations we used to build the houses in Mexicali.

Criterion *1: The operations do not impose dimensional constraints on the plan of the building. Instead, they create parts which are adapted in size to the place where they occur.*

It is obvious from the foregoing discussion that this is the first and most essential requirement.

The great weakness of the modular components is that a plan gets distorted when it is rearranged to fit the

modularity required by the components. For example, on a four-foot planning grid, a passage has to be four feet wide. But a passage that feels right in a particular place may be just 3′3″ or 2′11″ wide. If it has to be widened, it loses its feeling. Not only that. If the rest of the house has all been laid out, and the passage has to be widened to four feet, the rest of the plan will literally be torn apart: each space will have to have a slightly different proportion, and therefore a different feeling from the one that was originally laid out. In some cases, topological "tearing" will actually change basic adjacencies in the plan—and as we all know from experience laying out gridlike plans on paper, the grid will then ultimately control the plan entirely.

It is therefore essential that the plan's dimensions can be left exactly as they are—and that the building processes are fluid enough to make this possible.

(Incidentally, this is achieved, in part, merely by the sequence of patterns given in *A Pattern Language:* COLUMNS AT THE CORNERS, PERIMETER BEAMS, CEILING VAULTS, etc., which generate coherent structures without imposing distortions on the layout. See also, once again, *The Timeless Way of Building,* Chapter 23.)

Criterion 2: *The sequence of operations "generates" the building. It does not merely fill in the physical reality of a previously detailed design.*

In order to understand this criterion as clearly as possible, let us compare two rather different cases.

In one case, imagine a building which we have understood so perfectly before we begin construction that

the actual process of construction is not creative at all. We merely fill in the details that have already been thought through in ultimate detail at the drawing board.

Compare this with a second case, in which, at the time we start construction, we only have a partial, imperfect picture of the building. In this case, as we complete the different building operations, each one sets down new details which open the door to some further understanding which we need in order to know exactly how to perform the next operation in the sequence.

In the second case, we may say that the building operations "generate" the building, because they are creative: they produce things which were not known before they were done; each one adds some extra dimension, some extra detail, to the conception of the building. On the other hand, in the first case, we cannot say that the building operations "generate" the building, because the operations are essentially passive, blind; they add nothing to the conception of the building, because that existed completely before construction began.

To a person who knows little about construction, it might seem that the first of these two alternatives is more desirable than the second. After all, if the building is perfectly understood from the moment that construction begins, it sounds as though there must be some kind of special perfection there—and this *seems* like a desirable thing.

In fact, however, this kind of rather mechanical perfection is very naive. It is, really, a mark of an unusual kind of simplicity—and not a good kind. Any builder who has long experience of construction knows that the

most beautiful details, the most satisfying arrange-
ments, cannot be predicted ahead of time, but arise as
spontaneous, often ingenious reactions to the particulars
which are encountered in the biilding site *during* con-
struction.

But, of course, this ad hoc process of construction,
which elaborates details as they are needed, according to
their local circumstances in the building, only works
when the process of construction itself has a certain nat-
ural grace or elegance. It cannot be done in just any
building process, because it can far too easily lead to an
endless series of mistakes, problems, and complications,
which will increase cost, slow down construction, and
even cause serious difficulties in the building.

This happens because, in a typical building process,
the operations interlock in rather complicated ways.
When doing one operation, it is usually necessary to be
worrying about other future operations, to make "room"
for them ahead of time. Thus, for instance, while
building a foundation, it will typically be necessary to
leave room for plumbing pipes, think through the exact
location of drains, think ahead to variations in the
thicknesses of walls that will be built much later, and
so on.

The need for this kind of "looking ahead" has a very
damaging effect on the construction process. For, since
the possibility of mistakes produced by this complexity
is a familiar fact of experience, people try to avoid the
mistakes simply by building the same house over and
over again, with all the details exactly the same as in a
previously built house. If the way an electrical conduit
fits neatly into the ceiling of a closet is to be useful in

another house, then this other house must have exactly the same closet, and exactly the same electrical circuits—exactly the same—since even slight changes will create a new situation, with unpredictable and often unprecedented difficulties.

Thus, the prospect of this kind of difficulty exerts a powerful pressure towards standardization of plans. It strongly encourages builders to build the same houses or apartments over and over again, even in their details, so that mistakes will not occur.

Yet, we are committed, by the arguments of Chapters 3 and 4, to a process in which plans are different, in which each house, as it is built, is—in its plan—unlike any house that has been built before. If we are to avoid the mistakes which occur because of confusions among different operations, we must have a building system in which these mistakes just do not occur, even when houses all have different plans.

This requires a system of operations in which the operations have a certain very special property: *namely, that we can complete each operation by itself, paying attention only to it, secure in the knowledge that the operations which follow can always be done, because it is their nature to be able to adapt themselves to the results of the operation already performed.*

Consider an example: the formation of a vault over a room. In the construction system in Mexicali, each room has a vault. This vault is made of concrete hand trowelled over burlap, which has been stretched over a wooden basket woven to the configuration of the room. Now this series of operations has the property that we can lay the room out to whatever shape is dictated by

its plan, without having to worry about the way the ceiling works, because no matter what exact shape the room takes, the ceiling can always be woven to fit it.

The same goes for the operation which fits the walls to the corners. When we place corner blocks to define the corners of a room, we are certain that we can always "stretch" a wall of wall blocks between the columns, because the blocks can be cut into the notches in the corner blocks. It is not, therefore, necessary to worry about the exact dimension of the wall, at the time we mark its corners—only about the corners themselves— because we are certain that the walls can be fitted to the corners afterward.

This is what we mean when we say that the sequence of operations "generates" the building. Each operation can be performed freely, to develop the products of the earlier operations, without complicated forethought.

And this kind of process is not only practical—or beautiful in a practical way. It is also a source of art and inspiration. A process which has this generative simplicity always allows a free building to be made, because the building grows slowly, step by step, the way a living organism grows—with no contortions having to be made along the way. And the result is simple and pure.

Criterion 3: The building operations are consistent with the patterns used to lay out the house plan.

When people use the pattern language to design their houses, the houses are different from most housing we know today, not only in the overall arrangements of

plan, but also in the specific shape of rooms, the heights of ceilings, the existence of alcoves and thick walls, the finest details of construction—the windows, and trim, and ornament.

Many of these patterns, discussed at length in *A Pattern Language,* are impossible to achieve cheaply with the construction systems used nowadays. The cost of stud framing, for example, is increased greatly when ceiling heights are varied or if walls meet at angles different from right angles. The thin walls do not encourage the building of window seats or alcoves or deep window reveals. Indeed, almost everything about the construction systems that are used today promotes uniformity and flatness and antiseptic smoothness—while the goal of many of the patterns is greater richness, more indentations and projections, surfaces which are less mechanically "perfect" and more finely tuned to local circumstances.

A building process which is consistent with the pattern language must therefore allow for simple and cheap construction of all the patterns which a family may use in their house layout. For example, the building system must allow ceiling heights to vary from room to room— higher ceilings over bigger rooms, lower ceilings over smaller rooms (ceiling height variety). It must allow for the pattern THE SHAPE OF INDOOR SPACE, which states that room angles need to be roughly, but not exactly, ninety degrees. It must allow for alcoves, window places, and thick walls, all built into the original structure of the house. It must allow for the pattern STRUCTURE FOLLOWS SOCIAL SPACES, which requires that the load-bearing structure of a building be con-

gruent with its social spaces—and therefore implies that a modular structural grid will most probably not be appropriate. It must allow for WINDOWS WHICH OPEN wide, and SMALL PANES of glass, and ornament. And it must allow for all these things easily—not as "extras," but as a normal part of the process.

Criterion 4: Each operation is complete in itself, and *is felt as a psychological fact of "accomplishment" when it is completed.*

These houses are not industrial products, in the normal sense, but human products. Whether the families themselves work on the houses or not, we intend the richness of the houses to be produced by the love and care with which they are made—either the love and care of the builders, or of the families, or both.

We have found out that this is affected very greatly by the psychological closure of the operations.

Compare, for example, the process of placing corner stones with the process of building the formwork for a foundation—both ways of starting the foundation of a house. In the literal sense, both are operations. But when the corner stones are placed, the person who does it has an immense feeling of accomplishment. A stage has been reached. The building has advanced another step. He feels complete when he has done it. By contrast, building the formwork for a foundation is a relatively shallow experience. The formwork can be finished, of course. But when it is finished, what has been accomplished? Something, certainly, but not quite so much. There is little exhilaration that goes with it.

Or compare a process in which walls and columns are all erected together, as one continuous structure, with a process in which there are two distinct operations: "erecting columns" and "placing the walls between the columns." Both processes can be equally practical. But there is an emotional crispness, a cognitive satisfaction, which comes more from the second than from the first, because distinct, attainable things have been done which contribute to the rhythm of the building process.

As far as possible, we believe it is important that the operations in a building process be conceived, defined, and cut apart in such a way that each one has this sense of completion, this exhilaration, this emotional crispness.

We should note, finally, that the operations which have this emotional crispness and integrity to the greatest degree are not only complete, integral, in themselves, but are also made up of smaller operations (suboperations) which have this same emotional completeness in *themselves*.

The process of making a slab is an operation of this kind. It is easy to understand and complete in itself, of course. There is a great sense of personal satisfaction when it is done. But, also, within this unitary operation, there are subsidiary units which, once again, have these same attributes. In our particular case, the slab operation consisted of the following smaller operations:

1. Placing tierra limo (fine sand) to the right level, and cutting beams in it.

2. Placing rebars and mesh.

3. Pouring the slab, screeding it to a rough level, and floating it.

4. Scattering the fine mixture of red oxide, cement, and sand on the still wet slab.

5. Trowelling to a hard finish, two hours later.

Each of these operations is itself a source of satisfaction when completed; it is itself a unit of accounting, a unit of time, and an element in the process. And the rhythm of the larger process is easily made up of these smaller units of rhythm, so complete within the larger units that they make the larger operation feel complete.

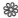

In the next few pages, we present the construction operations that we used in our houses in Mexicali. As we shall see, these building operations meet our four criteria very well, and thus satisfy the principle of step-by-step construction very strongly.

However, we must make it clear that we in no way consider these *particular* operations to be of special importance. They *embody* the principle of step-by-step construction very well, and they conform to the criteria just discussed. But of course any other system of step-by-step construction which meets these criteria would do just as well; and, indeed, in other contexts (other countries, climates, etc.) it would be absolutely necessary to develop other, comparable steps.

STEP-BY-STEP CONSTRUCTION

BUILDING OPERATIONS FOR MEXICALI

1. LAY OUT STAKES
2. EXCAVATE AND NEUTRALIZE SOIL
3. PLACE CORNER STONES
4. PLACE WALL FOUNDATIONS
5. PREPARE SLAB
6. PLACE UNDER-SLAB PLUMBING
7. POUR SLAB
8. ERECT COLUMNS
9. ERECT WALLS BETWEEN THE COLUMNS
10. INSTALL DOOR FRAMES
11. BUILD PERIMETER BEAMS
12. WEAVE ROOF BASKETS
13. ERECT GABLE ENDS
14. INSTALL ELECTRICAL CIRCUITS
15. PLACE ROOF FIRST COAT
16. PLACE ROOF TOP COAT
17. INSTALL WINDOW FRAMES
18. BUILD AND INSTALL WINDOWS
19. BUILD AND INSTALL DOORS
20. INSTALL PLUMBING
21. INSTALL ELECTRICAL
22. PAINT WALLS, ROOFS, AND TRIM
23. LAY BRICK FLOORS ON WALKS
 AND ARCADE FLOORS

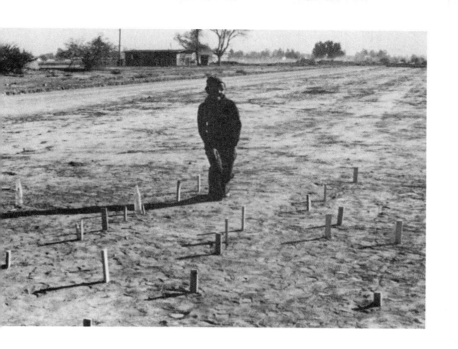

1. LAY OUT STAKES

1. *Place column blocks.* Place a column block at each corner and on each side of doors.

2. *Place wall blocks.* Place wall blocks between column blocks, and adjust column block positions to allow each wall to be made of an integral number of whole and half blocks.

3. *Straighten lines and angles.* Adjust blocks until each wall is an integral number of blocks or half blocks, with the plan disturbed as little as possible. (This does *not* require right angles in all corners.)

4. *Place stakes.* Replace corner blocks with 18″ #3 rebars, hammered deep into ground so that excavation will not disturb them.

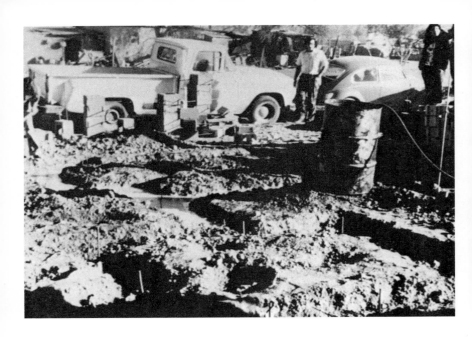

2. EXCAVATE AND NEUTRALIZE SOIL

1. *Excavate trenches.* Dig trenches, 8″ deep, along center lines, to form wall foundations, 12″ wide at top, 8″ wide at bottom.

2. *Pick earth.* Use pickaxes to loosen soil in center of slab area and at bottom of trenches, to a further depth of 8″; loosen soil, and prepare for flooding.

3. *Flood with lime.* Flood with a 5 percent lime solution.

4. *Wait five days.* Wait for the lime solution and mud to dry out.

5. *Compact.* Compact and reform approximate shape.

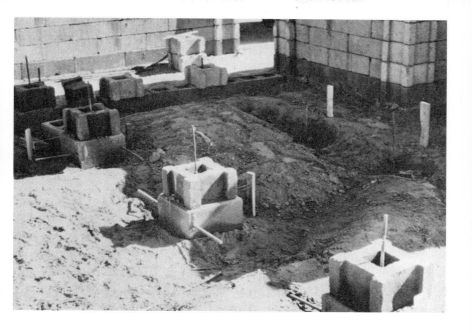

3. PLACE CORNER STONES

1. *Choose level.* Choose a finish floor level.

2. *Place tierra limo.* Place a base of tierra limo at each column position, to bring blocks to level of #1.

3. *Place blocks.* Place each block over a stake already in the ground.

4. *Level blocks.* As you place each block, use a line level to get it level with the previous block; then use carpenter's level to check the top of the block level in both directions.

5. *Check levels.*

6. *Place column block.* Once blocks are level, start putting a concrete column block over each foundation block.

7. *Place rebars.* Place an 18″ #5 rebar in each column, so that it projects at least 7″ above the top.

8. *Fill blocks.* Fill blocks with a 1:9 concrete.

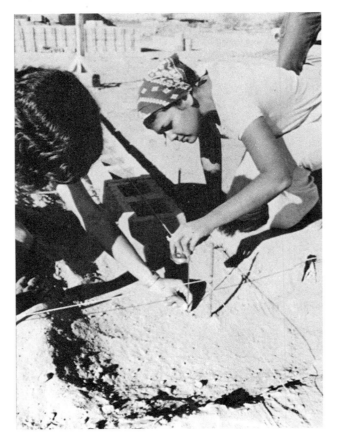

4. PLACE WALL FOUNDATIONS

1. *Place foundation blocks,* to form a line along wall line, with rebars pointing inward.

2. *Level blocks.* Level with tierra limo to the level of the corner foundation blocks.

3. *Place red wall blocks.* Place one course of red wall blocks, interlocked with corner blocks.

4. *Insert rebars.* Place one #3 rebar in alternate cores.

5. *Fill cores.* Grout cores with 1:9 mix. Fill the core halfway up the upper block.

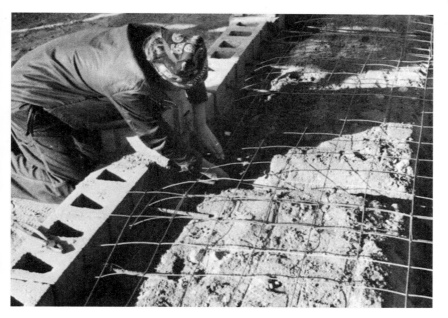

5. PREPARE SLAB

1. *Place lines.* Tie the lines across the foundation blocks to indicate a level that is 2″ below the top of the finished slab level.

2. *Fill with tierra limo.* Fill with tierra limo to the level of the lines.

3. *Compact well.* Compact and fill until the material is solid.

4. *Cut beams.* Use a steel trowel to cut ground beams out of the tierra limo.

5. *Cut extra beams.* Now, in any slab which has a length of more than 8′, cut extra beams to divide it into sections.

6. *Place rebars.* Cut and shape **#**3 rebars for the beams, and place them 4–5″ below the slab top.

7. *Place wire mesh.* Cut and place wire mesh. Tie the mesh to rebars at edges, and secure overlaps in the mesh.

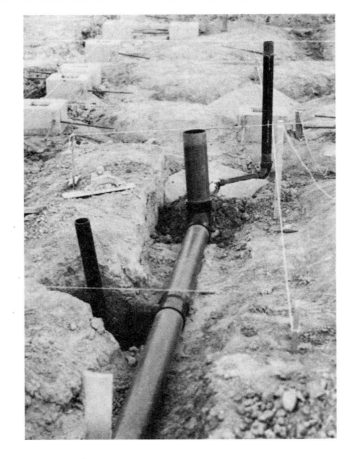

6. PLACE UNDER-SLAB PLUMBING

1. *Plot drain lines.* Get horizontal and vertical positions, with fall, elbow, and manhole positions.

2. *Buy pieces.* Buy lines, joints in ABS pipe.

3. *Assemble pieces.*

4. *Dig holes in positions.*

5. *Place pipes.* Prop them in position, using tierra limo fill to hold them steady.

6. *Backfill.* Fill holes with tierra limo.

7. *Cover tops.* Tie plastic over open tops, to prevent concrete from entering during the slab pour.

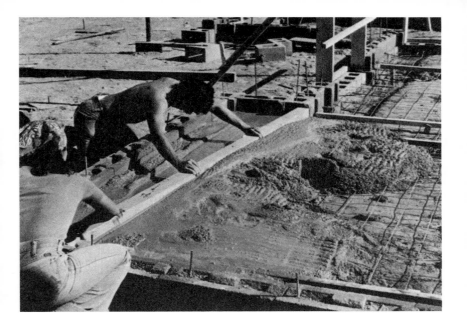

7. POUR SLAB

1. *Place mixers.*

2. *Prepare wheelbarrow runs.*

3. *Wet tierra limo.* Immediately before pouring each section of slab, wet it thoroughly until water stands on surface. This must be done immediately before the pour, so the tierra limo is still wet when concrete arrives.

4. *Pour concrete.*

5. *Screed concrete.* Using the top of wall blocks at edge, and special 2x4 screeds, level off the concrete.

6. *Float concrete.* With aluminum or wood floats.

7. *Scatter red oxide.* Use a sieve to scatter a mix of red oxide, cement, and sand, on the wet slab.

8. *Wait two hours.*

9. *Trowel surface.* With steel trowels, finish to a perfect surface.

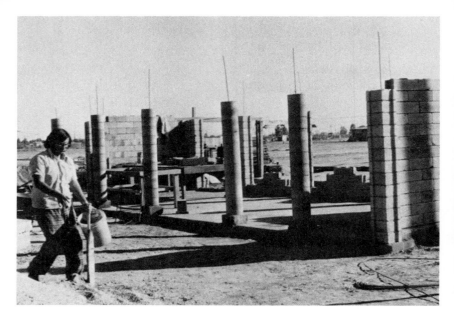

8. ERECT COLUMNS

1. *Clean bottom block.*

2. *Tie rebars.*

3. *Stack blocks.* Stack in groups of twelve, next to each column.

4. *Clean blocks.*

5. *Place blocks.* Check plumb and level of column, and of the top block at each stage. If not perfect, turn the block through 90, 180, or 270 degrees until it is perfect.

6. *Wet blocks.*

7. *Fill blocks.* After six blocks, fill with 1:9 concrete.

8. *Place blocks.* After 4 hours, continue placing the blocks on column.

9. *Wet blocks.*

10. *Fill blocks.* Fill the top six blocks.

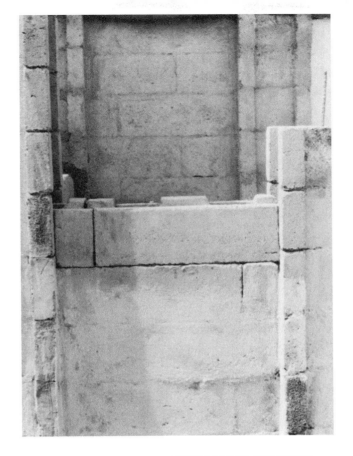

9. ERECT WALLS BETWEEN THE COLUMNS

1. *Chalk rebar positions.* Do this so that it is clear which holes to put rebars in when wall is built.

2. *Cut blocks.* Cut to size on cutter, and file smooth.

3. *Place blocks.* Place each block with a back-and-forth motion until it beds down.

4. *Fix windows.* After the fourth course, decide on window openings and variants in sill height.

5. *Place rebars.* In holes marked by chalk marks (see #1, above).

6. *Fill rebar cores.* Wet cores, and fill with a wet 1:9 mix, well compacted.

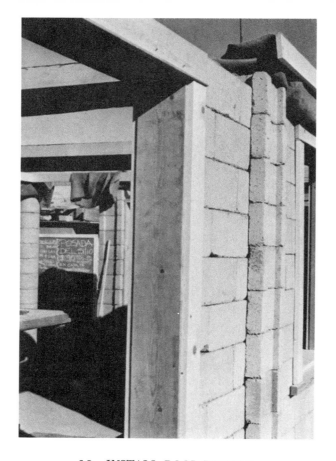

10. INSTALL DOOR FRAMES

1. *Calculate dimensions.*

2. *Cut lengths. Cut header.*

3. *Rout header.* Rout to fit vertical side pieces.

4. *Install expanders* (blocks of wood in column). Reposition frame and nail header.

5. *Drill for lag bolts.* Drill through side pieces with a ⅜ drill and countersink with 1″ drill.

6. *Attach lag bolts.* Install lead and lag screw, keeping frame vertical.

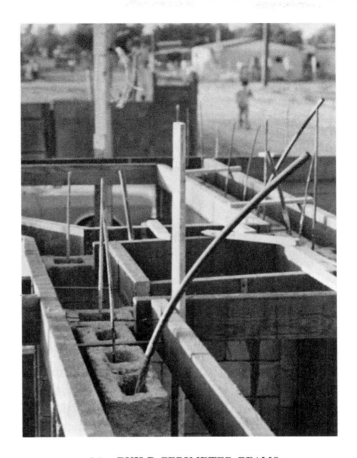

11. BUILD PERIMETER BEAMS

1. *Inventory beam lengths.*
2. *Cut 2x6's.*
3. *Nail 2x6's together at the tops with 1x2's.*
4. *Set beams in place.*
5. *Close ends together to close perimeter.*
6. *Nail U-frames* in place, moving around each room.
7. *Close underside.* Use pieces of scrap 1x4's over walls, and 1x10's over windows, and clear spans.

12. WEAVE ROOF BASKETS

1. *Set 1x2's.* Place a 1x2 along beam, 2 inches in from the inner edge, to form a trap for basket. Attach to U-rings with wire.

2. *Mark basket positions.* Make pencil marks at equal intervals, approximately 18" apart.

3. *Soak strips.* Soak strips in water until they are soft enough to bend easily.

4. *Weave basket.* Weave a diamond lattice, with each alternate piece crossing under and over.

5. *Nail crossings.* Nail each crossing from above, using a second hammer underneath to steady. Start with center line and work toward the beams.

6. *Place reinforcing.* Place #3 rebars in every beam.

7. *Fill beam.* Fill the beam up to the top of the 2x6, so that it catches the bottom of all basket strips and holds them firmly.

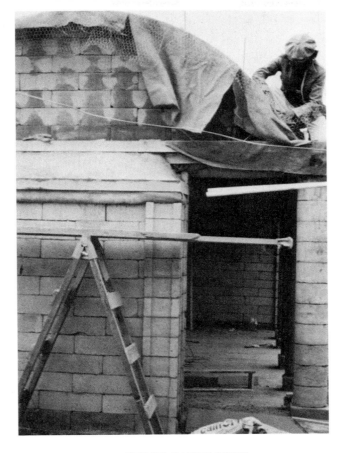

13. ERECT GABLE ENDS

1. *Place blocks.* Place blocks over end beams to form a gable with the same profile as the basket. Cut blocks to be shorter than the curve.

2. *Fill angles.* Fill angles with stiff concrete/mortar to round blocks off to a correct curve.

3. *Leave vent holes.* Leave vent holes in the gable to allow air to escape. As high as possible.

4. *Place rebars.* Place extra rebars to come to the full height of the cells.

5. *Fill cells.*

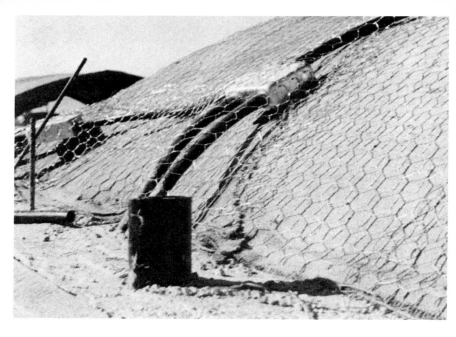

14. INSTALL ELECTRICAL CIRCUITS

1. *Plan circuits.* Each house should have at least four circuits: for the kitchen, refrigerator, living area, and bedrooms.

2. *Connect junction boxes.* Connect junction boxes to the tops of the vertical tubes, above the basket.

3. *Place boxes* Bend over tubes, and locate junction boxes near the bottom of the basket, with the opening facing inside. Use a flat piece of wood on the inside of the basket; tie the junction box to this wood with wire to hold it in place during subsequent roof operations.

4. *Connect ceiling boxes.* Connect boxes on the ceiling with junction boxes over switches.

5. *Place main service box.*

6. *Place conduits over baskets.* Hook junction boxes together with a ½″ conduit to the main service box.

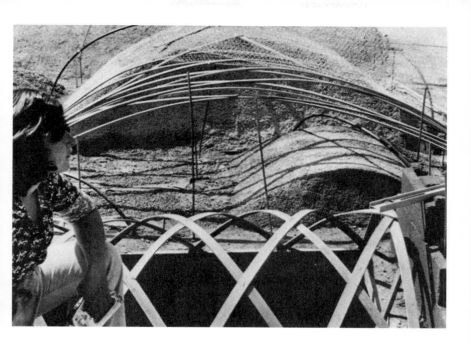

15. PLACE ROOF FIRST COAT

1. *Cut burlap.* Cut burlap in swaths which fit perfectly over the diamond lattice.

2. *Staple burlap.* Staple to the lattice strips.

3. *Cut and staple chicken wire.* Do the same with a layer of chicken wire, making sure to tie the wire down into the beam.

4. *Mix concrete.* Start an ultralightweight mix, which has 4 parts perlite.

5. *Trowel concrete.* Trowel on a coat about ¾″ thick overall working from the top outwards to the sides.

6. *Brace where necessary.* If any parts of the roof sag, brace them locally with boards and 2x4's.

7. *Cure concrete.* Wet the concrete three times a day for at least 3 days.

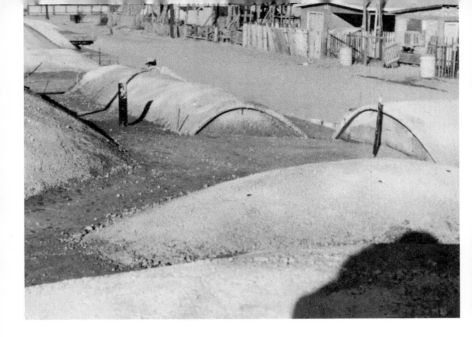

16. PLACE ROOF TOP COAT

1. *Nail cornice.* Nail a 1x4 along outside top of beam, to form cornice.

2. *Nail drip formwork.* Nail a second piece outside cornice, to make formwork for an overlapping cap.

3. *Place rebars.* Place a **#**5 rebar towards the outside of the beam volume.

4. *Bend vertical bars.* Bend the vertical bars from the wall so that they lap the beam bar.

5. *Place lines.* Place lines to guarantee a straight and horizontal roof line.

6. *Mix concrete.* Make a lightweight mix, 3 parts sand, 6 parts pumice, and 1 part cement.

7. *Trowel concrete.* Place to a depth of about 1½ inches over the previous coat.

8. *Float to a smooth finish.*

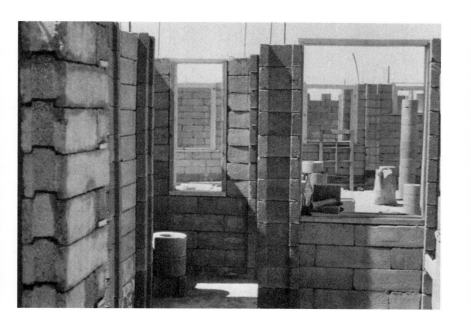

17. INSTALL WINDOW FRAMES

1. *Check light.* Check the amount of light in each room.

2. *Enlarge window openings.* Break out blocks to enlarge windows wherever necessary.

3. *Measure openings.*

4. *Order materials.*

5. *Cut pieces.*

6. *Rout and plane sill.*

7. *Assemble frame.* Nail the frame together with diagonal brace to preserve perfect squareness.

8. *Place blocks and wedges.* Nail blocks to the underside of the perimeter beam.

9. *Fit frame.* Plumb sides and nail in place.

STEP-BY-STEP CONSTRUCTION

18. BUILD AND INSTALL WINDOWS

1. *Choose format.* For each window, decide on window format: cross pieces, vertical pieces, pane size.

2. *Measure window and compute components.* Use measurement sheet to compute components.

3. *Cut components.* Cut on a table jig, to exact lengths, out of stock sizes of ⅜, 1⅛, and 1½.

4. *Assemble edges.* Glue and nail top, bottom, and sides as four separate components.

5. *Glue and clamp.* Glue and clamp the four edges together with C-clamps, taking special care with right angles.

6. *Insert muntins.*

7. *Set nails.* Punch in nails, putty, and sand.

8. *Plane edges.* Plane edges to fit window frame.

9. *Hang windows.* Mark hinge positions, chisel out, drill and screw.

19. BUILD AND INSTALL DOORS

1. *Choose format.* Decide on format of door, size of lights, and the location of transom.

2. *Measure and cut.* Choose pieces of 1x6 for stiles, rails, and transom. Cut to length.

3. *Assemble.* Assemble, glue, and clamp these major pieces.

4. *Insert stops for inserts.* Make stops of 1x1 material.

5. *Cut and place plywood inserts.*

6. *Cut and place glass inserts.*

7. *Set hinges.* Mark 12 inches from each end; set them into the frame.

8. *Install lockset.* Drill out, install lock, attach handles.

9. *Hang the door.* Mark frame, attach hinges and place doorstops.

20. INSTALL PLUMBING

1. *Calculate pipe.* Calculate required lengths of pipe to use minimum amount, and minimize places where pipes have to cross hallways and doorways. For hot water, use ¾″ galvanized; for cold water, use ¾″ PVC.

2. *Place pipe.* Run the water pipe around the base of rooms; screw it flat against concrete wall blocks with metal straps.

3. *Install shutoff valves at fixture locations.*

4. *Hook up to main water supply.*

21. INSTALL ELECTRICAL

1. *Use #12 insulated copper wire.*

2. *Cut wire to length,* leaving 6″ at ends for connections in boxes.

3. *Pull wire.* Use steel wire already in tubes to pull the copper wire through.

4. *Make connections at junction boxes.*

5. *Install fixtures.* Connect and fix in place switches, outlets, and light fixtures.

22. PAINT WALLS, ROOFS, AND TRIM

1. *Prepare walls.* Use lime plaster to fill cracks in holes, repair broken blocks, and smooth surfaces. Only use where cracks are large and unsightly. Small cracks add to texture and are left as they are.

2. *Test colors.* Do experiments at full scale to determine the range of colors to be used on walls, cornices, and window trims. Make subtle color experiments on scrap until satisfied by beauty of colors.

3. *Whitewash exterior.* We whitewashed walls with a white that has green in it, to counteract glare and to go with the blue and green cornice colors.

4. *Paint inside.* Use white latex paint on inside walls.

5. *Paint cornices.* We used shades of blue, and a golden green to paint cornice lines.

6. *Oil windows and frames.*

23. LAY BRICK FLOORS ON WALKS AND ARCADE FLOORS

1. *Lay out edges.* Mark the exact edges of all paved areas.

2. *Set floor height.* Place stakes to set floor height a few inches below slab height.

3. *Excavate.* Dig out earth to a level 4 inches below finish height.

4. *Place tierra limo base.* Place 2 inches of tierra limo, moisten, and compact and level.

5. *Place bricks.* Lay bricks in tierra limo, in regular patterns, herringbone, or alternating squares.

6. *Fill cracks.* Pour sand between cracks, wet down, pour sand, wet down, and repeat until the path surface is dense and compact.

We finish this chapter with a discussion of the problem of permission. Under normal circumstances, the process by which a building receives a building permit requires a set of drawings for the building, complete with details and specifications.

Within the process we are describing here, such a procedure is, of course, impractical and self-defeating. Since each house is different, the production of architectural drawings for each one would greatly increase the cost of the houses. Furthermore, and perhaps more crucial, the need to make a set of drawings will inevitably encourage the draftsman to introduce all kinds of harmful changes in the drawings—straightening of lines, smoothing out of oddities, little injections of "style"— all of which are merely the result of the fact that the draftsman has to feel that he has put "something" into the buildings. All these "somethings" merely take the building further away from the original intention of the family who laid it out. They serve no useful purpose, but only make the building layout worse.

Nevertheless, most cities and local governments maintain the right to issue building permits, in order to protect the people who use the buildings from shoddy or dangerous workmanship. And it is certainly reasonable that a community should feel secure in the knowledge that every building meets certain reasonable standards of structural safety.

In order to meet the requirements of local building permission, but in a way which avoids the use of expensive and destructive working drawings for every building, we believe that it is quite possible for a government building inspection department to issue a per-

ORIGINAL FOUNDATION SYSTEM

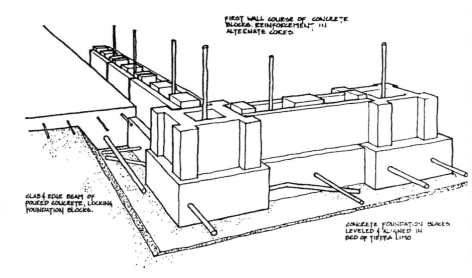

FIRST WALL COURSE OF CONCRETE
BLOCKS. REINFORCEMENT IN
ALTERNATE CORES

SLAB & EDGE BEAM OF
POURED CONCRETE, LOCKING
FOUNDATION BLOCKS.

CONCRETE FOUNDATION BLOCKS
LEVELED & ALIGNED IN
BED OF TIERRA LIMO

mit to a building *process* (that is, to a set of building operations, as we have defined them), and thereby to give permission, automatically, to every building that is built according to these operations and that also meets certain minimal rules of layout.

This is exactly what we did in Mexicali. We submitted a description of the building operations to the Public Works Department. The Chief Engineer of the Public Works Department asked for certain minor modifications in the location and spacing of reinforcing bars. Once we had made these changes, he approved the process.

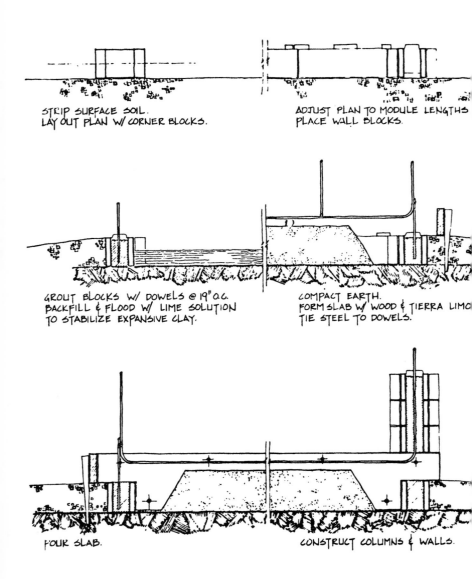

REVISED FOUNDATION SEQUENCE.
A SERIES OF TRANSPARENT OPERATIONS

STRIP SURFACE SOIL.
LAY OUT PLAN W/ CORNER BLOCKS.

ADJUST PLAN TO MODULE LENGTHS
PLACE WALL BLOCKS.

GROUT BLOCKS W/ DOWELS @ 19" O.C.
BACKFILL & FLOOD W/ LIME SOLUTION
TO STABILIZE EXPANSIVE CLAY.

COMPACT EARTH.
FORM SLAB W/ WOOD & TIERRA LIMO
TIE STEEL TO DOWELS.

POUR SLAB.

CONSTRUCT COLUMNS & WALLS.

BASIC INTERLOCKING BLOCK SYSTEM

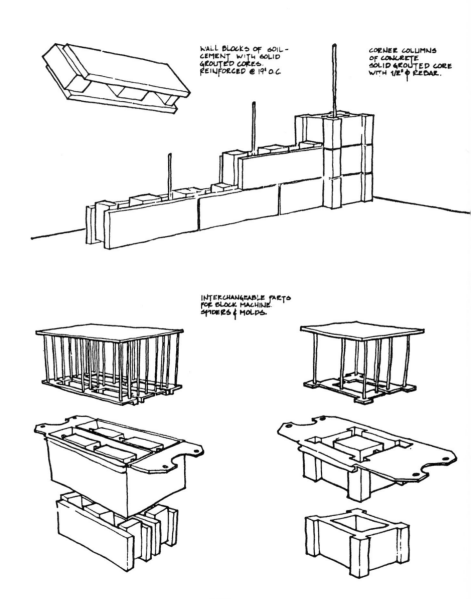

WALL BLOCKS OF SOIL-
CEMENT WITH SOLID
GROUTED CORES.
REINFORCED @ 19" O.C.

CORNER COLUMNS
OF CONCRETE
SOLID GROUTED CORE
WITH 1/2" Φ REBAR.

INTERCHANGEABLE PARTS
FOR BLOCK MACHINE.
SPIDERS & MOLDS.

259

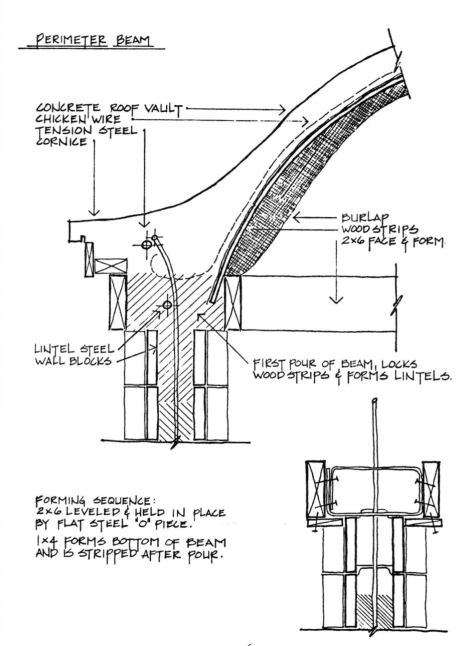

Perimeter Beam

CONCRETE ROOF VAULT
CHICKEN WIRE
TENSION STEEL
CORNICE

BURLAP
WOOD STRIPS
2×6 FACE & FORM.

LINTEL STEEL
WALL BLOCKS

FIRST POUR OF BEAM, LOCKS
WOOD STRIPS & FORMS LINTELS.

FORMING SEQUENCE:
2×6 LEVELED & HELD IN PLACE
BY FLAT STEEL "O" PIECE.

1×4 FORMS BOTTOM OF BEAM
AND IS STRIPPED AFTER POUR.

260

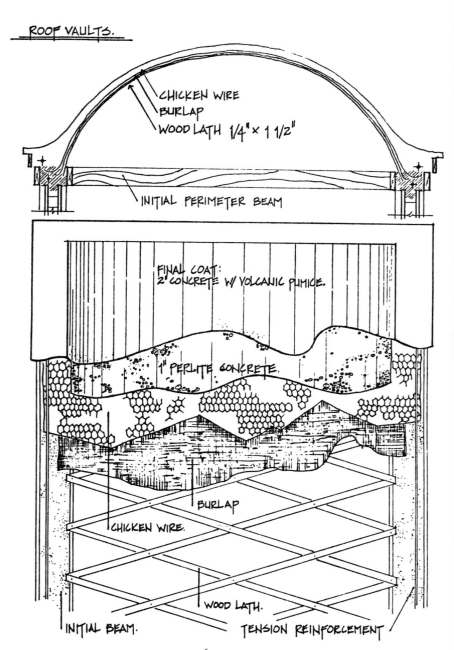

ROOF VAULTS.

CHICKEN WIRE
BURLAP
WOOD LATH 1/4" × 1 1/2"

INITIAL PERIMETER BEAM

FINAL COAT:
2" CONCRETE W/ VOLCANIC PUMICE.

1" PERLITE CONCRETE.

BURLAP

CHICKEN WIRE.

WOOD LATH.

INITIAL BEAM. TENSION REINFORCEMENT

261

From that moment on, the *individual* buildings did not require building permits. The plans had to meet the following important conditions: (a) no clear span beam with the cross section specified in the operations could span more than six feet; and (b) no vault could span more than fifteen feet. But beyond that, the houses were built without specific permission being given to individual houses or to house plans. It was never necessary to go to the expense of having drawings made nor to run the risk of distorting the families' layouts by making drawings.

Each building in our process was therefore under construction within a few days of the time when it was first laid out!

Furthermore, we ourselves did not make any plan or drawing of any house at the time of its construction, even for our own use. To make a set of drawings would have been impossible, since each building was not known in detail until after it had actually been built. Also, the loss of time created by the drawing of plans and by the obtaining of permission would have killed the process stone dead.

It is essential to recognize that, as a precondition for its success, this process absolutely requires an agreement with the local government whereby permission is given to building operations, not to individual building plans.

CHAPTER 6

COST CONTROL

THE PRINCIPLE OF COST CONTROL

In view of the facts that every house is different, that there are no precise building plans before construction starts, and that the buildings evolve and change during the process of construction, we propose a new system of cost control that is adapted to this much greater richness and is capable of keeping costs below certain fixed limits, in spite of the evolution, changes, and modifications that take place during construction.

This cost control is achieved essentially by making sure that both materials and labor are paid for in a way that is exactly parallel with the system of operations that constitute the building process, and is controlled by its relation to the steps of this process, one step at a time.

Our experience has shown that with this system of cost control, it is possible to hold down the prices of the buildings to a firm cost per square meter which is lower than the typical square-meter cost for housing of comparable finish.

The reader may be surprised to find cost control as the subject of a chapter, and thus given importance equal to the other principles enunciated in earlier chapters. However, it is essential to realize that a large part of the uniformity of houses in today's society, in today's tracts and urban prisons, the drab repetition of box after box after box, is created by problems of cost, *and that these problems of cost are, in large part, problems of cost control.*

Obviously, cost is essential. No buildings can be built without immense attention being paid to their costs; and in the field of housing, it is usually important to keep these costs down to an absolute minimum.

Costs are reduced, in large part, by standardization. But the fact that every house in a row of houses is the same does not reduce costs because it reduces the materials in the building. The quantities of materials are the same as they would be if all the houses were different. And it does not really reduce costs by reducing the labor. For if the operations are smooth enough, the cost of labor depends only on the total volume of the operations, not on their configuration (see discussion below).

In fact, "low-cost" houses and apartments are usually made identical because the cost of *administration* would increase enormously if they were all different. Put

bluntly, it would be a headache for administrators if the houses were all different.

Administration has three parts: cost of design, cost of permissions, and cost of on-site administration.

Now, we have already shown in Chapter 4 that the cost of design in our process is no higher than usual, because "design" does not require a complete set of architectural plans, but merely a set of points marked in the ground with stakes, which is done by the families. So that part of the administration is not expensive.

Furthermore, we have shown in Chapter 5 that the cost of permission is no higher than usual, because the permission is given to the *process*, not to any individual plans. The fact that the houses are all different, therefore, need not increase the cost of permission.

But, finally, we have the problem of administering the construction contract and controlling cost. Identical houses and identical apartments are very easy to build cheaply, because, since they are all alike, the costs are easy to see, and the problem of cost control is therefore easy to manage. If each house is different, the problem of cost control—under conventional forms of cost control—would become a nightmare of administration. This one thing alone would make the task of construction almost prohibitively difficult.

The only reason we were able to construct the buildings described in this book, at a reasonable price, is that we managed the process with a system of cost control which is so flexible, so simple, and so well-adapted to the problems of variety that it can cope with different houses as easily as it can cope with similar ones.

The secret of this cost control system is that it is

perfectly congruent with the system of operations described in the last chapter. It is based on these operations; it follows these operations; and it makes sense in terms of these operations. And when the system of operations is itself being used to organize the work, on site, the problem of cost control then becomes a simple and natural minor addition to the task of organizing the operations. Thus, the backbone of the entire cost control system lies in the close connection between the operations, defined in the last chapter, and the cost accounts.

In a nutshell, the connection is the following one:

First, each operation can be "counted" in some specific system of units. Thus, for example, we measure (or "count") foundations in m^1 (linear meters), because foundation is a unit of length. Slabs are measured in m^2 (area). Windows are measured in m^2 (area). Doors are measured by the number ($\#$). Occasionally the measures are surprising. Thus, for instance, walls are measured in m^1 (length), not area, because, within this building process, all walls are the same height, and it is more convenient to measure length, ignoring window openings, than it would be to laboriously count all the exact square meters of wall.

Second, we know, by rough statistical analysis of the houses how much of each one of these operations there is per square meter of house. Thus, for example, we know that, on the average, one of these houses has 0.97 linear meters of wall per square meter of floor area. Of course, this number varies from house to house, according to its configuration. For example, a house with a very long perimeter might actually have 1.13 meters

of wall per square meter; and a compact house may have 0.84 meters of wall per square meter of house. However, after studying many typical plans that arise within the pattern language and at the rough size under construction (60–70 square meters), we were able to establish a typical number for each operation. This means that we are able to establish the quantity of each operation that is required for a house, simply as a function of the area of the house.

Third, we can make an analysis of the amount of materials that are required by each unit of operation, and we can translate this into money. This means that we know exactly how much the material in each operation costs per unit of operation.

Fourth, we can also make an analysis of the amount of labor which is required by each operation—both skilled and unskilled—and we can express this as a certain number of man-hours per unit of operation. This means that we know exactly how much the labor of each operation costs per unit of operation.

These figures are reliable enough so that we can make a detailed estimate of the price of each house simply as a function of its area. The estimate is then reliable enough for us as contractors to use it as a bid. This means that the moment a family has laid out their house, we can make a direct bid for the price of building that house simply as a function of its area.

As a result, even though the houses in Mexicali were all different, we were able to make a detailed cost estimate for the bank, the moment the houses were laid out. This estimate included the cost of tools (for the families), the cost of materials and labor, and even the

costs of improvements in the common land. In short, it included everything; and the bank made its loan to the family, in the amount required, based directly on this estimate—and within a matter of days released the funds for construction to us.

It is very important to recognize that this process was smooth and reliable. Under normal circumstances, the bank would require a detailed bid for each house, and the contractor would normally make a separate estimate for each house, since each house has its own configuration—all this leading to a complexity which tends to discourage the variety of houses which we have. However, under the circumstances of our process, we were able to pass through this initial stage in a matter of days, with no delays at all.

In order to understand this procedure more fully, we now present the following table, in which the basic relations between house area, operations, and cost are laid out.

Each operation has one row in the table. In the first column, we give the units in which this operation is to be counted (linear meters, square meters, number, etc). In the next column, we give the price per unit of the operation, in pesos. In the third column, we give the total quantity of this operation which is allowed per square meter of house. This figure is obtained statistically, as explained earlier in the chapter. In the fourth column, we give the cost of that operation per square meter of house (this is the product of the second and third columns). Finally, in the fifth column, we give the cost of each operation as a percentage of the house's total cost.

TABLE I. CONSTRUCTION OPERATIONS (materials)

	unit	unit price (pesos)	max # of units allowed/ m^2 of house	price/m^2 of house	% of total
Layout & tools	1	2800/house		37.3	6%
Excavation	m^2	8.3/m^2	1.00	8.3	1
Corner stones	#	26.6 ea	.53	14.1	2
Wall foundation	m^1	19.2/m	1.05	20.2	3
Slab preparation	m^2	9/m^2	.77	6.9	1
Underslab plumbing	1	600		8	1
Slab	m^2	18/m^2	.77	13.9	2
Columns	#	41 ea	.53	21.7	4
Walls	m^1	93/m	.97	90.2	15
Door frames	#	120 ea	.08	9.6	2
Perimeter beams	m^1	30/m	1.10	33.0	6
Roof basket	m^2	38/m^2	1.00	38.0	7
Gable ends	#	112 ea	.08	9.0	2
Electrical circuits	rooms	110/room	.10	11.0	2
Roof, 1st coat	m^2	66/m^2	1.00	66.0	11
Roof, 2nd coat	m^2	44/m^2	1.00	44.0	8
Window frames	m^2	121/m^2	.18	21.8	4
Windows	m^2	148/m^2	.18	26.6	5
Doors	#	250 ea	.08	20.0	3
Plumbing fixtures	1	3300		44	8
Electrical fixtures	rooms	85/room	.10	8.5	2
Painting	m^2	10/m^2	1.94	19.4	3
Paving	m^2	20/m^2	.30	6	1
Common land	1	500/house		6.7	1
		TOTAL (pesos)		584.2	

Since this table gives us the cost per square meter of each operation, we may now estimate the total cost of a house simply by multiplying the total square-meter price by the number of square meters in the house.

It should be understood that this analysis of cost, although reasonably accurate, is still only approximate. For example, when a house is unusually long and narrow, it will have a slightly higher total perimeter per square meter than an average house. In this case, then, the total length of wall is greater than that allowed for by our table.

However, we were able to take care of this problem by means of the following on-site procedure that was used during the construction process.

All the houses in the first cluster were built concurrently. This means that the same operation was going on in all the houses at the same time.

When the process approached a given operation, the architect-builder made a survey of each house to determine the total quantity of this operation that would be required there. Thus, for operation #5, we counted the number of columns that the house had. For operation #17, we measured the total length of wall. For operation #21, we measured the total area of window which the house was going to have.

In each case, we compared the *actual* quantity of the operation with the theoretical quantity of the operation that was allowed as a function of our theoretical table. Whenever the actual quantity was less than the amount allowed, the former quantity of material was issued to the family at the time of the next operation. If the quantity was *greater* than the amount allowed, then the

TABLE 2A. RODRIGUEZ HOUSE: 75.2 m^2 (material costs)

	pesos estimated	+ extras	actual spent
Layout & tools	2800		1048
Excavation	624		277
Corner stones	1060		910
Wall foundation	1519	+208	1356
Slab preparation	519		724
Underslab plumbing	602		843
Slab	1045	+417	1458
Columns	1632	+41	1141
Walls	6783		6416
Door frames	722	+38	808
Perimeter beams	2482		3494
Roof basket	2858		2719
Gable ends	677		907
Electrical circuits	832	+60	891
Roof, 1st coat	4963		3610
Roof, 2nd coat	3309		2403
Window frames	1639		1813
Windows	2000	+322	2267
Doors	1504		1360
Plumbing fixtures	3309	+100	3760
Electrical fixtures	639		1560
Painting	1459		990
Paving	451		305
Common land	504		1380
TOTALS	43932	+1186	42440

family was charged a surcharge for the extra materials consumed. In this way, any unusual configuration in the house that consumed a quantity of material above average had to be paid for as an extra by the family. Our agreement with the bank was such that these extras were simply charged to the family's bill—and the loan amount, which had been settled approximately, at the beginning of the construction project, was slightly in-

TABLE 2B. COSIO HOUSE: 84.6 m^2 (material costs)

	pesoes estimated	+ extras	actual spent
Layout & tools	2800	+24	1184
Excavation	702		313
Corner stones	1193		1029
Wall foundation	1709	+147	1474
Slab preparation	584		851
Underslab plumbing	677		986
Slab	1176	+209	1714
Columns	1836		1290
Walls	7631	+66	7250
Door frames	812	+77	921
Perimeter beams	2792	+185	3948
Roof basket	3215		3061
Gable ends	761		1028
Electrical circuits	931		1042
Roof, 1st coat	5584	+326	4061
Roof, 2nd coat	3722		2703
Window frames	1844		2057j
Windows	2250		2571
Doors	1692		1543
Plumbing fixtures	3722	+38	4230
Electrical fixtures	719		1356
Painting	1641		1129
Paving	508		349
Common land	500		1380
TOTAL	49001	+1072	47479

creased to include whatever extras the family consumed during the construction process.

Tables 2A–2E show the consumption of material for the twenty-four operations for each of the first five houses. In the first column, we see the quantity of each operation allowed per square meter of house (expressed in pesos). This is obtained by simply multiplying the price of the operation per square meter (from column 4

TABLE 2C. DURAN HOUSE: 65.5 m^2 (material costs)

	pesos estimated	+ extras	actual spent
Layout & tools	2800		890
Excavation	543		235
Corner stones	923		775
Wall foundation	1323		1108
Slab preparation	452		616
Underslab plumbing	524	+204	816
Slab	911	+111	1235
Columns	1421	+41	970
Walls	5908		5453
Door frames	629	+43	677
Perimeter beams	2162	+171	2970
Roof basket	2489		1413
Gable ends	589		766
Electrical circuits	720	+50	680
Roof, 1st coat	4323		3144
Roof, 2nd coat	2882		1797
Window frames	1427		1533
Windows	1742		1916
Doors	1310		1150
Plumbing fixtures	3300		3275
Electrical fixtures	557	+42	975
Painting	1271		927
Paving	393		287
Common land	500		1380
TOTAL	39099	+662	34988

of Table 1) by the total area of the house. In the third column, we see the actual quantity of this operation which was consumed by the house.

This system of accounting, because it was tied in precisely to the cost and performance of the individual operations, meant that there was no possible way in which materials could be wasted. Each family received exactly the quantity of materials that was required to

TABLE 2D. REYES HOUSE: 76.0 m^2 (material costs)

	pesos estimated	+ extras	actual spent
Layout & tools	2800		1063
Excavation	631		281
Corner stones	1072	+41	925
Wall foundation	1535		1327
Slab preparation	524		767
Underslab plumbing	600		878
Slab	1056	+79	1545
Columns	1649		1158
Walls	6855		6512
Door frames	730	+86	622
Perimeter beams	2508		3546
Roof basket	2888		1609
Gable ends	684		918
Electrical circuits	836	+58	875
Roof, 1st coat	5016		3648
Roof, 2nd coat	3344		2428
Window frames	1657		1837
Windows	2022		2296
Doors	1520	+250	1377
Plumbing fixtures	3344		3800
Electrical fixtures	646	+75	1365
Painting	1474	+450	1001
Paving	456		341
Common land	509		1380
TOTAL	44356	+1039	41499

build the house; and each family was required to build the house; and each family was responsible for watching those materials until they were installed in the house.

In principle, the labor for these operations can be accounted in exactly the same way. Table 3 gives the cost of labor, operation by operation, for the statistical house. In the first column, we show the unit of the

TABLE 2E. TAPIA HOUSE: 73.7 m^2 (material costs)

	pesos estimated	+ extras	actual spent
Layout & tools	2800		1027
Excavation	618		271
Corner stones	1039		892
Wall foundation	1489	+92	1279
Slab preparation	505		734
Underslab plumbing	590	+14	857
Slab	1024		1488
Columns	1599		1118
Walls	6648	+103	6287
Door frames	708		649
Perimeter beams	2432	+292	3424
Roof basket	2801		1587
Gable ends	663		862
Electrical circuits	811		775
Roof, 1st coat	4864		3538
Roof, 2nd coat	3243		2022
Window frames	1607		1725
Windows	1960		2155
Doors	1474	+250	1293
Plumbing fixtures	3243		3685
Electrical fixtures	626	+42	1365
Painting	1430		1032
Paving	442		326
Common land	494		1380
TOTAL	43110	+793	39771

operation. In the second column, we give the price of
the labor per unit of operation. The price is based on a
combination of skilled and unskilled labor, reckoned in
pesos. Like all other costs in this chapter, they represent
1976 pesos, and are based on the then going wages,
which were 20 pesos per hour for unskilled labor and
35 pesos per hour for skilled labor. In the third col-
umn, we show the amount of each unit per square me-

TABLE 3. CONSTRUCTION OPERATIONS (labor)

	unit	unit price (pesos)	number of units per m^2 of house	labor price m^2 of construction
Layout & tools	1	—		
Excavation	m^2	24.4	100	24.4
Corner stones	#	36.8	.53	19.5
Wall foundation	m^1	14.0	1.05	14.7
Slab preparation	m^2	38.1	.77	29.34
Underslab plumbing	1	640		
Slab	m^2	38.1	.77	29.34
Columns	#	37.0	.53	19.61
Walls	m^1	41.5	.97	40.26
Door frames	#	122.5	.08	7.8
Perimeter beams	m^1	33.3	1.10	36.63
Roof basket	m^2	36.6	1.00	36.6
Gable ends	#	305.0	.08	24.4
Electrical circuits	rooms	147	.10	14.7
Roof, 1st coat	m^2	24.4	1.00	24.4
Roof, 2nd coat	m^2	24.4	1.00	24.4
Window frames	m^2	101.7	.18	18.31
Windows	m^2	254.4	.18	45.79
Doors	#	191.3	.08	15.30
Plumbing fixtures	1	1800		
Electrical fixtures	rooms	214	.10	21.4
Painting	m^2	12.6	1.94	24.4
Paving	m^2	30.7	.30	9.21
Common land	1	1000/house		

ter of house (this comes from Table 1). In the fourth column, we show the resultant price per operation per square meter of house, again in pesos. Like the figures in Table 1, these are typical figures that are to be used for estimating. As we shall see below, they are reliable and accurate enough to establish a very good cost control on the different houses.

In the actual experiment we are describing, we did not use this approach to the price of labor, since the labor was done entirely by the families themselves, together with student apprentices from the university, who were working under our direction.

However, we give this table because, as we have stated, we believe that the process of production that we are describing here will work under quite general conditions and is not applicable merely in those cases where families wish to build for themselves.

To show this, we may consider the following estimate of the actual amounts of labor that were consumed in the construction of our houses. For this purpose, we reckon the labor of the family members as unskilled, the labor of our student apprentices as semiskilled, and the occasional labor of other tradesmen (used to finish off one or two operations towards the end of the project) as skilled. Using these categories, we then find that the labor actually used for the construction of the houses was well within the limits imposed by our theoretical table. Table 4 gives the comparison for one house (Duran), in hours of skilled and unskilled labor, as estimated by our table and as actually consumed in the construction process by the Duran family and by the student apprentices who worked on the Duran house.

In the first column, we see the actual labor done by the family. It is given in pesos, reckoned at 20 pesos per hour. This money was not actually paid to the families, but it helps us to keep a perspective on the actual price of what was built—or what would have been paid to unskilled laborers performing the same tasks. The second column gives the actual labor done by our ap-

TABLE 4. LABOR COSTS FOR DURAN HOUSE

	family @ 20 pesos/hr	appr. @ 26 pesos/hr	prof @ 35 pesos/hr	predicted labor cost	actual cost of apprentices and skilled labor	cost of labor in house if all labor were paid
Excavation	456	967	—	1599	967	1423
Corner stones	384	499	—	1277	499	883
Wall foundation	288	575	—	963	575	863
Slab Preparation	960	1248	—	1921	1248	2208
Underslab plumbing	320	416	—	640	416	736
Slab	960	1248	—	1921	1248	2208
Columns	576	468	—	1284	468	1044
Walls	720	1248	—	2637	1248	1968
Door frames	144	280	—	642	280	424
Perimeter beams	960	2808	—	2399	2808	3768
Roof basket	600	1872	—	2399	1872	2472
Gable ends	480	642	—	1598	624	1104
Electrical circuits	288	374	—	963	374	662
Roof, 1st coat	800	1040	—	1598	1040	1840
Roof, 2nd coat	800	1040	560	1598	1600	2400
Window frames	400	1040	1120	1199	2160	2560
Windows	480	936	—	2999	936	4776
Doors	—	400	700	1002	1100	1100
Plumbing fixtures	—	468	1785	1572	2253	2253
Electrical fixtures	—	624	—	1402	624	624
Painting	600	260	1050	1598	1310	1910
Paving	200	260	630	603	890	1090
Common land	144	468	362	871	830	974
TOTALS	10560	19163	6207	34685	25370	39290

prentices. It is also given in pesos, now reckoned at 26 pesos per hour (the going rate for semiskilled labor). In the third column, we see the labor done by skilled craftsmen who came in to help with finishing operations. Their labor is also shown in pesos, and was paid at the rate of 35 pesos per hour. In the fourth column, we give the predicted labor cost for each operation, given the fact that this house had 65.5 m^2 of area. (The prediction is based on the figures given in Table 3.) In column, 4, we give the actual cost of the labor done by apprentices and skilled craftsmen. This is what the labor actually cost for the house. In column 5, we give the cost of the total labor for this house, including the cost of the family's own labor, assumed to be unskilled. This tells us what the labor for the house would have cost if the house had been built entirely without the family's help, using only paid labor. All rates are for 1976.

THE COST OF LABOR

As we have seen in the foreoing section, our method of cost control was effective in controlling costs for both materials and labor. The facts speak for themselves. But the result which we obtained requires a word of explanation and discussion. In the present forms of mass-produced housing, it is axiomatic that labor costs are the key to the production problem; and it is also axiomatic that the price of complexity and variety is, always, an increase in the cost of labor. Within a typical

building process, it would therefore be assumed that our variety of house designs, the uniqueness of the individual houses, would certainly increase the cost of labor.

How is it, then, that our process manages to keep the cost of labor down?

Let us first consider the labor cost of complexity, at a very simple level.

When an architect designs a very complex house, the cost usually goes up for the following reasons:

1. The cost of design goes up.

2. Special details have to be worked out for every part, and these require more labor, and therefore more money, during actual construction.

In this process, we overcome these two increases in cost as follows:

1. The greater intricacy of the design comes from the people, and is therefore free.

2. The greater complexity, and cost, of the construction itself is kept to a minimum by the fact that all building tasks are conceived as *processes*—not as assembly of components—and these processes produce an infinite variety of different particulars, according to context, without any appreciable increase in cost. For example, windows of different sizes are produced at a fixed cost per square foot, even though each one is different. Baskets which are woven can be woven to any shape, without altering price, provided that the shapes lie in some range of what is reasonably easy to do. This range lies in the architect-builder's expertise; it is up to him to make clear that certain particular impossible configurations must be excluded during the layout stage.

If we consider the normal process of mass housing

construction, in which trained crews move systematically from one house to the next, going down a row of identical houses and doing exactly the same thing over and over and over again, it is clear that a large part of their efficiency comes from the fact that they do the same operations over and over again. Because they learn precisely how to hit every nail, the members of the crew know, from experience, exactly when they have to come together, exactly when one man has to hold something while the others tie it or nail it, and so on.

But of course, in our process, the walls are not standard. The layout of each house is different. However, the *operations* are still standard. Thus, our process has exactly the same kind of repetition going on—in the *process*. The sequence of operations, the order of the actions that have to be performed, and the human motions which make up each operation, are still highly repetitive. It is therefore possible for a crew to learn this process, down to the last detail, from doing it over and over again, and this creates speed and efficiency, just as it does in the larger repetition of the present-day mass-production process.

The question is: is it true, empirically, that a trained crew, doing the same operation over and over again, but each time making a different physical configuration with the same operation, can work as fast as another crew that is also repeating the same operation over and over again, but is constantly building the same configuration?

In order to understand this question clearly, let us consider, for the sake of example, four masons who are laying concrete block walls.

Mason 1 lays five walls of equal height and equal length; each wall is four feet high and ten feet long.

Mason 2 lays five walls of *un*equal height and *un*equal length, but with their *total* area the same; each wall is forty square feet in area.

Mason 3 lays five walls of equal height and unequal length, and of lengths which cannot be made up of an integral number of half blocks.

Mason 4 lays five walls of the same total area as before, but their lengths are different *and* their heights are different non-integral multiples of blocks, and in addition each one has a different treatment of the top course, one with a corbelled top, another round, etc.

We can understand the whole problem very clearly by considering the speed at which these four masons are able to work.

Masons 1 and 2 will finish at about the same time. Although the first one makes the same wall five times over, and the second one makes five walls, all different, of the same total area, the two masons will take the same amount of time because they perform exactly the same operations.

On the other hand, masons 3 and 4 will almost certainly take longer. Mason 3 does one extra operation: he has to cut blocks at the end of every wall, which takes extra time. Mason 4 does two extra operations: he has to cut blocks, and he has to make something different along the top of every wall, which also takes extra time. Both masons 3 and 4 will take longer, and will therefore increase the cost of walls.

The fundamental reason that our building process can produce houses which are all different, without increasing

costs, is that it is based on a process which is like the process that mason 2 uses. The process is made up of operations which are standard and ordinary, used thirdly to build an infinite variety of configurations. It does not require extra operations, and it does not, 'therefore, increase the cost of labor as do the processes used by masons 3 and 4.

Of course, it is also true that each house will have one or two of those charming details which are genuinely unique: a seat, built by a door; a special surround built around a window; a bay window; a small fountain; a sculpture on the roof.

These extra details, of course, come into the category of masons 3 and 4. However, in the process we have outlined, they can be done by the families themselves. That is, once the members of the family are competent in the general approach to construction, it is the most natural thing in the world for them to devote their labor to creating some special place, some special detail—which may take hours and hours of love and patience, but which will not figure at all in the overall calculation of costs.

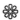

We finish this chapter by discussing an entirely different aspect of cost: the cost and nature of the building operations themselves.

So far, we have been discussing cost entirely from the point of view of its control: we have described a process which allows us to make sure that buildings can be built exactly for the estimated price, even when they

have the enormous human variety which this book describes.

It is important to realize that we did, also, take great pains with the design of the building operations themselves, to make sure that they were as cheap as possible, as simple as possible, as modest as possible, yet still enriching the buildings, making them pleasant, making them human.

This aspect of the building process hinges, essentially, on an unusual way of looking at the standards which a building might reasonably have.

In some curious way that is not very easy to define, the modern world has distorted our attitude to our material surroundings. Of course, it is true that the wonders of technology—the beautiful new materials, amazing new machines, conveniences—have helped us make us feel more comfortable in our houses; and the desire for these things is natural and very fundamental. For example, the comfortable bathroom or the comfortable kitchen, have become an essential part of modern life. In many countries, people move out of beautiful traditional houses into ugly, small, boxlike apartments, only because the plumbing is so marvellous. Although this is perhaps sometimes a little humorous, it is anyway, human. We all have this tendency. There is something real about it.

But alongside this rather natural kind of tendency, there are other tendencies which reach proportions that are almost absurd. In San Francisco, an ordinance was passed recently, forbidding the use of ornaments on the upper parts of buildings, in case they break loose in an earthquake and hurt people. This takes a normal con-

cern for structural safety and makes it ridiculous, spirit-killing even. It has gone out of proportion.

In a similar way, the "standards" which modern housing has to meet have gone out of proportion in many different categories. The standards require that bedrooms be very large, they forbid narrow stairs, they forbid small bed alcoves tucked into a closet, they forbid the use of earth as a floor material, even in a garage—all in all, they impose a level of finish, hygiene, structural safety, and cleanliness of appearance which probably doubles a building's cost.

And alongside this very high level of standards imposed by law, by code, by banks, and by public agencies, there is a similar madness in the attitudes which people have themselves developed towards houses.

Although their grandparents might have had the most wonderful rough brick floor on the porch, people become upset if the flatness of the surface of the porch is uneven, even by a millimeter. People require a level of finish which has been taught by machines, but which has nothing sensible or necessary to do with the comfort of a house. The walls must be perfectly flat, doors must be perfectly smooth, paint must be perfectly even in color, and tiles must be laid without even a hair's breadth of a discrepancy in their alignment. None of this makes sense, none of it makes the building more comfortable, but all of it adds greatly to the cost.

We have deliberately turned our backs on these prevailing attitudes. We have tried to define building operations which will make the building safe, sound, clean, and neat—but within reasonable limits, so that we can keep the building prices down. To do this, we

have paid attention to a standards and levels of finish which actually make the building comfortable to live in, and we have insisted on those, but we have tried to forget the artificially raised standards which come only from people's images and have nothing to do with down-to-earth, sensible, everyday comfort.

For example, when our engineer first designed the slab, since the ground was very weak—clay, with much subsidence—the "proper" engineering design ended up with a price for the slab that would have been 35 percent of the total building cost. This was quite impossible. What do do? Current engineering principles—and the banking and building regulations which are guided by current engineering principles—make absolutely no contribution to the problem. The real question is: given a certain need to build a house for $3,000, how much should one reasonably allocate to the slab?

To solve the problem, we have reduced the steel content drastically. By doing so, we have created a situation where there is a probability that some slabs will fail with hairline cracks. It will be a small percentage. But it seems better to build a thousand houses, with a 5 percent probability of failure, than it is to build five hundred houses for the same money, with a 1 percent probability of failure. This is obvious. But there is no present theory of engineering design which takes it into account.

And in the same spirit, throughout the building design, we have tried to find materials which dramatically lower the cost without altering the real human comfort in any significant way.

For example, one of our reasons for using interlock-

ing blocks was to be able to lay them without mortar. In the plumbing, we used galvanized pipe only for the hot water, and plastic pipe for both the cold water and the drains. Our attempts at making a rigid roof basket were motivated by the fact that elaborate formwork underneath is expensive both in labor and materials. In the beginning, we attempted to use bamboo and palm branches instead of steel reinforcing, to cut back on costs.

In order to make a floor which had a pleasant feeling, but without going to the expense of tiles or bricks, we used a mixture of red oxide and cement, sprinkled on at the time of pouring the slab, to give the floor a warm red color. The window frames, although they are trimmed and look good on the buildings, are about the simplest possible—again, both in terms of materials and time. The same is true for the windows and doors themselves. The cornice was designed to help the appearance of the building, but also to make the perimeter beam no bigger than the minimum specification of our engineer.

These decisions make the buildings more beautiful in their overall character, but somewhat rougher in the details, than conventional buildings are. In this respect, they are perhaps more like the houses which our grandparents had. But it must be remembered that we built these houses for a total price of 75,000 pesos each—half what a standard factory-built, government-sponsored house of the same size cost in Mexico at the time.

In short, the houses were remarkably cheap. The actual budget for the houses was 40,000 pesos each ($3,500). This paid for materials. If we include the

labor of the families and the labor of the two apprentice architect-builders who took the place of the paid labor that would normally be required to help a family complete a house, these houses still cost less than 75,000 pesos. In 1976, the going price for a comparably-sized house or government institution in Infonavid was about 150,000 pesos—just twice as much as ours.

If we can build twice as many houses as the government can for the same capital outlay, and at the same time they are more beautiful and more filled with spirit, it seems hard to argue with it.

CHAPTER 7

THE HUMAN RHYTHM OF
THE PROCESS

THE PRINCIPLE OF HUMAN RHYTHM

Finally, it is essential that the building process itself exist as a human process with a human rhythm. It is not merely a mechanical process in which a building which has already been designed now gets assembled. It is, instead, a human process, which allows spirit, humor, and emotion to be part of it and to enter the fabric of the buildings themselves, so that the buildings are felt, in the end, as the products of the rhythm which produced them.

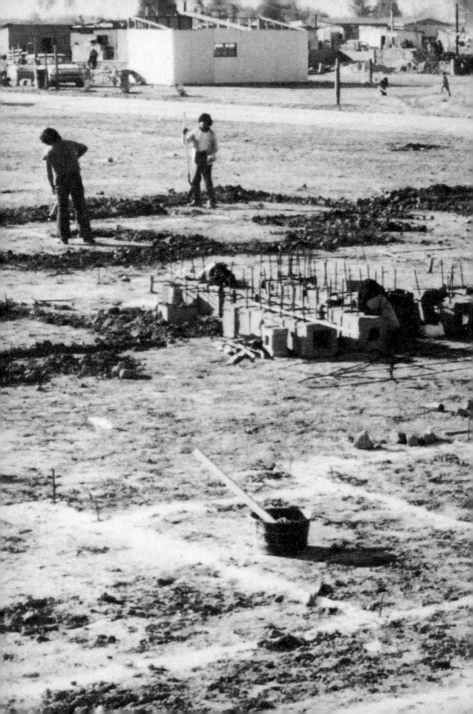

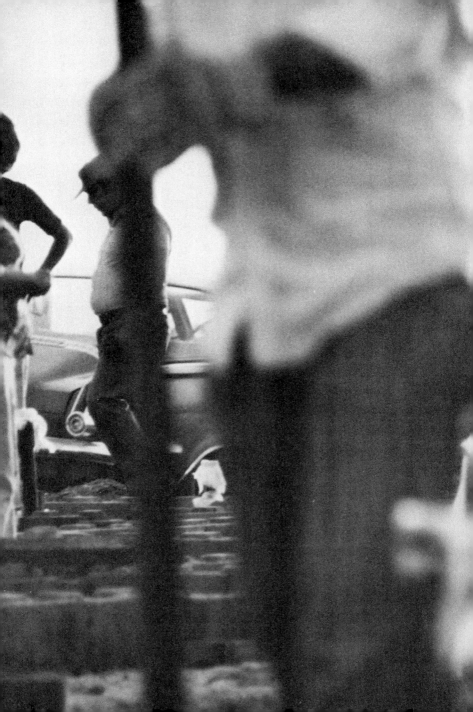

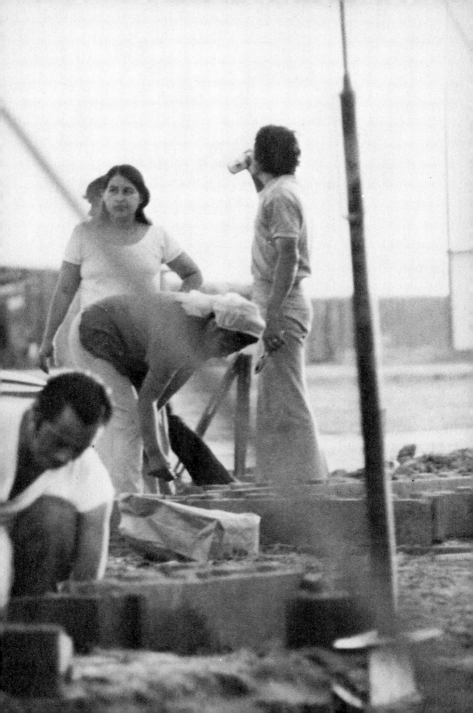

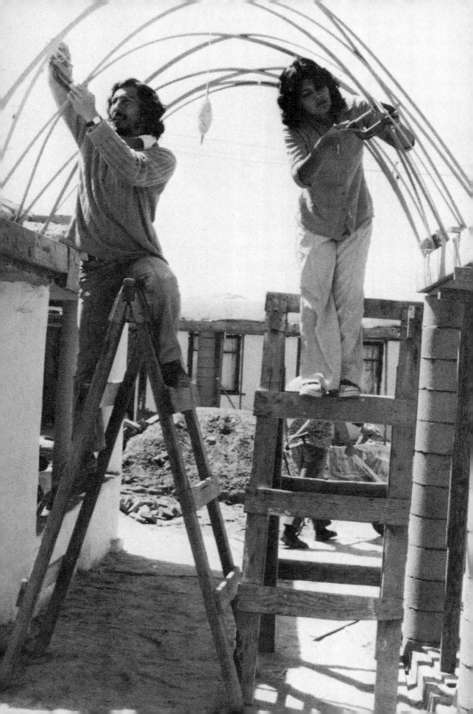

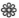

In today's production of houses, the actual construction is essentially factory-like. Labor is related to the building process entirely through the medium of money. The builders are remote emotionally from the houses, and the families cannot enter in, formally or informally, because their informal rhythm is different from the money-intensive factory rhythm of the workers.

Apart from occasional jokes among the workmen, the site is a rather grim business where people are going about their work in order to receive their paychecks. The building site as a fundamental human experience, the process of the house construction as a fundamental part of a human life—all that is gone, one more way in which people have been robbed of vital experience by the march of technology.

All this happens because the building site is essentially in the control of large-scale contractors, building inspectors, safety inspectors, and the contingencies of large-scale access by heavy equipment and machinery.

Yet, under ideal circumstances, the growth of a house is as important an event in the life of a person or a family as the birth of a child . . . it is a time when the energies of people reach special proportions, a time to look back on in the years of living in the house. But for this to happen, the control of the on-site human

events must be in the hands of the people themselves—with local builders who have personal relationships with the families. . . .

We therefore propose to replace the mechanical building operation of present systems of production with a more human operation in which the joy of building becomes paramount, in which the builders have a direct human relation to the work itself, to the houses, to the place of the houses, and to the people that the houses are for, and in which the families themselves may enter in, as much or as little as they want to, in the process, so that the building process as a whole becomes a record of achievement, a human struggle to be remembered, a memory, a moment of life, which will remain in the houses, once occupied, a process which will continue, in the years that follow, in the slow improvement, growth, and maintenance of the same houses—and in which, above all, the houses take their place in the community as part of a living process, a source of life, which spreads into the life of the society.

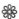

In the Mexicali project, it was, above all, a very human thing that happened on the site. For in the end, the reality of the process—quite apart from the principles of the architect-builder, and the house cluster, and cost accounting, and all that—is what people dealt with day by day, and what now remains in everyone's memory even after the construction has stopped.

The night watchman walking by the window at sunrise on his way home, the dusty sun already beginning

to bake our rooms . . . The men who deliver the sand and gravel coming by every couple of days, the great piles of gravel slipping out of the truck; writing a bill; giving them a check every week . . . Driving across town to buy electrical supplies; waiting in the supply house with the electricians, drinking cool water; loading the tubing and fittings into the truck.

The roof pours were great events. Everyone on the site would work on one house at a time, in a day. People would begin arriving at 7:00 A.M.; by 7:30 or 8:00, the operation was in full swing. Temperature: 85°. One team of two or three mans the concrete mixer, measuring in buckets of sand, gravel, and half sacks of cement, adding water, keeping concrete production going. They are wearing wet masks to keep the concrete dust out of their lungs. Another team is manning the wheelbarrows, transporting the wet concrete from the mixer to the site of the pour. Another team is on the ground, below the roofs, lifting the concrete up in buckets to a fourth team, who dump the concrete on the roof and throw the empty buckets back down to be refilled.

A fifth team spreads the concrete out and smooths it with trowels. When things get going, all five teams are working together like clockwork, maybe a total of fifteen or eighteen people. Time: 9:30 A.M. Temperature: 95°. By 10:30, people have been working three hours, and perhaps one-third of the roof area has been covered. Someone walks up the dirt street in the blazing sun to the little grocery store "ABARROTES: ASI ES LA VIDA" and brings back a dozen Coca Colas, cherry sodas, and pineapple sodas. By now the temperature may be 100°

or 105°. Keep on working, take a sip of soda now and then. Hands getting covered with concrete, lots of joking, even singing. ("No gagno mucho dinero. . . .") Nothing can stop this operation now—except for the pushcart vendors, who know their territory and start selling goatmeat tacos, peeled cucumbers, large slices of *jicama,* all for one peso. Time for a break; we are two-thirds done, and the temperature is 110°. Everyone gathers at the street for twenty minutes, then goes back to lifting concrete onto the roof, shovelling concrete into and out of the mixer. By 2:30 or 3:00, it is all over: another house has its roof. The mixer and tools are washed down with water, the roof itself is wet down, and everyone gathers in the shade for rest and cerveza.

The men making the blocks also have a rhythm all their own. One doing the mixing, one at the machine, one wheeling the blocks away to dry. This goes on every day, in another part of the site.

Building the walls, this was an easy operation, one that the women and even the children of the families could help with.

But even with this, some of the families did not know what to do, and had to be shown. I remember explaining to Julio Rodriguez how the blocks fit together; and then deciding on the window openings, imagining where the windows whould be.

The project was a great object of curiosity in the neighborhood. In the beginning, many people thought it was a church. Most people liked it, but assumed that the houses were too expensive for them to afford. But there were also lots of inquiries about buying blocks, buying other materials, building houses this way.

At the first meetings of the families on the site, when families were choosing their lots and working out the basic boundary lines with each other, Julio Rodriguez brought a bottle of tequila in his pocket, for everyone to share. It was only after everyone had drunk a little tequila that the meeting could begin.

Of course, things did not always go well. One day we heard that José Lopez Portillo, the next President of Mexico, was going to come to see our project on a visit to Mexicali in about three weeks' time: the local government wanted to show its efforts in new housing programs to him. Naturally we wanted the project to look as good as possible for him, and the buildings to be as far along as possible. So we made a special effort, with people working extra-long days, pouring roof vaults, making windows, painting, putting down brick paving. On the morning of the scheduled visit, the place looked beautiful. The families and all the other people involved with the project came all dressed up, with great anticipation of the visit. But he never came—he fell behind schedule and had to pass us by. That day was a great disappointment.

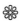

Of course, this human quality the process had is not just a feature of *any* building process. And it is not automatic, just because people are working together. It is a characteristic which had to be planted there, which could be nurtured, and which must be given as much attention, as definite a position in the process as the laying out of floor plans or the mixing of concrete.

In our experience, this special character seems to depend on at least the following specific aspects of the construction process:

1. That people work together at a definite hour every day.
2. That each family has to contribute at least some physical labor.
3. That something definite is completed every day.
4. That people help each other on the more arduous operations.
5. That there is a celebration at the end of every operation.

1. PEOPLE WORK TOGETHER AT A DEFINITE HOUR EVERY DAY.

The essence of the process with the families is a human thing. On the one hand, we have to be sure that they understand how much work they have to do, and that they will do it. On the other hand, we also have to convey to them that it is a circus, a party, a wonderful time.

Here are some notes I made at the time:

Today, in the first meeting after the contract, with work starting tomorrow, I spoke about this a little with them:

"You must understand that the most essential thing is to keep to a certain schedule, and that you, not we, have the ultimate responsibility for that. Each operation requires a defined number of days. It must be finished by the time set, and if it is not finished, we have the right to hire extra people, at your expense, to finish the work very rapidly, and so keep things on time.

"The students will be available whenever you are, and will work side by side with you, helping you—but they will not work alone, so it is up to you to meet the schedule, and its success hinges on your presence.

"This means that if a certain operation is not finished, then we will have to work into the night to complete it. This won't happen often, but when it does happen, we shall all have to stay here and do it.

"Remember, this is something that is only happening once in your life: for a few weeks it will be hard—a time to remember. But at the same time, it will be a sort of party all the time. If we do it like that, it will be wonderful."

Julio at once suggested a party, with carne asada, as soon as possible, as an inauguration, and we began making plans for it.

2. EACH FAMILY HAS TO CONTRIBUTE AT LEAST SOME PHYSICAL LABOR.

We have said many times over that we do *not* consider it essential that the families build their own houses—only that they design them.

In this sense, "self-help" is not essential to the process which we are defining in this book. Houses built within this system of production can also be built entirely by professional labor, so long as they are first laid out by the families.

However, we do consider that, for the spirit of the process and for the spirit of the houses, the families themselves must become involved physically, at least to some small extent—at least enough to feel the process in their bones and in their hands.

Even partial physical contact with the construction of a house has an amazing effect on a person's conscious-

ness—and leaves him with a relationship entirely different from the one he has purely as a "buyer." A story from one of our projects in Berkeley: We were building an extension to a small factory—a lunch room for the employees. We built it mainly at night, when the factory was empty, so as not to conflict with the working schedule of the factory. When we were almost finished, one of the employees came in while I was working on some cabinets. Suddenly he said in a very unfriendly voice, "You have a stain here on your counter top." I turned around and said, "That isn't our counter top, it's *your* counter top. If there's a stain in it—here's a piece of sandpaper." I gave him a piece of sandpaper. Within five minutes he had the stain rubbed out, and his whole attitude had changed entirely. He was smiling; he "belonged there." Sanding that one tiny stain, two inches across, had changed his relationship to a whole area— perhaps a thousand square feet of new construction. It was his now.

In the Mexicali houses, the families played a much larger role than that—they contributed almost half the labor of the construction. It was hard sometimes, but there was a lot of life in it. For instance, from my notes:

After one day
The excavation went beautifully. Many people working all together, a beautiful sight.

Three houses have their trenches completely dug. Two houses don't. What to do with them.

But Makaria's family is slow, because her husband, even though he was free all day yesterday, just didn't come. And Lilia's family is not used to hard labor—they are very slow,

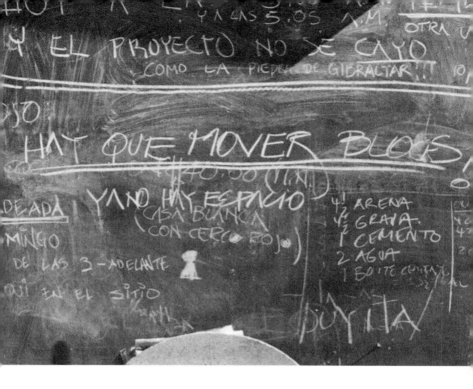

and watch instead of working. But even so, we help them; gave Lilia a shovel yesterday, but she needed a lot of encouragement and help.

3. SOMETHING DEFINITE IS COMPLETED EVERY DAY.

This sounds obvious, but it is really far from obvious. Indeed, it is perhaps the central, most important one of the five points. And it is by no means true that this always happens on a typical building project.

In conventional construction today, people work by the clock. When the clock says time to go home, work stops. But in such a process, the stopping point is com-

pletely arbitrary; there is no sense of concrete accomplishment. Instead, only the sense of time spent.

In our process, on the contrary, every operation on the site has its rhythm. Digging: one shovel every few seconds—a beat like dancing; laying blocks: one every three minutes, say—again, a perfect rhythm.

And the operations themselves: one every week; finishing on a certain day; with a climax on that day, Sunday.

When you lose this rhythm, nothing works, it slows down, becomes a drag. But so long as the rhythm is sustained it works.

In order to keep to the rhythm, one night we were on the site until three in the morning, placing lime and water, to be sure that, several days ahead, the rhythm would be maintained.

It is like a dance, like dancing a building; this is the art of construction; moving differently, is nothing.

The rhythm of the process depends not only on the fact that the operations can be broken down into subsidiary units, but also on the fact that each operation, and each unit, results each day in something which is physically more complete, so that every day we go home with something new accomplished.

4. PEOPLE HELP EACH OTHER ON THE MORE ARDUOUS OPERATIONS.

The sense of community, and the rhythm of community, is already created by the fact that people are all working together, at the same time each day; they work in harmony with each other, pace each other, work

harder because they see the others working, and know that, in return, others are drawing the same encouragement from seeing them working steadily; and so keep working, in order to keep the pace of the whole.

But this sense of communal reliance becomes even more specific, more concrete, in those operations where people actually need physical help from one another.

Most operations can be accomplished by one or two people at a time: building columns, building walls, installing windows—here people are working in parallel. But certain operations—flooding the site, levelling the site, pouring the slabs, placing the concrete on the vaults—are so arduous that they need many people working together, even to accomplish them in one small place. At this time, each family, or each group of workers, concentrate their efforts on one house at a time—and the houses are done in turn, one after the other.

And of course, this means that every person has laid his hands on every house in the cluster, and that each person also has reason to be grateful to each other person working.

Under these circumstances, the cluster becomes far more than just a physical place: it is a group of people tied together by work, by effort. It is the one thing, above all, which unites the project.

5. THERE IS A CELEBRATION AT THE END OF EVERY OPERATION.

And of course, there is the barrel of beer at the end of every operation. The sense of accomplishment is so

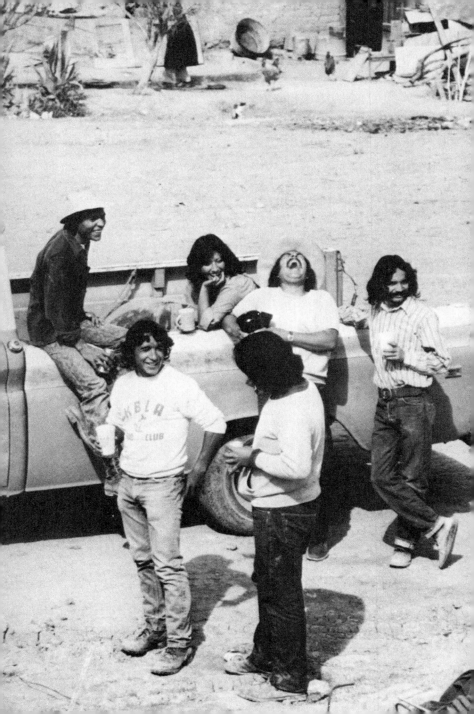

great, it is quite spontaneous, necessary, almost inevitable.

Sometimes there was a full-scale party—with dancing in the loggia of the builder's yard until two or three in the morning . . .

At other times a feast—carne asada—the specialty from northern Mexico: thin strips of beef are cooked over an open fire, chopped into smaller strips, and rolled in hot tortillas with peppers.

Julio Rodriguez brought his guitar—a group singing around the fire. One time he brought his friends from work, with their guitars, and that night there was dancing to the live music of the guitars—not just the records in the loggia.

And even at the simplest times, there was at least a barrel of beer—after pouring a slab, starting as early as possible to keep the concrete workable before the sun became too hot—the slab would be started at quarter to six, and finished by noon or one o'clock—and then a barrel of beer, people drinking, as if it were lemonade, to wet their mouths, and then lying, half drunk, next to the freshly trowelled slab—feet in the air, princes in the dust.

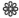

The importance of the human process in Mexicali is captured most poignantly, perhaps, by this entry in my notebook:

Last night, at the fiesta which the five families had to celebrate the completion of the foundation, José Tapia came up to me and told me in words of almost inexplicable warmth

and fervor that this was the most wonderful process he had ever experienced, that he had only the desire to work more, that he wanted to help the other families complete their houses; that when the group of five houses was finished, he wanted to help other families have the same experience; that it was an honor and a wonderful thing for him to be part of this process; and that he wanted to thank me from the bottom of his heart, over and over again—and that words could not adequately express his feeling.

José's family is the one which is always furthest ahead with their house; they finish everything before everyone else; his brother comes and works with him on the weekends; and in the singing around the fire last night, he became almost wild, singing a high-pitched shout of joy at the end of each phrase—almost a shout of liberty.

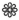

When we first arrived back at the site after we had been gone for about five months, we did not immediately go across the street to look at the houses, even though that was the reason we were there. We felt, already, that the houses were no longer our domain, even though we had been in charge of construction of the cluster for so long. Invited in by José, we began a discussion of how it was, to be in the new house, and asked him if he had actually experienced any social change, change in himself, any kind of greater freedom greater potency, as a result of his experiences in the project. At first he was a little vague; the question seemed very abstract to him—but then, as he began to understand more clearly that we were asking about his

concrete experiences, he said a very remarkable thing. He said. ". . . well, I have not specifically noticed any effect of the project on my work, or my attitude towards society—but I have noticed that I now do quite different things at home from what I used to do in our old house. In our old house, when I came home from work we used to go to the movies, go to the bar, things like that, in our spare time, more or less just to kill time. Now, because I like it here, and feel so good here in this house, because it suits me so well., I have suddenly realized that there are all sorts of other things to do. I can sit down and read a book, I can educate myself, I can make something, I can talk to my wife about what we can do to improve the house, or do something with my brother in the yard outside . . . so it has changed me personally; it has changed my personal life, I feel more potent in myself, not in relation to society, but in relation to the small things I do every day, when I am in the home, and when I come home from work."

Lilia Duran is also extremely pleased with her house. I saw her one morning in the house, and said that I thought it was very good. She said that it's not only that, but that it suits her family perfectly—that people come and say that it is small, but that it seems to have everything that is needed, and only what is needed, and is just right for the family. I said that she must be glad to be moved in after that difficult year of building. She said that didn't matter; the thing that was important was that the house is so well suited to her family. There are no problems at all with the house, she said.

Next, Julio Rodriguez told us what he remembered the most about the past year, and what was the best past for him.

"The best part," he said, "was that I learned so much. I learned how to put in windows, I learned how to make doors, I learned how to work with concrete—I didn't know how to do any of that before. But I think the best part was that I learned how to live better. I learned how to be comfortable, I didn't realize any of this before, either. I feel at home here, it suits me. In the place where we lived before, we didn't have sewers, we didn't have a toilet inside, we didn't even have a kitchen sink to wash the dishes in. In this year we learned about all these things."

I said, "Julio, it's interesting that you talk about *learning* about these things, rather than *having* them."

"Yes," he said, "most of the people in this neighborhood have more money than we have, they can afford all these things. But actually we are richer than they are, because we learned about them. We're going to pay the house off slowly. The loan had to be increased by almost 25,000 pesos, because of the devaluation of the peso last year, and my wife is taking a job to do that. But it is a success—it's wonderful to be here, in my own house."

We asked Makaria Reyes what it was about the process that *she* liked most.

"Well," she said, "everything about the process was so nice, I can't separate one thing from another. I had never done anything like this in my life before: building walls and columns, and digging, and nailing, and all that."

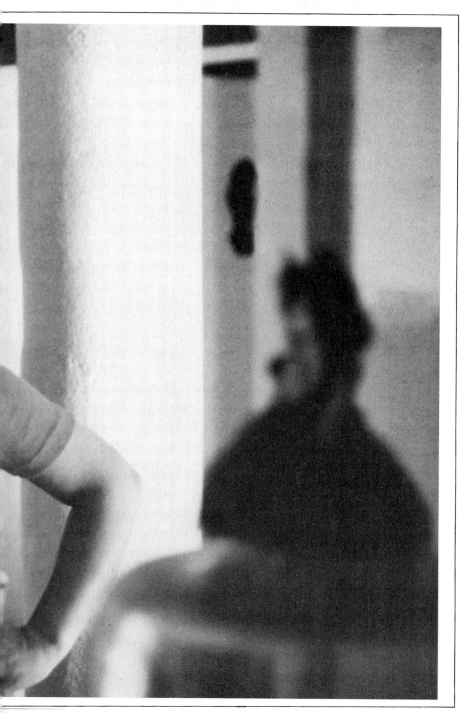

"But if you had to pick out one thing to recommend to someone else, what would it be?"

"Well, I don't know. It was so enjoyable, such a new experience, I never knew before that I could do things like that. If I had to pick out one thing especially, it might be the columns. They were so easy to do, and went up so quickly, and you could see so much of the house when they were finished. But all the pick and shovel work, I loved it. It is amazing that we could do all that."

"How is it that your house is finished so perfectly, more perfectly than the others?"

"Well, I spent a lot of time. Emma and I, we worked so closely together all the time."

"You are the only woman in the five families who really took a major part in the construction, isn't that true?"

"Yes, it is. I think it is partly out of necessity, because José Luis couldn't work on it, and partly because Emma helped me so much. I just had no idea that such things were possible for a woman, and we decided at every stage to do it as well as we possibly could. Do you remember the day we tried to put the main beam of the passage up, and it was crooked, and we did it over and over again, until we got it perfectly straight?

"Perhaps because we are both women, both of us, Emma and I, had the same experience—that up until this happened, we never imagined that it was possible for us to do such things. And it was so wonderful to find out that we could, that we did as good a job at every step as we possibly could. And we helped each other, making sure that every detail was just right.

"It is amazing to think of all that dust and mud where the house is now. Do you remember when it was just mud, and we were standing here with pick-axes, and digging out the beams? And now, here it is, my house, with all these things, and so nice, and every part of it just how I want it.

"It seems incredible when I think back to all that dust and mud that was here when we started."

The student trainees who worked on Makaria's house and saw it through to the finish, Emma and Chino, now have been given keys to the house by Makaria, and can use it as their own whenever they want to. They have coffee there and make their own lunch there—whether or not Makaria or her husband is at home. If they should knock at the door, Makaria will say, "Why do you knock?" They are treated now as members of the family, after these months of working together to build the house.

Makaria's house is also somewhat a center of community life in the cluster. Makaria works during the day and therefore does not have time to make tortillas, so Julio Rodriguez's wife, and Emma Cosio also, send over tortillas in the evening. The other families in the cluster gather at Makaria's house also, to drink beer and coffee, and to watch television. We asked Makaria if things were like this in the neighborhood where she lived before.

"No," she said, "in my old neighborhood, nobody ever went out to visit neighbors in the evening. Everyone just stayed home. It is very different here."

This discussion took place after the families had been in their houses for only a month, and they were still

doing work to finish their houses—painting, plastering, finishing the common structures outside. A big fiesta was being planned for the time when everything would be finished. The director of the bank and the governor of the state had been invited, and everyone was looking forward to it.

It is very important to compare the feelings which the families have, about their houses with the feelings which government officials have about the houses.

During the process, we had a variety of negative reactions from various government officials. They didn't like the "appearance" of the houses. They didn't like the fact that the plans were rambling. They didn't like the fact that some of the houses had unfinished pieces next to them. They didn't like the fact that each house had a unique and different character. They didn't like the fact that there were technical difficulties during the production of the blocks.

These reactions were not based on ill will. They were perfectly understandable, given the fact that this process was as radical and as different from the "normal" housing project as it was. Of course, it is to be expected that people who are used to stamping their approval on acres of houses, all built perfectly by prefabrication from the same mould, would find the project strange. And it is understandable, too, that they may be impatient about the fact that an internationally known group of architects should come to Mexicali, and, after many months, have made only five houses: because the fundamental nature of the changes, and the difficulties involved in making these changes, to create a process that has the

characteristics described in this book, are not obvious at all to someone who has not thought carefully and deeply about the process.

But one thing no one can change. The fact is that the families themselves are happy—some of them almost deliriously happy—about their houses. No one can change that.

They feel satisfied, happy; they feel that they have well-built houses, which are truly theirs; their sweat has mixed with the mortar of the houses; these houses belong to them.

When we compare the bookish dissatisfaction which the government officials have with the palpable reality of the families and their delight, and we realize that the officials continue in their distaste and opposition even though they know that the families love their houses and are completely satisfied, must we not then wonder at the frightful arrogance which allows these officials to continue in their opinion?

Does it not become utterly clear, then, that the game of housing, the production of housing, is indeed a game, recklessly played by banks and realtors and building inspection departments in total disregard of the feelings of the people—so much so that they cannot be influenced, even, by the deep and final satisfaction of a family who love their house?

I, myself, when I look at these five houses and the cluster of these houses, am filled with something which is as close to a religious feeling as any social act in our society today can bring me to.

Here are these five families, completed, almost as though with their own bare hands, they have created

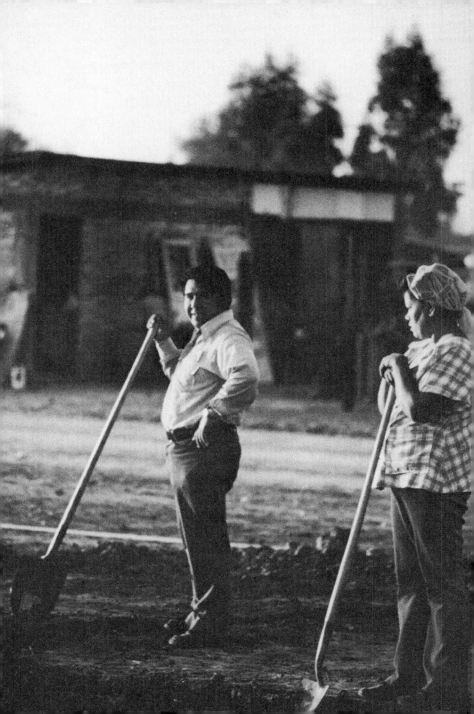

themselves, they have lifted themselves up out of the mire which their society has created for them, as though they have pushed out of the cave of phantoms into the light of day. They have made their own stuff, they have made themselves solid in the world, have shaped the world as they have shaped themselves, and live now, in the world they have created for themselves, changed, transformed, opened, powerful, free in their glory, stamping their feet, watching the water trickle in the common land, looking after their neighbors' children, waiting now to help their friends take part in the same kind of process, also on this piece of land, or in another corner of the town.

They have become powerful, and are powerful, in a way which almost takes the breath away. They, they themselves, have created their own lives, not in that half-conscious, underground, interior way which we all do, but manifestly, out there on their own land: they are alive; they breathe the breath of their own houses . . .

PART THREE

LARGE-SCALE
PRODUCTION

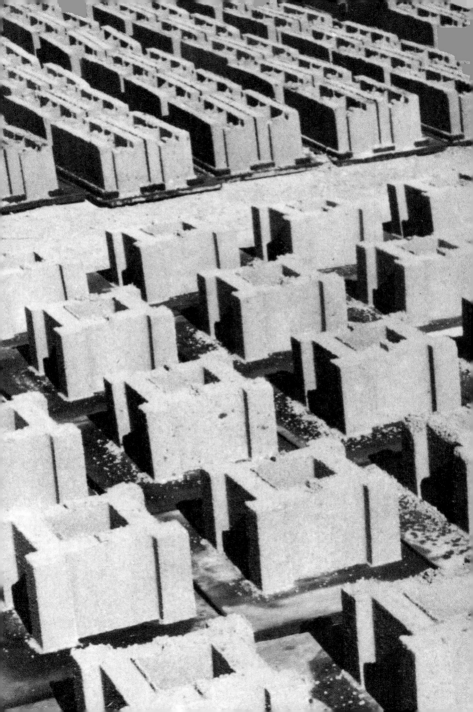

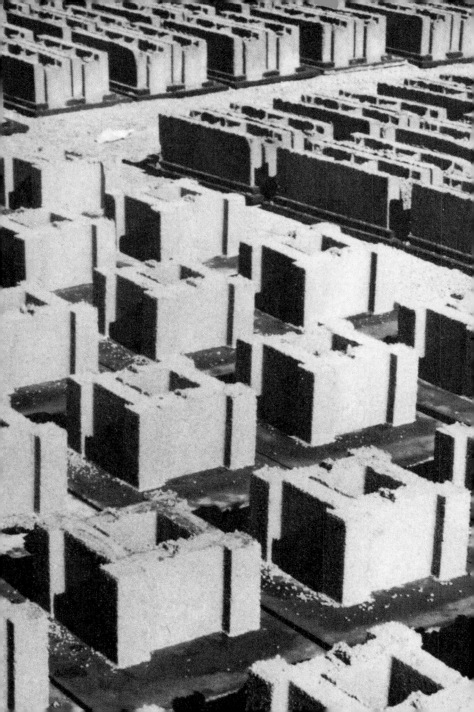

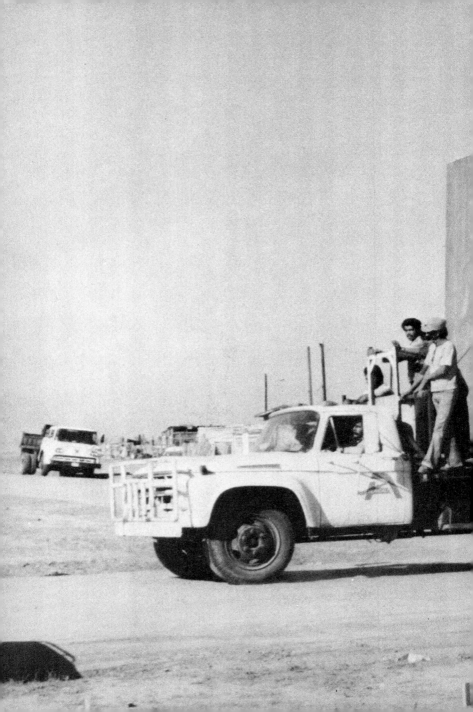

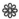

We have, so far, seen one particular version of a new production process. It is a version which existed under very special conditions peculiar to Mexico. The seven principles which govern this process are embodied in this one particular case. However, we have no grounds, so far, for believing that this kind of process could be extended to cover a wide variety of different cases, in different cultures, different economic conditions, etc. In short, we have no grounds at all, so far, for believing that this process might be completely general. Yet we claim that it is not merely a process which happens to work in northern Mexico, but that it is capable of being the backbone of every housing process in the world: and that indeed it should be so.

In this third part of the book, we shall try to suggest that this simple process is capable of being extended to cover every imaginable kind of housing, and capable of being central to the worldwide production of houses. In this sense, we shall now argue that the title of this book is indeed appropriate: that what we have described is indeed a general model for the production of houses, not merely for a particular housing project in northern Mexico.

We must therefore establish that the general principles we have laid down in no way require either the particular physical characteristics or the particular eco-

nomic conditions which we have described. We must show that it is possible to imagine an entire network of housing production, worldwide, in which the vast variety of possible housing production processes that now exist are all transformed so that they include, as a minimum core, the seven principles we have described. And we must establish, of course, that similar processes are capable of covering a great range of possible cultures, densities, and methods of financing.

The crux of this task is economic. We simply need to describe the practical economic conditions which are needed to maintain a builder's yard, to train architect-builders, and to achieve an efficient rate of construction, so that we get a realistic picture of what the overall housing production process might be like if versions of this process were indeed adopted on a worldwide scale.

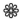

It is certainly clear that the kind of houses we have built in Mexico can be built on a small scale, in limited numbers, almost anywhere. No one will challenge the project on the grounds of small-scale unfeasibility.

But "the housing problem," as it is usually understood, requires the construction of millions upon millions of houses. And it requires that these millions of houses be built fast. And on this point people may very well balk. "It is indeed possible to build a handful of houses in the manner described," they may argue, "but what we need to know is whether such a process makes any sense at all on a large scale, whether such houses can be built by the thousands and by the millions, and

whether the apparent savings of such a process still remain when we try to implement it on a large scale."

This archetypal objection might be put another way, namely: It is possible to define any number of wonderful processes, like the one described, which work in the small; but as soon as we try to expand production, and to maintain a high volume of production in a short time, then the "realities" of housing production come into play, and these realities—realities of component production, realities of labor, realities of unions, realities of financing—require that housing be produced by some kind of highly mechanized industrial process, with a great deal of assembly undertaken in the factory, and with the time spent on-site reduced to a minimum.

This is the argument which housing specialists have been putting forward for almost forty years. The sound of this argument has become so convincing that many people assume that it is valid without even pausing; and the same people may assume, also without pausing, that the kind of process we have described just cannot work on a large scale, because it just does not conform to the archetypal image of a mass process which has been engraved in our minds.

To counteract the effect of this unconscious certainty about the form of mass housing, we must now ask, very searchingly, under just what conditions, and at what cost, a process of the kind we have described might work on a large scale and might be able to produce, not merely handfuls of houses, but thousands and thousands of houses per year, in any given region.

Specifically, among the questions we must answer are the following:

1. How many top-level architect-builders are needed to manage these projects?
2. How fast can this number of architect-builders be trained?
3. What is the cost of management? Is it within reasonable limits?
4. Is the relationship between clusters and yards that has been described, a feasible one?
5. How many architect-builders does the process require in all?
6. What is the capital cost?

To put this discussion in the most concrete terms, let us begin by estimating the total needed annual housing production for a typical metropolitan region.

The United States, with a total housing stock of about 80,000,000 dwellings, builds about 800,000 new houses per year. Mexico, with a total existing housing stock of about 30,000,000 dwellings, builds about 500,000 houses per year.

In general, a region needs between 1 and 2 percent of its housing stock in new dwellings per year, to replenish the stock, replace derelict dwellings, improve obsolete structures, and account for population increase.

Consider, then, a city somewhere in the world, with a total population of one million people and a stock of about one-quarter million to one half million houses. In order to replenish this stock and make up for population growth, this city will need about five thousand new houses built per year.

Let us consider, then, how the process which we

have described might be organized to be capable of building five thousand dwellings per year in a city of one million people.

If the process follows the seven principles described in Part I of this book, we know that the houses will be arranged in clusters. Of course, these clusters will vary in size, but certainly none will have less than, say, two houses each—and it seems unreasonable to imagine that any cluster which really works from a human point of view will have more than about a dozen houses. To be conservative, let us say that the clusters have an average of five dwellings each. Our city of two million people will then require the construction of one thousand new clusters per year.

Now we begin to face the apparent difficulty inherent in decentralization. Under present conditions, with mass housing projects and vast tracts of new development, the total number of five thousand new dwellings might require no more than a few dozen monster projects per year. However, within the framework we have described, we need to imagine one thousand independent or partly independent clusters being built every year in a much more decentralized manner.

How can this be organized from a human point of view?

The crux of the matter lies in the fact that the architect-builder, who is essential to the process, does not and cannot manage vast numbers of houses at the same time. In a large industrial housing project, it is perfectly conceivable for one architect to manage the construction of a thousand units. Similarly, it is quite conceivable for one engineer to manage a thousand units, and for one contractor, using industrial techniques, to

produce a thousand units. This may be efficient from a purely mechanical viewpoint, but we know that it produces terrible houses. If we are to convert the production of houses to a process managed by architect-builders, who by definition have a more personal relation to the families and a more personal relation to the buildings they produce, then inevitably we must have a relatively large number of architect-builders working in order to produce the same number of houses. To understand this situation, let us try to make a reasonably precise estimate of the number of architect-builders who would actually be required to produce two thousand clusters of five houses each per year.

We may obtain our estimate by bracketing it between two limits: a lower limit given by considerations of humanity and human adaptation, and an upper limit given by economic considerations.

The lower limit comes into being as follows. Obviously, as we have just noted, we shall get inhuman results when one person manages the construction of a thousand dwellings per year. That is fairly clear. But to make buildings human, to allow families to design their own houses and still stay on top of production problems, to deal with the inevitable variety and complexity that are introduced when every house is unique, how many dwellings can one architect-builder manage per year without sacrificing quality?

To come at the problem from the other direction, it is also obvious that we shall get very human and beautiful results if there is one architect-builder for every house. But of course that is quite impossible. Either the builder would starve or the house would be much

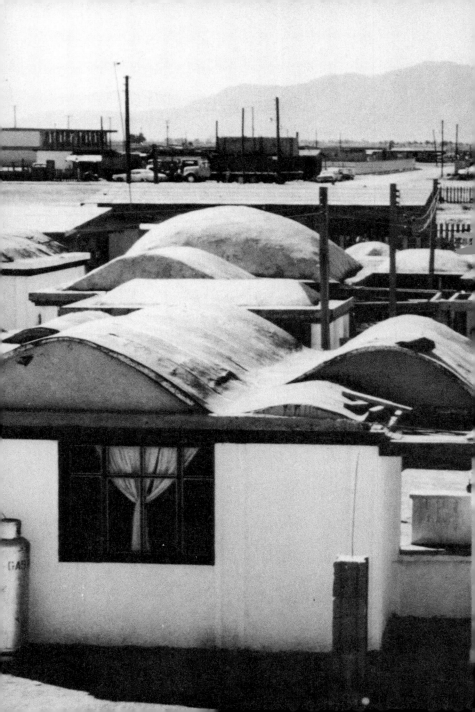

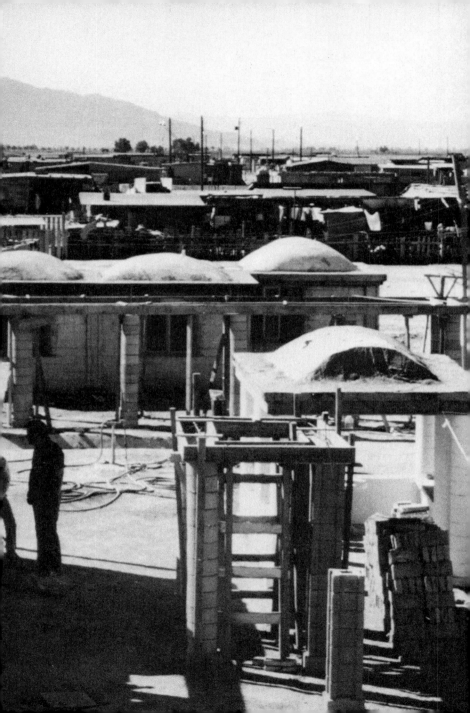

too expensive, because it alone would have to pay a year's salary for a highly skilled professional. Each architect-builder must produce some minimum number of houses per year in order to bring the cost of his own salary, per house, into a reasonable range.

Finally, it is also obvious for quite another reason that we cannot have a process which requires too many architect-builders: simple availability. If a city of one million people needs five thousand houses to be built per year, and if each house required one architect-builder, we would need five thousand architect-builders in a city of one million, or one for every two hundred persons. Not only is this quite unlikely even in the long run—it is also impossible to implement, because all these people would need to be trained, and they cannot be trained overnight. If the process is to be realistic, we must find a balance in which the number of architect-builders required is at least approximately compatible with a realistic rate of training, so that the process can get a good start within the next five or ten years.

Let us, then, obtain these three numerical estimates, which will help us to see how the process can realistically be organized.

We begin by estimating the maximum number of houses which one architect-builder can manage without sacrificing quality.

Our own experiment gives us only indirect data for this calculation, since we had an unusually high number of architect-builder apprentices, who did a great deal of work. However, from other experiences we have had, we believe that one person could not, at any one time, work with more than about twenty families and still

manage to keep on top of the site planning, design, and construction.

Ideally, in order to be involved in the construction of the houses in the most beautiful way, we would recommend that one architect-builder work with one cluster at a time. If the houses are completed in six months (a fairly reasonable overall average), this would enable one architect-builder to manage two clusters per year. Under these conditions, he would be able to maintain the best possible relation to the families and to the process of construction itself. If the architect-builder is working with two experienced master craftsmen (one carpenter, say, and one mason), then we believe that he and they together can manage two clusters at a time, or a total of four clusters per year.

In short, from the point of view of quality, the architect-builder can manage, *at the most*, twenty houses per year. Any attempt to manage more than that will probably degenerate into some version of the present architect/contractor division, since the architect will have to manage design and planning, the contractor will have to manage construction, and there will really be too much construction for one person, to handle.

Let us now examine the same question from the point of view of cost and salary. Assume that the architect-builder functions in the same capacities as the architect and the general contractor combined. Since his role is essentially one of organizing operations, demonstrating techniques, and deciding shapes, sizes, and materials, he does not contribute greatly to the directly productive labor of the house, and his salary cannot therefore be more than, say, 10 percent of the building cost—or

perhaps 20 percent at the outside, if we combine the architect's 10 percent and the general contractor's 10 percent. What does this mean in actual dollars and cents?

In Mexico, the construction of a house of the type we have been building might legitimately cost $5,000 (for 70 m^2), equivalent to 100,000 pesos. Ten percent of this is $500. Now, a young architect in Mexico would expect to receive a salary of some $800 per month, or $10,000 per year. In order to make this salary, the architect would therefore need to be responsible for at least twenty houses (if we assume 10 percent of construction price), or for ten houses (if we assume 20 percent of construction price).

In the United States, a very cheap basic house of 1,200 square feet will have a typical construction price of $50,000.* In this case, 10 percent of the construction price is $5,000 per house. A young architect will expect a salary of at least $15,000 per year, which would require him to build three houses per year. A reasonable salary for a more mature architect-builder, comparable to the salaries of a union carpenter or higher-level architect, will be perhaps $30,000 per year, which would require responsibility for at least 6 houses per year.

In Bangkok, where a house might cost as little as $2,000, and where a young architect would expect to receive $6,000 per year, the architect-builder will have to control at least thirty houses per year (if we assume 10 percent of the cost), or fifteen houses per year (if we assume 20 percent of the cost).

* Note: In this chapter, as in all others, discussion of money is in terms of 1976 dollars, pesos, etc.

We see, then, that the practical feasibility of this process varies from country to country, according to the relation between prevailing house costs and prevailing salaries for architects and builders. We see, however, that, except for very fortunate cases like the United States, the architect-builder will certainly have to manage *at least* ten houses a year in order to make a living without driving the cost of the houses sky-high.

This *minimum* rate of ten per year happens to be close to the *maximum* of twenty per year which we arrived at from the consideration of quality. There is, in short, a rather narrow range of numbers which will work. If the architect-builder takes responsibility for less than ten houses per year, he cannot make a living except in countries where houses are very expensive, as in the United States. On the other hand, if he takes responsibility for more than about twenty per year, he will not be able to maintain the intimate human relation with the families and with the buildings which is required for good adaptation and careful work.

Let us see, next, how many builder's yards there might reasonably be in our city of one million people. If we have one architect-builder producing two clusters of five houses each per year, our city of one million people will require five hundred architect-builders, or one for every two thousand inhabitants. If every architect-builder had his own builder's yard, there would also be five hundred builder's yards in the city. However, as we shall see, there are compelling reasons for the architect-builders to work in teams, so that the number of builder's yards would be considerably smaller. Let us examine the figures.

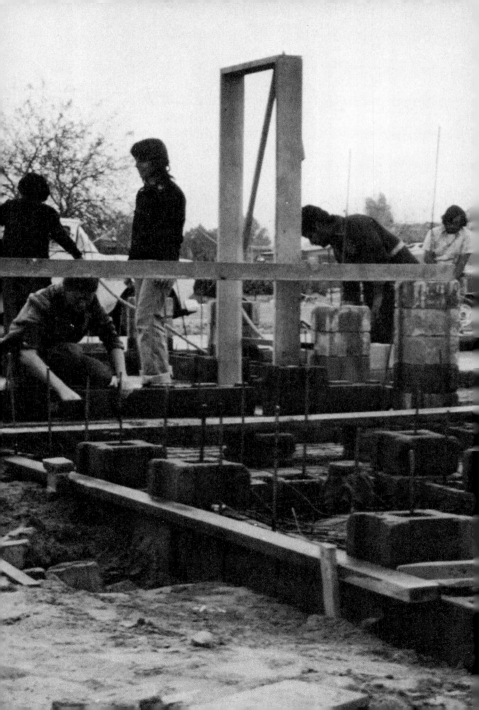

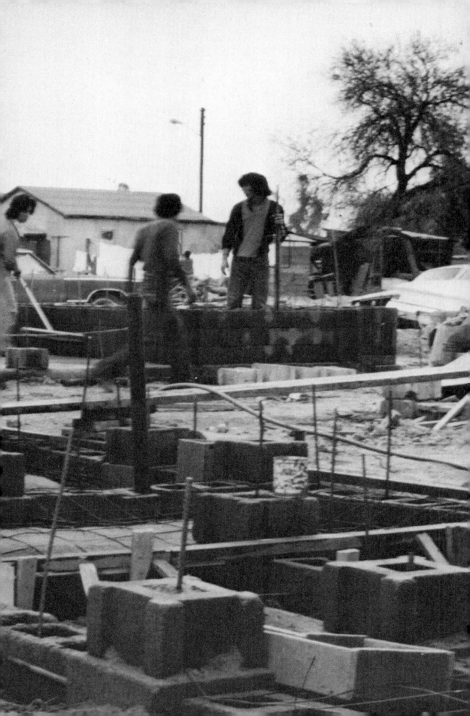

First of all, as we found, the process of design and construction, within the framework of a pattern language, is essentially a communal experience. It benefits enormously from discussion and debate—and, above all, it becomes more enjoyable when the work, triumphs, difficulties, and joys can be shared.

Secondly, of course, all the major tools and equipment are expensive. Concrete mixers, big saws, planing machines, heavy-duty grinders, welders, and other kinds of expensive equipment cannot easily be bought by an individual architect-builder, but the cost becomes manageable when these tools are shared.

Third, there are certain kinds of administrative processes—ordering materials, dealing with city government, controlling cost, managing the warehouse, repairing tools, etc.—which require staff. One architect-builder cannot easily pay the salaries of the people who are required. But, again, when several architect-builders work together out of the same builder's yard, these costs become manageable.

After considering the cost of these overhead expenses and taking into account the practical daily problems of confusion introduced by size, we have come to the conclusion that the ideal builder's yard will have three to four architect-builders working there.

We are now able to define an "ideal" system of housing production, as follows:

1. The system is organized around a builder's yard which contains somewhere on the order of three architect-builders working together. They share heavy equipment and other overheads.

2. Each architect-builder produces approximately one cluster of five houses, every six months.

3. Each family has one mason/carpenter working full-time with them. He is responsible for teaching the family, guiding them, and working with them in every phase of the work. He is also directly responsible to the architect-builder for carrying his decisions.

4. In addition, there is a stream of incidental specialized labor, brought in to solve special problems (plumbing, electricity, etc.) when they occur. The total of this kind of work will be the equivalent of one man full-time, for the cluster—though actually the work will be spread over several different professionals.

5. The yard will require one full-time accountant in charge of purchases, and one full-time man in charge of the disbursement of materials and the repair of tools and equipment.

6. It is probably necessary to have one full-time watchman-caretaker in the yard, in charge of odd jobs, maintenance, etc. This category is uncertain.

7. Finally, the same builder's yard, in charge of three clusters at a time, will need a certain fixed monthly budget for overhead (supplies, electricity, etc.) and for maintenance and replacement of tools and equipment.

It is estimated that such a builder's yard, with three architect-builders, eighteen masons and tradesmen, and three others, will be able to produce fifteen houses (three clusters) in six months, provided that each family provides two able-bodied people for four hours per day each, to contribute labor to the houses.

This particular arrangement will be able to produce

houses at the following cost (in Mexico and as always, 1976 pesos):

Builder's yard salaries, per month:
 3 architect-builders @ 8,000
 pesos/month 24,000 pesos
 15 masons @ 4,500 pesos/month 67,500 pesos
 3 administration staff @ 6,000
 pesos/month <u>18,000 pesos</u>
 Total per month 109,500 pesos

 Total salary cost per house (for six months,
 divided by fifteen houses) 109,500 ×
 $\frac{6}{15}$ 43,800 pesos
 For materials per house 40,000 pesos
 For land per house 15,000 pesos

TOTAL COST PER HOUSE IN THIS SYSTEM.... 98,800 pesos

This compares with about 150,000 pesos for a house of the same size built by INFONAVID in 1976, built to similar standards, stamped out, with none of the features of our houses.

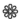

We now have a preliminary but realistic picture of the kind of decentralization which the production of houses really requires. It is a structure or informal organization that is quite different from the one we have in our minds today when we think about solutions to "the housing problem." Yet, as we have seen, it is perfectly capable of producing the number of houses required, with a new level of quality. The number of houses built annually by each architect-builder is small enough to maintain the subtle human connections which make the houses useful, intimate, and beautiful—and

yet large enough to make sure that the cost of his salary is not disproportionate. In short, the process works economically. And the total number of architect-builders needed, though large, is quite reasonable—and any society could be functioning in this manner within ten or fifteen years.

To end this chapter, let us go back to our imaginary city of one million people, and try to imagine what it might be like with all its builder's yards spread throughout it.

As we have already seen, the city will require an annual housing production of about 5,000 houses per year, to replenish its housing stock.

In the system of production we have described, this will need some five hundred architect-builders, working out of some 150 to 200 builder's yards.

Spatially, these builder's yards will be decentralized—that is, spread out quite uniformly throughout the city. Since a city of one million will typically have a total area of about 200 square miles (assuming about 5,000 persons per square mile), there will be just about one builder's yard, every square mile . . . one yard every mile, in each direction.

Of course, these thousand builder's yards will all be slightly different. The building process cannot be perfectly transmitted on paper; and it cannot therefore be imposed or spread too widely.

What happens instead is that the building process in a builder's yard is a *culture:* a system of rules, and knowledge, and processes, which spreads by word of mouth and hand-to-hand practice.

Even if a group of builders in one builder's yard were to try to copy exactly what the builders in another

builder's yard are doing, they would not succeed. Inevitably, they would start developing their own versions of what is being done, both in the larger patterns of the language and in the details of the building operations—until, finally, each builder's yard, each neighborhood, has its own style of architecture, its own way of building.

And yet, at the same time, the larger area within the boundary of the city is still relatively homogeneous: with the overall region, the many buildings being built are all versions of one building process, perpetually evolving. What any one yard produces is merely variant of one local culture, of one particular group of architect-builders.

So we see a city with a hundred different individual traditions, but with a homogeneous tradition in the whole: almost as, in earlier times, a hundred different traditions used to lie in different nearby geographic regions.

And let us assume, now, that this process does indeed spread widely across a city, to such an extent that the whole housing production is in the hands of such a process.

Imagine it. In a city like Mexicali, with half a million people, there would be as many as one hundred builder's yards, and one thousand new clusters per year. . . .

Just try to imagine the city with 1000 new clusters every year, in each cluster four families, or six, or ten, working together, designing their common land, taking responsibility for their own houses, for the shape of them, joining hands in simple things, conscious of their

own creative power, having a genuine, deep-seated relation to the soil on which their houses stand . . .

This is a social revolution. It is as if the rebirth of society itself might start again . . . as if the people, hungry for a conscious, sensible relation to their daily lives, would find it, and be capable of sharing it, so much that finally the entire city comes to life with the pulse of groups of people in every neighborhood making and shaping their own existence.

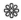

Our experiments suggest that the possibility of this kind of large-scale revolution is almost independent of time, and place, and culture. Although we have only described one particular experiment in this book, with one particular set of conditions, other experiments of ours suggest that the general process we have outlined—and the possibility of this kind of social revolution—is largely independent of culture, density, methods of financing, or rate of growth.

We believe that the essentials of the process, with minor variations, remain as valid at high density or low density as they are at middle-range density; that the process is as valid in Norway, or China, or California, or India, as it is in Mexico; that the process is largely independent of methods of construction, and can be equally valid for houses of brick, or concrete, of mud, or of wood; that some version of the process is as valid for houses built by craftsmen, or even for houses built by industry (always provided that the people who run the industry are willing to set up a process which fol-

lows the outlines we have specified) as it is when the families themselves help build their houses; and that the process can be very slow, with houses taking five or ten years to build . . . or very fast, with houses built in batches every three to four months.

In short, we believe that the process we have defined, *in some version or another,* is almost completely general. The social revolution which our principles imply can happen, on a large scale, almost anywhere, and under almost any cultural conditions.

PART FOUR

THE SHIFT OF PARADIGM

In theory it is clear then, that this new process of production could take care of the production of houses for an entire city, or a region—and that it could, in principle, even be used to generate the housing supply of an entire society. From a strictly arithmetic point of view, from the point of view of economies of scale, of numbers, and of salaries, the change in production is quite possible.

And yet, of course, this change is far from simple. Anyone who knows the present state of housing production in the world knows, instinctively, that what we have described will actually be very hard to do on a large scale. So we come, now, in this last chapter, to the source of this instinctive knowledge, and to the possible ways of overcoming the problems that this instinct foresees.

At first sight, the instinct which tells us that this kind of production is going to be hard to implement seems to have to do with specific difficulties. We can imagine, for example, difficulties with building codes, or difficulties with the flow of money in society, possible difficulties with monetary resources, with bank loans for housing programs, difficulties of a procedural, or political sort.

In an earlier draft of this chapter, we tried to give a point-by-point analysis of all these "real world" prob-

lems, in an effort to show, one by one, how they could be solved, on a large scale, in our present-day society.

But somehow, no matter how we wrote this chapter, it always seemed thin. Either the solutions we proposed were too concrete and specific, or, in other versions, too vague and general. Somehow, now matter how we wrote this chapter, it never seemed entirely convincing, even though it actually gave detailed answers to all the specific points which might arise.

After much discussion, we realized that the reason for our failures to write this chapter adequately lay in a problem of a very different sort. The fact is that the vague sense of uneasiness posed by such a deep shift in societal structures is a deep-seated uneasiness, not caused by any specific functional problems, but simply by the unfamiliarity of the whole system of production we are proposing, by the fact that, at its deepest structural level, it proposes, or requires, changes which are almost *unimaginable* in the context of modern thought—and that it is this almost literally unimaginable character which the process has, the violence it does to modern cognitive categories, the discomfort it presents, simply as a pattern of thought, which is at the root of the difficulty of implementing it.

It is therefore this deepest problem which we have chosen to discuss in this final chapter of the book.

At the beginning of this book, in Part One, we have expressed the fact that our present forms of housing production are governed by certain unconscious, as-

sumed, rules of conduct, institutions, laws . . . and that it is this deep structure which, above all, influences the way in which houses are produced.

Evidently, the form of production which we have described here requires *another,* different set of assumptions, institutions, and laws . . . it defines a new deep structure, which cannot coexist with the old one, and which will therefore have to replace it if it is ever to succeed on a larger scale.

And, of course, this process of replacement will be anything but painless. The process involves pain, not so much because it requires a redistribution of power, money, control. . . . as is so often said by political theorists. In our view, the process creates pain because it is so painful, cognitively, to have all one's familiar categories threatened, attacked, replaced.

When one cognitive structure, one paradigm, seeks to replace another, it is on the emotional level, the intellectual level, the social level, above all, that pain is created; and in order to conduct this struggle sensibly, it is this fact, over all others, which must be understood.

To make this clear, we may again begin with a discussion of our experiment in Mexicali . . . but looking at it, this time, from a different point of view. For what we have not described, yet, is the weight of difficulties which accompanied us, the daily struggle . . . and the way in which this daily struggle was caused by the fact that what we were doing did not fit into people's familiar categories of thought, and therefore seemed alien and threatening, even when it was, in simple fact, so ordinary and pleasant.

When we began the project, we originally intended to build thirty houses in one year. In fact we completed only five in the time allotted, and for various reasons, which we shall explain, the government withdrew its support, so that the remaining twenty-five houses were not built at all. Further, we intended that the builder's yard which we built, and which we then handed over to the apprentices we trained, would have enough momentum to keep the project going, to produce a steady and increasing flow of similarly built houses in the area around the project. This also did not happen. Again, the project failed to get continued support from the government of Baja California.

There were several reasons for this lack of support. First, perhaps most important, the government authorities were astonished, even dismayed, to see that the houses we built were so "traditional" in appearance. They had, it seems, expected that we would produce rapidly erected modular buildings . . . and had somehow even had the impression that we were worldwide experts in the construction of such modular marvels . . . The almost naive, childish, rudimentary outward character of the houses disturbed them extremely. (Remember that the families, by their own frequent testimony, love their houses.)

Second, our experiments wih construction systems also dismayed them. In spite of the fact that we explained, repeatedly, that the construction operations were in a state of development, and in spite of the fact that we had said from the outset that we would undertake experiments during construction of the builder's yard, still, in those cases where our experiments failed, thus

teaching us valuable lessons (for example, about the use of palm fronds for reinforcing, because the walls cracked), these experiments were not seen as important failures, comparable to any other experiments of a scientific nature, but were instead seen as evidence of an unworkable process.

Third, we had from the beginning, included as part of the project a very ambitious attempt to produce a stable earth-cement block. We proved, early on, that an adobe block, with a small percentage of added cement, could be immensely strong, with twice the compression strength of a standard concrete block, provided that it is produced under very great pressure indeed. However, in order to manufacture these blocks, the block-making machine we had bought for the builder's yard had to be modified more and more, and even in the end we were still not able to produce the high pressure required for the proper moulding of the soil cement. Finally, so as not to increase the delays in construction, we had to reduce the earth content greatly and ended up building what is, in fact, a concrete block with some added soil (about 20 percent soil content)—far from our own original wishes. However, the fact that we had failed to produce the promised earth block added once again to the government's lack of confidence.

And there were failures, too, from our own point of view. The houses, for example, are very nice, and we are very happy that they so beautifully reflect the needs of different families. But they are still far from the limpid simplicity of traditional houses, which was our aim. The roofs are still a little awkward, for example. And the plans, too, have limits. The houses are very

nice internally, but they do not form outdoor space which is as pleasant, or as simple, or as profound as we can imagine it. For instance, the common land has a rather complex shape, and several of the gardens are not quite in the right place. The freedom of the pattern language, especially in the hands of our apprentices, who did not fully understand the deepest ways of making buildings simple, occasionally caused a kind of confusion compared with what we now understand, and what we now will do next time.

And what makes us very sad indeed is that, three years after its construction, our builder's yard is now essentially abandoned. We made it very elaborate because we assumed that the government in Mexico would continue to support the process. When their support faded, the physical buildings of the builder's yard had no clear function, and because of peculiarities in the way the land was held, legally, were not transferred to any other use, either; so now, the most beautiful part of the buildings which we built stand idle. And yet these buildings, which we built first, with our own deeper understanding of the pattern language, were the most beautiful buildings in the project. That is very distressing, perhaps the most distressing thing of all.

All in all, viewed objectively, the government's growing lack of confidence was perhaps entirely reasonable, *if we assume that they expected a perfectly worked out process, with no faults, working as smoothly as the present-day production system.*

But in fact, of course, this would have been a totally unreasonable expectation.

The process of production which we have defined is

fundamentally different from the process of production which exists today. A changeover to such an entirely different process must, almost inevitably, be accompanied by deep and serious problems of implementation. In the Introduction, we have explained that the present system of production—and, indeed, any system of production which exists in a society—is deeply embedded in that society, exists implicitly in a thousand everyday relationships, habits, "normal" practices, and ways of doing things which are followed without thinking. It is, in short, unconscious and completely part of everyday life, at a level which is so obvious, so deep, and so implicit that no one questions it.

This means, of course, that a new process, when it begins to show itself, is irritating in a thousand small ways to almost everyone who comes in contact with it. It is not only working imperfectly, but in a thousand small ways, wherever it touches the unconscious certainties which make the present process work, it rubs people the wrong way, seems obtuse, unnecessary, "different" . . .

And, indeed, we ourselves experienced the effects of this unconscious difference, of this incompatibility, of this unpleasant "rub" between the new process we were trying to create and the old process which existed in everybody's bones, to a very large degree . . . far larger than the fact that government authorities lost confidence and were irritated . . . it appeared almost as if it were somehow unconsciously responsible for human difficulties in the work group, even within our own team, among our apprentices . . .

At certain times, the work became almost incredibly difficult, because of the accumulation of small human

pressures, themselves caused by gossip, by practical snags, by subtle comments, by disagreements—all caused by the mismatch between the accepted, existing process and the new process which we had set in motion.

For example, the bank's inspector, who made field inspections to determine the completion of stages of construction, was a young architect with no special training, who had failed in architecture school. To him, the buildings were "unusual." He was unfamiliar with the construction system, and so gratuitously suggested to the families that it was unsafe. This, of course, alarmed them enormously, and we had finally to bring the Public Works engineers, who had already approved the construction system, to tell them personally of their confidence in it. All this was caused merely by the fact that vault systems are not typical in today's construction.

In the same way, each point of mismatch—the lack of drawings, the contribution of families to labor, the different approach taken to the process of surveying house lots, the different manner in which money was handled and accounted for, the use of new building techniques, our own physical appearance (we were dressed, of course, for construction work, in a society where "Arquitecto" is a term of respect given to a beautifully dressed official), the use of common tools, the problems caused by loss or careless use of tools, the attitude of our students, who assumed that what was important was the building system, and who failed to understand the deeper social revisions involved—each of these problems reverberated outward, causing gossip, dissension, and, gradually, a wearing thin of tempers,

the difficulty of maintaining equilibrium in the face of enormous obstacles. . . .

All this was caused by the fact that, inevitably, most of the people we met had a view of housing production shaped by present practice, and experienced mental disorientation whenever they saw the points of mismatch. Since any one detail of our project, taken out of context, seemed to be a "mistake" within the old context, and since very few people had a complete overall view of the process, which included all its aspects working together, many, many people saw what we were doing in terms of "mistakes" referred to the existing system . . . and as they communicated this feeling to families, or to the students we had as apprentices, or to our team members, all of us experienced a growing sense of strain, caused by the truly immense accumulated antagonism that seemed to arise.

It required immense power of determination for us to maintain our balance in the face of these difficulties.

But these kinds of cognitive and perceptual mismatches were almost bound to exist, just because the new process of production really is fundamentally different from the existing one, and because it does express the rudiments of a new paradigm, a new sense of reality.

A new sense of reality, a new paradigm, a new set of cognitive categories, cannot replace an old one overnight. It is inevitable that there must be a time of pain, during which the new categories, and the new cognitive structures which underlie this process of production, replace the old ones.

We finally come face to face, then, with the unavoidable fact that the system of production which we

have described really does describe an entirely new type of reality. It describes a new "something" which is essentially a new social system, it describes a new way of conceiving houses, a new way of conceiving the relationship between people and their houses, a new way of conceiving the relationship between the builder and the built.

Although the difficulties which we have described in the last few pages may seem bleak, at bottom they are far more positive. For the difficulties which we first think of—the practical difficulties which deal with planning codes, financing, mortgages, unions, construction management, and the like—these difficulties are all, in the end, perfectly solvable. . . . provided that the person who sets out to solve them has already made the necessary shift in his internal picture of the world, and is comfortable with the shift of paradigm that this book describes.

It is the shift of paradigm, the shift of world view, which is the serious difficulty. As we know, a shift of world view can take years, decades, even generations. Even today, for instance, fifty years after the discovery of quantum mechanics, many people still have difficulty with the idea that light is neither particle, nor wave, but both.

And yet a shift of world view, a change in fundamental categories which requires that we see the world in a new way. . . . sooner or later, this shift does come. Although it is hard for one generation to give up the world view they grew up with, and sometimes even hard for their children to give up the same view, if they have learned it with their mother's milk—still, sooner

or later, each generation does die off, and sooner or later, a world view, made of an entirely new set of categories, does gradually replace the one which it outgrows.

Just so, sooner or later, even though it does require fundamental change, the point of view which we have been describing in this book will seem completely natural, and ordinary. By then, at that stage, the practical difficulties which seem so huge today, will simply be forgotten.

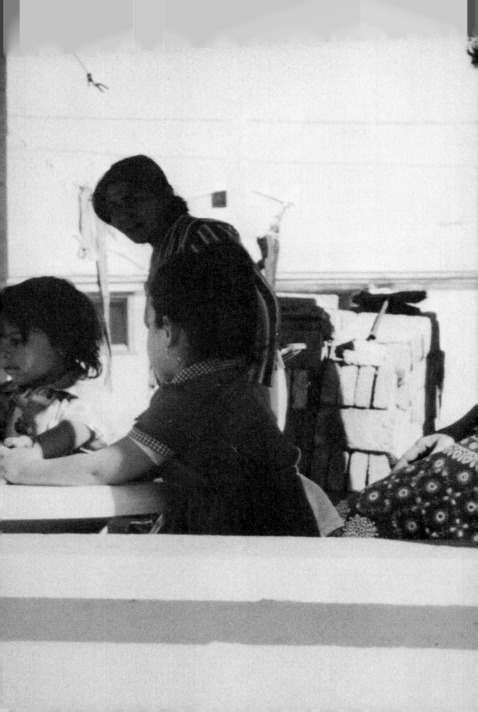

POSTSCRIPT ON COLOR

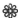

The way these buildings got their color, gives a final summary, in miniature, of the entire building process.

When we finished the first group of buildings—the builder's yard—it came time to paint them. Many of the students on the site wanted, at that stage, to paint them simply white and leave the wood natural . . . very architectural. But I had a vision of these buildings being somehow tinged with blue . . . almost ethereal . . . For many of the students building there, this seemed too strange. However, I insisted even though, finally, only I myself and Howard saw the beauty of this possibility.

So we began experiments, to find out exactly how to paint the color. These experiments took almost two weeks, of continuous work, painting one mock-up after another, slightly changing colors, until we finally discovered just exactly how it must be done.

To do these experiments, we nailed up boards, in the configuration of the cornice up on the wall, and painted them, time after time.

We began with the blue. It had seemed some kind of sky blue, a heavenly blue. . . . and it took a long time to find a blue which had the right amount of light in it.

The breakthrough came, when we realized the need for a hairline above the blue. At first we saw this hair-

line as a golden one, a thin golden line. But as Howard tried to produce this color, it became obvious that the feeling of this golden line could be produced, not by a yellow, but by green. So we had a green hairline above the blue. But this green, it had immense amounts of yellow in it. I had no idea that one could add so much yellow pigment to a green, and still have it a golden green, not yellow at all. This color, finally, pale, golden yellow green, was the color which made the blue of the cornice shine.

And then, to make the blue right, the blue itself was faintly tinged with green . . . so small a quantity that it was still quite blue—not blue green, but just subtly shifted.

And finally, the white itself, of the wall needed to be changed. Although it was to be a whitewashed wall below the blue line of the cornice, it turned out that to make it comfortable and to reduce the brilliance, and make it soft, this whitewash too, had to be faintly tinged with green. So in the end the wall was a faint lime green, so lightly green that anyone who looks at it thinks it is white . . . but still it harmonizes softly with the blue and golden green above it.

Even when we had made these discoveries, after days of work, we still had to check them on fairly large areas of the building. We painted a whole wall of one building, about twelve feet long, two or three times . . . and finally, when we saw the whole thing in a large enough amount to see that it came out just right, then we were satisfied, and went ahead to paint the entire building complex.

Altogether, the amount of mixing, and painting, and

making other mixes, and painting them, and looking at them . . . was enormous. It went on day after day, for almost the whole two weeks . . . in many cases, intensified by the lack of understanding of the people round about, who felt that it should all be white, or who simply could not understand how carefully, with what concentration, it is necessary to keep going through trial and error, over and again, to get a thing just right.

At one time, Howard's love of green became so strong that he wanted to change the whole thing from the blue line to a green . . . and we painted the inner courtyard with a lime green cornice just to try it. But this was less beautiful than the original blue cornice which was on the other buildings. Somehow the blue line caught the sky just right, and made these buildings almost perfect.

But it is amazing to record, even now to write it down, how much work went into that one thing, to get it right.

ACKNOWLEDGMENTS

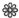

Given the unusual difficulties of the Mexicali project, we especially salute the many different people who worked with us, and thank them for the struggle they engaged in with us: both those who believed in what we were doing, and struggled on our behalf, and also those who, believing more in the present form of production, struggled half-consciously against us, because of their discomfort.

We begin by thanking those members of the Universidad Autonoma de Baja California, in Mexicali, who helped to make our process succeed: the director of the School of Architecture, Ruben Castro, and Professors Carlos Garcia, Manuel Esparza, Polo Carillo, and Jorge Nuñez. Most of all, among these friends and colleagues at the university, we should like to single out Jorge Nuñez, who constantly gave us his friendship in times of trouble, and his help in times of progress.

In the government of Baja California, we thank, first of all, the governor of the State, Milton Castellanos, who from the beginning gave this project his support and encouragement. If it had not been for his enthusiasm, and his specific authority, the many other individuals and organizations of the government would never have been able to give us the help they did. Then, specifically, among individuals in the government of Baja California, we should like to thank Sanchez Hernan-

ACKNOWLEDGMENTS

dez, the director of public works; Rogelio Blanco, director of engineering; Rodolfo Escamillo Soto, director of Bienes Raices; and Brindiz Herrera, director of ISSSTECALI, the credit union which financed the houses.

Among our own colleagues, we thank Jenny Young, who came with her husband Don Corner and voluntarily gave her help throughout the project; and Harry Van Oudenallen, who, after his great work in helping to implement the University of Oregon plan (see *The Oregon Experiment*), came to Mexicali with us for a few months and helped in the early stages of the project. We also thank Peter Bosselmann (he made the drawing on page 10), Peter Lee, Tomas Sanchez, Michele Bashin, Martin Just, Antonio Risianto, and Dorit Fromm, who came to work in Mexicali while they were students at the University of California. And we thank all those colleagues who, since the time of the project itself, have helped us by reading and criticizing this manuscript. This includes Jim Axley, who also made the structural calculations for us, Sara Ishikawa, Soli Angel, Roslyn Lindheim, Halim Abdelhalim, David Dacus, David Week, and Chris Arnold.

Finally, we give our deepest thanks to our apprentices, those eight students at the Universidad Autonoma de Baja California who are mentioned on the title page of this book. They gave themselves tirelessly to the project by their constant hard work; and they stuck it out through thick and thin, with all the long delays and difficulties. If it had not been for them, we would simply not have been able to complete this project. Without any doubt, this work is theirs as much as it is ours.